Velazquez's
Bodegones

Velazquez's
Bodegones

A Study in Seventeenth-Century Spanish Genre Painting

Barry Wind

The
George Mason
University Press

Copyright © 1987 by
George Mason University Press

4400 University Drive
Fairfax, VA 22030

All rights reserved

Printed in the United States of America

British Cataloging in Publication Information Available

Distributed by arrangement with
University Publishing Associates, Inc.

4720 Boston Way
Lanham, MD 20706

3 Henrietta Street
London WC2E 8LU England

Library of Congress Cataloging in Publication Data

Wind, Barry.
 Velázquez's bodegones.

 Bibliography: p.
 Includes index.
 1. Velázquez, Francisco Pacheco—Themes, motives.
2. Velázquez, Francisco Pacheco—Criticism and
interpretation. 3. Genre painting, Spanish.
4. Genre painting—17th century—Spain. I. Title.
ND813.V41W55 1987 759.6 85-48037
ISBN 0-8026-0006-9 (alk. paper)
ISBN 0-8026-0007-7 (pbk. : alk. paper)

All George Mason University Press books are produced on acid-free
paper which exceeds the minimum standards set by the National
Historical Publications and Records Commission.

To Geraldine, James, and
Clifford

Contents

Illustrations

Preface

IN HIS LAUDATORY BIOGRAPHY OF VELÁZ-
quez, published in *El museo pictórico y escala óptica,* the late
Baroque painter and critic Antonio Palomino marveled at
the master's early essays of naturalism which captured "the
true image of reality." In fact, even though some viewed
these pictures as "cosas rústicas," rough and humble pieces
distant from the serious and noble images of Raphael,
Palomino reported that Velázquez's proud reply was: "I
would rather be first in that coarse stuff than second in
fineness." These juvenilia, given the name *bodegones,* are
distinguished by a lively and remarkable naturalism and
are rightly placed among Velázquez's most famous works.
They include *The Servant* (Chicago, Art Institute), *The
Supper at Emmaus* (Blessington, Beit Collection), *Old
Woman Cooking Eggs* (Edinburgh, National Gallery), *The
Luncheon* (Budapest, Museum of Fine Arts), *Three Men at a
Table* (Leningrad, Hermitage), *The Water Carrier* and *Two
Men at a Table* (London, Apsley House), and *Kitchen Scene
with Christ in the House of Mary and Martha* (London,
National Gallery). *The Musical Trio* (Berlin, Dahlem), *The
Vintager* (Jacksonville, Cummer Art Gallery), the *Old
Woman Selling Fruit* (Oslo, National Gallery), *Head of a
Young Man* (Leningrad, Hermitage), and the *Young Woman*

at a Table (private collection) are also *bodegones* that have been attributed controversially to Velázquez. This small but significant corpus contains some of the best genre painting of the period. Indeed, even that paragon of neoclassical artists, Anton Rafael Mengs, concluded that although Velázquez's subjects were akin to genre scenes by Rembrandt, Dou, and Teniers, Velázquez far exceeded these masters.

Yet despite the chorus of praise for these pictures, as well as the numerous and often illuminating monographs devoted to the artist, these important paintings remain problematical. Seen as a prelude to the brilliant efflorescence of Velázquez's career at the Spanish court, the *bodegones* are often given short shrift. Thus a recent monograph on Velázquez devotes almost three times as much space to *Las Meninas* as it does to all of the *bodegones*.

The traditional stylistic problems of chronology, attribution, and stylistic sources of the master's early works have generated conflicting opinions. It is my hope that this book will illuminate the *bodegones* and thus provide a more complete picture of Velázquez's development in Seville. Of particular significance is the controversy surrounding prototypes. Thus, in the clamor to find sources in such artists as Aertsen, Campi, and Caravaggio, it seems to me that an important facet of Velázquez's education has been overlooked, his formation in the Pacheco workshop and his relationship to the native tradition of Spain. For instance, the teachings of Velázquez's master, Francisco Pacheco, an avowed admirer of Bassano and a proponent of a sober style of restricted color, doubtless had an impact upon the young Velázquez.

It is the Spanish tradition, too, that provides a fulcrum for Velázquez's iconography. The dazzling naturalism of the *bodegones* has often precluded iconographic interpreta-

tion. But it has become increasingly apparent that Baroque genre painting is redolent with meaning. Velázquez's pictures are apparently no exception, for they too reflect the cultural fabric of the Golden Age. The *bodegones* range in subject matter from the vulgar and lascivious to the sober and hieratically philosophical. The pictures are often studded with proverbial references, calling to mind the significance of apothegms so esteemed by Cervantes: "Sancho Panza's proverbs . . . are no less valuable for their conciseness."

Velázquez is the greatest of the Spanish genre painters. However, this study would be incomplete if it did not discuss genre painting by other Spanish artists as well. Accordingly, in an excursus which considers the impact of Velázquez's genre painting upon subsequent Spanish artists, I have devoted some space to works produced in the wake of Velázquez. I have given far more discussion to Velázquez's great successor in Seville, Bartolomé Murillo. My primary focus is on the often elusive but rather rich iconography of these pictures, although I also treat problems of attribution and chronology.

But it is Velázquez who remains the fulcrum of this study, for it is Velázquez's *bodegones* which are the apogee of Spanish genre painting. In a perceptive and revealing comparison, Baltasar Gracián, the great master of subtle allusion in the Golden Age, remarked upon the likeness of the ancient painter Timanthes to Velázquez. Doubtless Gracián knew that Pliny considered Timanthes to be "the only artist whose works always suggest more than is in the picture and great as is his dexterity, his power of invention yet exceeds it." We expect no less from Velázquez.

Acknowledgments

I BEGAN MY WORK ON VELÁZQUEZ AND SPAN-
ish genre painting in 1978. My interest in genre painting,
however, stems from the 1960s, stimulated by Professor
Donald Posner, who directed my dissertation on Italian
Baroque genre painting.

It is a pleasure to acknowledge those who have helped
me throughout the course of this study. I am indebted to
the Graduate School of the University of Wisconsin-Mil-
waukee for providing me with a research grant that al-
lowed me to study many of the pictures at first hand. I am
also grateful to the College of Letters and Science of the
University of Wisconsin-Milwaukee for making funds
available to purchase photographs.

A number of colleagues both in this country and abroad
have generously provided me with photographs and in-
formation. I am particularly grateful to Dr. Marianna
Haraszti-Takács, Dr. José Lopez-Rey, Dr. Pierre Rosen-
berg, and Dr. Erich Schleier.

I owe a special debt of thanks to Dr. Lubomír Konečný,
who read an earlier version of the manuscript and made
many useful bibliographic citations. Professor Jonathan
Brown also read the manuscript, and I am grateful for his
perceptive comments and suggestions.

Above all, I am indebted to my wife, Geraldine. As a dragooned cicerone she descended into dark dungeons and climbed steep towers, keeping our sons occupied while I was sequestered in a library or a print room. She is also a scholar who generously took time away from her own work to aid me with mine. Her comments and criticisms, invariably on target, were enormously valuable. Her encouragement was sustaining.

Velazquez's
Bodegones

1

The Bodegón *and Art Theory*

"WELL THEN," DECLARED FRANCISCO PA-
checo, Velázquez's father-in-law and mentor, "should we
not esteem *bodegones?* Certainly, if they are painted as my
son-in-law paints them, elevating himself with this talent
and surpassing others. They deserve very great praise."[1] It
is clear that Pacheco admired *bodegones,* which were espe-
cially noteworthy for their extraordinary naturalism. But
neither Pacheco, nor subsequent theorists, clearly defined
the term. *Bodegón* has always been used for still-life paint-
ing, and now out of comfortable habit, art historians also
apply it to those remarkably naturalistic early works by
Velázquez which combine genre and still-life elements.
For example, the *Three Men at a Table* in Leningrad (fig. 1),
a comic, raucous banquet which revels in a zestful vulgar-
ity, is a *bodegón.* Yet the *Supper at Emmaus* in the Beit
Collection (fig. 2) is also called a *bodegón,* since the major
focus is on the foreground where the preoccupied kitchen
maid appears with an array of crockery. The inclusion of
such discrepant themes under the rubric *bodegón* crosses
the boundary between sacred and profane subject matter.
Despite the assertion that the Golden Age critic knew

1

specifically what a *bodegón* was, the ambiguity of the term actually has its roots in seventeenth-century art theory.[2] An investigation of seventeenth- and eighteenth-century source literature reveals the tangled history of the term and its varying applications.

In the Golden Age, *bodegón* most frequently meant an eating or drinking place. In his *Discorso sobre la forma de reduzir la disciplina militar,* Sancho de Londoño soberly warned the recruit: "No soldier should enter a tavern at a public *bodegón* to eat."[3] In his travel diary, Cristobal de Villalon noted "muchos galanes" who spent their time drinking and eating in *bodegones.*[4] And in *Don Quixote,* that paradigm of Spanish Golden Age literature, Cervantes has Sancho Panza naïvely avow that art will immortalize the noble exploits of don and squire: "I swear . . . that before much time there will not be a *bodegón,* roadside inn, tavern or barbershop, where our glorious deeds will not be found."[5]

In the light of the literary references, we can assume that *bodegón* was a fairly common word. As far as I know, however, Carducho was the first art theorist to use the term. After a discourse on the impropriety of portraits depicting humble and even base sitters, Carducho focused his attention on other paintings of "conceptos humildes" which were "abatiendo el generoso Arte."

> As is seen today by many paintings of *bodegones* with low and very vile ideas, and many others of drunkards, others of cardsharpers, and similar things . . . four insolent pícaros, and two slovenly wenches. . . .[6]

Thus it is tempting to associate *bodegones* with the genre scenes which Carducho has cited. But, although *bodegones*

are tainted like the other paintings of drinkers and card-sharps, they are distinguished from them. Their subject matter remains undefined.

Carducho's criticism of this type of naturalistic subject matter can be viewed in terms of an art theoretical tradition which emphasized lofty themes. Carducho was, after all, an Italian and heir to the classical-idealizing theories of the cinquecento.[7] And Spain was fertile soil for the cultivation of these ideas. Indeed, the literary giants Lope de Vega and Cervantes, who dabbled in art criticism, had already advanced this esthetic. Lope equated painters who did not attempt to portray dignified figures with "pintores viles."[8] And Cervantes admonished the artist not to vomit ("vomitar") nature, but to imitate ("imitar") it wisely.[9]

On the other hand, Carducho's derogatory comments may, in part, have their point of origin in his frustrated ambitions. Seething with resentment because a Sevillian upstart had secured the court position which he so coveted, Carducho may have made Velázquez the indirect target of his ire.[10] For example, Carducho's criticism of literal-minded naturalism may have been spurred by the marvelous tactility of Velázquez's paintings.

> I see taffeta imitated so that it appears to be true taffeta, cloth canvas, a jar, a knife, a bench, bread, fruit, a bird, a dumb animal and a reasonable one, all made with great spirit, but without much genius, and without much draughtsmanship or study. . . .[11]

And Carducho's disparagement of paintings with a limited palette depicting "clothing and faces which appear very common and vile," conforms to his generally harsh view of naturalism but also suggests a specific criticism of

the terra cotta tonality and humble subject matter found
in the *Water Carrier* (fig. 3), a painting which Carducho
may have seen in Madrid.[12] Carducho's discussion of an
irreverent depiction of Christ in the house of Mary and
Martha with "a great deal of food, meat, capons, turkeys,
fruit, plates, and other kitchen items, making it appear
more like a glutton's tavern than a hospice of sanctity,"
may refer specifically to a Flemish portrayal in the manner
of Aertsen or Beuckelaer.[13] But Velázquez's two kitchen
pieces *cum* religious scenes, the *Supper at Emmaus* (fig. 2)
and the *Kitchen Scene with Christ in the House of Mary and
Martha* in London (fig. 4), may have provided some of the
provocation.

 In 1634, one year after the publication of Carducho's
belittling remarks, the term *bodegón* appears in an official
court document. Among the eighteen paintings which
Velázquez sold for two thousand ducados were history
paintings, a *Susanna* by Cambiaso, Titian's *Danae,* and
Velázquez's own *Bloody Coat of Joseph* and *Forge of Vulcan,*
portraits by Francisco de Rioja, five flower pieces, four
small landscapes, and two *bodegones*.[14] Like most sale refer-
ences this one is noticeably reticent. Although it is differ-
entiated from history, portraiture, landscape, and flower
painting, we are no closer to knowing the precise content
of a *bodegón*. Indeed, inventories of seventeenth-century
collections are invariably not very helpful in defining the
term. In 1655 "tres bodegones" of Velázquez are men-
tioned in the Orosco collection in Seville, but we do not
know their subject matter.[15] What is rather surprising is
that a number of inventories do not refer to *bodegón* at all.
Consequently the inventory of the Fonseca collection
taken in 1627—a collection which contained the *Water
Carrier*—did not cite any *bodegones*.[16] And in the inventory
of the collection of Manuel Nieto de Guzmán, docu-

mented in 1661, a picture of a fortune teller is also not referred to as a *bodegón*.[17] Conversely, it is very clear that *bodegón* was intended to mean still life at a very early time. Thus the inventory of doña Ana Diaz de Vellegas, taken in 1610, explicitly cited "un bodegón de frutas."[18]

The most elaborate discussion of *bodegones* is found in book 3, chapter 8, of Pacheco's *El arte de la pintura*. Although Pacheco had been working on this compendium of opinion, dogma, and art-theoretical lore since the early seventeenth century, much of the chapter in question was probably written in the 1630s as a response to Carducho's oblique attacks on Velázquez's presumed "pensamientos viles.'[19] Like Carducho, Pacheco believed in the process of ideal selection.[20] Bassano was presumably an inferior painter to Michelangelo and Raphael because of the nature of his humble subject matter.[21] Yet Pacheco's spirited advocacy of naturalism and less lofty subject matter, with emphasis on the work of his son-in-law, suggests that this chapter was to be Velázquez's defense.

The chapter's catchall title, "De la Pintura de animales y aves, pescaderias y bodegones y de la ingeniosa invención de los retratos del natural," characterizes its rambling nature. It begins as a guide for the accomplished painter, who should be adept at depicting birds and animals, as well as fish, still lifes, and various human figures in the manner of Bassano and Pedro de Orrente. Pacheco wrote:

> In Spain our Pedro Orrente has gained a reputation with this kind of painting; even though it is different in manner from Bassano, he has made his style known through the same naturalism gaining new praise and glory: surely, this has been advantageous not only to him, but to many painters who have supported themselves with their copies,

painting spirited landscapes in the Italian manner, and
very natural.

Others are inclined to paint fish markets with great
variety; others dead birds and hunting pieces; others *bode-
gones* with different kinds of food and drink; others ridicu-
lous figures with diverse and ugly subjects which provoke
laughter; and all these things made with spirit and good
style are entertaining and show talent in their arrangement
and in their liveliness.

It is true that fish and birds and dead things are easier to
imitate because they keep their position as long as the
painter could wish. And the same is true of all the things of
eating or drinking, as in glasses and fruit. But in live
things, be they fish, birds, or animals, the painter must
exercise care to make the movements natural.[22]

In spite of his maundering prose, Pacheco's *bodegones*
emerge as a distinct and definable type differing from
landscapes and game pieces, and from paintings with
figures, "pescaderias," and those with "figuras ridiculas."
Bodegones appear to belong to the category of still life,
since they represent "diferencias de comida y bebida," and
like "vasos y frutas" they are easy to imitate. According to
this definition then, there are really no surviving *bodegones*
by Velázquez.

Pacheco referred to *bodegones* yet another time in this
chapter. But this second citation unfortunately clouds the
perception of *bodegón* as still life. Pacheco praised Veláz-
quez's *bodegones* and portraiture for their naturalism, and
conceded his debt to Velázquez's "poderoso exemplo."

Should we not esteem *bodegones*? Certainly if they are
painted as my son-in-law paints them. . . . So with this type

and with his portraits, which we will consider later, he found the true imitation of nature, inspiring many with his powerful example. Even I ventured it one time. To please a friend when I was in Madrid in 1625, I painted for him a small picture with two realistic figures, flowers and fruits and other knickknacks which today is in the possession of my learned friend, Francisco de Rioja.[23]

Can we infer from Pacheco's account of this now-lost painting combining still life and figures, that it was a *bodegón*? This paradigm of virtuoso naturalism Pacheco thought made "everything else by my hand appear painted beside it."[24] Yet unlike the *bodegones* initially described by Pacheco as a type of still life with "different kinds of food and drink," this painting does not contain anything associated with drinking. We cannot assume that the "juguetes" are anything more than what the word implies—"knickknacks."

Unfortunately, Pacheco provides the only firsthand commentary on Velázquez's *bodegones*. Jusepe Martínez, a court painter, doubtless knew Velázquez.[25] But although his *Discursos* may obliquely refer to Velázquez's paintings like the *Three Men at a Table* in its criticism of certain half-lengths distinguished solely by their simplistic imitation of nature, there is no mention of a *bodegón*.[26]

Antonio Palomino's *El museo pictórico,* published in the eighteenth century, actually represents a culmination of seventeenth-century art-theoretical thought. Indeed, Palomino's perceptions of Velázquez are based, in part, upon the now-lost biography by Juan Alfaro, Velázquez's pupil.[27] However, *El museo pictórico,* which contains an extensive biography of Velázquez as well as a dictionary of terms, compounds the problem of defining the *bodegón*.

Palomino's description of Velázquez's early works embellishes Pacheco's list of types of naturalistic painting.

> He was fond of painting, with most singular conceit and notable spirit, animals, birds, fishmarkets, and *bodegones,* which imitated nature perfectly, as well as beautiful landscapes and figures; different kinds of food and drink; fruits and poor and humble kitchenware, with great spirit, drawing and color so that they appeared real. . . .[28]

Bodegones are differentiated once more from figure painting, landscapes, and bird and animal pictures. But unlike Pacheco, Palomino also distinguished *bodegones* from "diferencias de comida y bebidas" as well as from other still-life objects.

Palomino followed his discussion of these various types of naturalistic painting with an account of specific Velázquez works.

> We must not pass in silence the painting that they call the *Water Carrier;* he is an old man, very badly dressed with an ugly and ragged smock which would reveal his chest and belly covered with scabs, and strong, hard calluses. And this work has been so lauded that it has been kept to this day in the Buen Retiro Palace.
>
> He painted another picture of two poor people eating at a humble little table, where there are various earthenware vessels, oranges, bread and other things, all observed with a singular diligence. Similar to this is another painting of a poorly dressed boy, with a little cap on his head, counting money on a table, while carefully adding with his fingers of his left hand; behind him is a boy observing some sea

breams and other fish, such as sardines, which are on the table; there are also a Roman lettuce (which in Madrid they call hearts) and an upside down kettle; to the left there is a kitchen cabinet with two shelves; on the first are some herrings and a loaf of Sevillian bread on a white cloth; on the second are two white earthenware plates and an earthenware cruet with green glaze; and on this painting he put his name, although now it is very worn and rubbed with time.

Like this is another, where one sees a board, used for a table, with a portable stove and a boiling pot on top of it, covered with a bowl. One sees the fire, the flames, and the sparks vividly; a tin kettle, an unglazed clay jar, some plates and bowls, a glazed jar, a mortar and pestle, and a bulb of garlic are nearby; and on the wall one can see a small basket hanging from a hook with a rag and other humble trifles; and the custodian of all of this is a boy with a jar in his hand and a coif on his head, who in his boorish costume presents a most ridiculous and comic subject.

Our Velázquez painted all his works at that time with this vigor, to differentiate himself from others and to pursue a new path. Knowing that Titian, Dürer, Raphael, and others held an advantage over him, and that their reputations had increased after their deaths, he availed himself of his fantastic inventiveness, painting coarse things with great show and singular light and color. Some objected that he did not paint, with delicacy and beauty, deeds of greater seriousness, emulating Raphael of Urbino. But Velázquez gallantly answered them, saying: "I would rather be first in this coarse stuff, than second in delicacy."

Those who have been praised in this type of painting have achieved fame through their accomplished spirit. Not only did our Velázquez follow such a humble path; many others have shared this inclination and particular disposition of mind. Pireicos, a famous painter of antiquity according to Pliny, painted humble things, gaining great

praise and glory for his works. They called him by the
nickname Riparografos, a Greek word, which means
painter of low and coarse things.

 With these beginnings and his portraits, which he did so
excellently . . . Velázquez found the true imitation of
nature, inspiring many with his powerful example. Pa-
checo tells us that he himself painted this type of thing in
emulation of Velázquez.[29]

Obviously, these paintings are never referred to as *bode-
gones*. And doubtless, there was no reason for Palomino to
consider them *bodegones*. Indeed, in his dictionary of artis-
tic terms, Palomino viewed *bodegón* as synonymous with
still life, defining it as "a type of painting where food is
depicted."[30] Palomino also used a variant of *bodegón, bode-
goncillo,* as equivalent to kitchen still life. Francisco Her-
rera, we are told, had a "singular pleasure in painting
bodegoncillos, with various kitchen trifles."[31] Like father like
son; Herrera el Mozo also painted still-life *bodegoncillos.*[32]
On the other hand, one can infer from Palomino's
description of scenes by Francisco Herrera el Rubio that
bodegones do contain human figures: "He painted many
ridiculous pieces, like *bodegones* and figures in the manner
of Callot. . . ."[33] Unless Palomino is referring to a witty still
life in the manner of Archimboldi, the ridiculous *bodegones*
may be comparable to Velázquez's comic *Three Men at a
Table.*
 Reading Palomino on the *bodegón* leaves us more con-
fused than enlightened. It would be convenient to accuse
him of the kind of slipshod thinking that one finds fre-
quently in the criticism of painter-theorists. But Palomino
was no mere painter turned critic. He was a systematic
scholar who had studied mathematics and jurisprudence

before becoming an apprentice to Valdés Leal.[34] But even an orderly mind must become a bit unraveled when faced with the anomaly of the term *bodegón*.

If art theorists used the word *bodegón* ambiguously, lexicographers, traditionally insistent upon precise terminology, did not. Indeed, eighteenth-century dictionaries are unanimous in adhering to a strict definition of *bodegón* as a still life. Thus, the monumental *Diccionario de la lengua castellana,* published in 1726, defined *bodegón* as follows: "In painting it is applied to those canvases where pieces of meat and fish, and poor people's foodstuff are painted."[35] This becomes the standard definition, which is not altered even by later eighteenth-century dictionaries incorporating revisions in the language. Thus, in the *Diccionario de la lengua castellana* of 1780 and the *Diccionario castellano* of 1786, a *bodegón* is simply defined as a type of painting which depicts "cosas comestibles."[36]

Most eighteenth-century art theorists also did not consider *bodegones* to be synonymous with figure painting. There was, however, one notable exception. The indefatigable diarist Antonio Ponz described Velázquez's *bodegones* as genre pieces representing figures eating and drinking. Teniers painted a type of genre known as "bambochadas," but Velázquez painted "a *bodegón* with two boys who are eating and drinking," which Ponz saw in the Royal Palace in Madrid.[37] Ponz also gave a detailed description of three genre paintings that he saw in the Martínez collection in Cádiz.

> Three *bodegones* by Don Diego Velázquez merit very particular mention. In one there are three half-length figures seated at a table with a lot of different fish. . . . In another, there are four figures also seated to eat; two of them have

the same features that two figures have in Velázquez's
painting of the comic triumph of Bacchus *(Los Borrachos)* in
the possession of his majesty in the Royal Palace. . . . The
table is stacked with a lot of meat, and as in the first piece,
hanging fish, birds, and dead game, etc.

The third is of equal conception, a piece depicting glut-
tonous actions, with three seated figures and a great deal of
suspended meat, with strings of sausages, pork sausages,
black puddings, loins, etc.[38]

For Ponz, the *bodegón* is clearly a vulgar eating piece
combining figures and foodstuff. If Ponz's limited defini-
tion of *bodegón* were consistent, it would bring us closer to
precise usage for the term. Unfortunately, Ponz is no
more consistent than his predecessors, for Giordano also
painted an eating piece with humble characters that Ponz
called "una bambochada."[39]

Ponz may have considered Velázquez to be a painter of a
particular type of genre, *bodegón,* but for other eighteenth-
century theorists the *bodegón* was synonymous with still
life. Thus, Marcos Antonio de Orellana differentiated
Esteban March's battle pieces, histories, and landscapes
from the still-life pieces which included "bodegones, fru-
tas, y aves."[40] Indeed, genre pieces were considered "bam-
bochadas" and not *bodegones.* Francisco Preciado de la
Vega, for example, described Velázquez's early works as
representations of half-length figures "en bambochadas."[41]
The criticism of the respected late-eighteenth-century his-
torian of Spanish art, Juan Augustin Ceán Bermúdez, can
serve to epitomize current ideas concerning Velázquez
and the *bodegón.* In the *Diccionari o histórico,* Ceán sketched
the progress of Velázquez's career from still-life painter to
figure painter, linking these early figure paintings with
Dutch and Flemish genre scenes; "he passed on to paint-

ing pictures of figures occupied in common and domestic duties in the manner of David Teniers and other Flemish and Dutch artists which are called *bambochadas*. . . . To this first style belongs the *Aguador of Seville* which is in the palace at Madrid. . . ."[42] For Ceán Bermúdez a genre piece was a "bambochada"; whereas "to paint *bodegones* is the same as painting food and kitchenware."[43] Ceán's discussion of Velázquez's early works in the *Historia del arte de la pintura,* published in the third decade of the nineteenth century, represents the culmination of the trend which allied the *bodegón* with still life. Thus, Velázquez began his career as a painter of *bodegones* and then moved on to such figure painting as "los pobres que le pedian limosna."[44]

As we have seen, the word *bodegón* is not consistently applied to any one type of genre or still-life painting. Francisco Pacheco, the writer closest to the problem, is unfortunately the writer who creates confusion about the definition, for the *bodegón* is differentiated from figure painting in one passage of the *Arte de la pintura* and apparently considered a genre piece with still life in yet another. This duality is our critical patrimony. The eighteenth-century theorist had to deal with it. Some used the term *bodegón* for an eating piece; others for a still life of foodstuff. The twentieth-century art historian, inheriting a legacy of imprecision, has compounded it by broadening the perimeters of the term to include the *Water Carrier* as well as the religious scenes with kitchen still lifes.

However, a partial resolution of the ambiguity may be suggested by the very source that created the initial confusion. Indeed, Pacheco may provide us with at least a fulcrum for discussing Velázquez's early painting. One can consider vulgar, comic genre scenes like the *Three Men at a Table,* the *Luncheon* in Budapest (fig. 5), or the *Musical Trio* as a special subtype equivalent to Pacheco's paintings of

"ridiculous figures with diverse and ugly subjects." Although Pacheco's ideas may stem ultimately from the Italian concept of "pitture ridicole," genre was frequently linked to comedy in Spanish art theory.[45] Siguenza, for instance, commented on how one laughed at the sight of Bassano's depiction of a farmer's house.[46] Pacheco's citation of Pireicos as "an antique painter inclined to ordinary and amusing things" reinforces this concept of a type of comic genre painting.[47] Indeed, among Pireicos's "cosas humildes" were paintings of meals, suggesting an antique prototype for Velázquez's comic repasts.[48] The comic qualities of some of Velázquez's early genre paintings were also noticed in the eighteenth century. Palomino, for example, described a now-lost Velázquez painting of a peasant boy with a jar in his hand as "un sujeto muy ridiculo."[49] And in a letter to Ponz, Mengs equated the genre painters Dou and Teniers with "la poesía cómica" and considered Velázquez's early half-lengths as the paradigm of this comic type.[50]

If certain Velázquez paintings may be "figuras ridiculas," what are the others? In spite of their prominent kitchen ambience, paintings like the *Supper at Emmaus* and the *Kitchen Scene with Christ in the House of Mary and Martha* are obviously religious scenes and not *bodegones*. The remaining paintings, like the *Water Carrier* and others, like the *Old Woman Cooking Eggs*, with their combination of still life and figures, have characteristics which are reminiscent of Pacheco's painting for Rioja, but none of Velázquez's surviving putative *bodegones* are ever directly labeled as such by seventeenth- and eighteenth-century theorists.

Bodegón may not be the correct term for these paintings, but the designation "genre" for paintings like the *Water Carrier* is an equally imprecise term which does little to clarify matters.[51] Nor does "bambochada," the alternative

offered by the eighteenth-century sources resolve the question, since this term actually relates to the small figure paintings by Peter van Laer and his followers.[52]

Certainly we should reassess the term *bodegón*. Nevertheless, the religious paintings *cum* kitchen pieces and the genre scenes should be treated together, since they are united by common stylistic, and often similar iconographic, concerns.

Notes

1. F. Pacheco, *Arte de la pintura* (1649), ed. F. J. Sánchez Cantón (Madrid, 1956), 11, 137.

2. J. López-Rey *(Velázquez: A Catalogue Raisonné of His Oeuvre,* [London, 1963], 29) maintains, for example, that the *bodegón* was considered a combination of still life and human figures by Velázquez's contemporaries.

3. S. de Londoño, *Discorso sobre la forma de reduzir la disciplina militar* (Madrid, 1593), 32.

4. C. de Villalon, *Viaje de Turquia (1557),* ed. M. Serrano y Sanz *(Madrid, 1905), 11, 92.*

5. *Don Quixote,* 2:lxxi.

6. V. Carducho, *Diálogos de la pintura* (1633), ed. D. G. Cruzada Villaamil (Madrid, 1865), 253.

7. On Carducho's debt to Italian sources see M. C. Volk, *Vincencio Carducho and Seventeenth Century Castilian Painting* (New York and London, 1977), 92–129.

8. Lope de Vega, "Al nacimiento del principe," in *Fuentes literarias para la historia del arte español,* ed. F. J. Sánchez, vol. 5 (Madrid, 1941), 409.

9. *El licenciado vidriera* (1613) in *Novelas ejemplares,* ed. F. Rodríguez Marín (Madrid, 1917), 49.

10. On the rancorous competition see López-Rey, *Velázquez,* 40–41.

11. Carducho, *Diálogos*, 135.

12. Ibid., 193. For the provenance of the *Water Carrier*, which was in Madrid by the late 1620s, see López-Rey, *Velázquez*, 163.

13. Carducho, *Diálogos*, 265. Carducho may have seen Matham's engraving after Aertsen representing the *Supper at Emmaus*. A. L. Mayer ("Velázquez und die niederlandischen Küchenstücke," *Kunstchronik und Kunstmark* 30 [1918/19]:i. 236–37) has linked this print to the *Christ in the House of Mary and Martha.* Carducho's claim (p. 127) that great artists were not portraitists also may be aimed at Velázquez, who had established his reputation at court as a portraitist. Cf. López-Rey, *Velázquez*, 41. It is for this reason, and other criticisms cited in the text, that I find it difficult to accept Volk's suggestion *(Vincencio Carducho,* 108–112) that Velázquez was the anonymous, and rather obsequious, disciple, of the *Diálogos.* Actually, Carducho may be relying simply upon a literary convention common to art theory. Pino's *Diálogo della pittura* (1548), for example, employed the device of master and pupil. And in the seventeenth century, Félibien's *Entretiens* (1666) made use of a similar format.

14. *Carta de pago a Velázquez de mil ducados por el precio de 18 cuadros de pintura* (1634), in *Varia Velazqueña* (Madrid, 1960), 2:240.

15. D. Kinkead, "Tres bodegones de Diego Velázquez en una colección sevillana de siglo XVII," *Archivo Español de Arte* 52 (1979):185.

16. J. López Navio, "Velázquez tasa los cuadros de su protector D. Juan de Fonseca," *Archivo Españolde Arte,* 34 (1961), 64.

17. M. Agulló Cobo, *Noticias sobre pintores madrileños de los siglos XVI y XVII* (Granada, 1978), 114.

18. Ibid., 135. I suspect that this may also be the meaning behind the "tres bodegones de Italia," cited in an inventory of 1608, painted by Pantoja de la Cruz. See F. J. Sánchez Cantón, "Sobre la vida y los obras de Juan Pantoja de la Cruz," *Archivo Español de Arte* 20 (1947):102. When the manuscript was in the course of publication the catalogue for the show *Spanish Still-Life* (W. Jordan and S. Schroth, Fort Worth, 1985) appeared. Sara Schroth has published early seventeenth century inventory ref-

erences (33-34) which demonstrate that at least some pictures in the manner of Aertsen and Campi—paintings with still life and figures—were considered *bodegones*.

19. Pacheco's manuscript was completed in 1638. But the writing of it was an ongoing process stemming from the first decade of the seventeenth century. See *Arte de la pintura*, ed. F. J. Sánchez Cantón, 1:xi, xx–xxi.

20. Ibid., 200, 250–51.

21. Ibid., 475–76.

22. Ibid., 2:134–35. Pacheco's use of the word *disposición* to indicate the arrangement of these paintings may echo the terminology of poetic theorists who used the word synonymously with *order*. Cf. Cervantes, Prologue to *La Galatea* (1588), ed. J. B. Avalle-Arce (Madrid, 1961), 9. Pacheco's discussion of the ease of portraying still life finds its counterpart in *seicento* Italian theory. See G. Mancini, *Considerazioni sulla pittura*, ed. A. Marucchi and L. Salerno (Rome, 1956), 1:113–14.

23. Pacheco, *Arte*, 137.

24. Ibid.

25. For Martínez's career as painter and theorist see Martínez, *Discursos practicables del nobilísimo arte de la pintura* (Madrid, 1866), x–xiv.

26. Ibid., 77–78.

27. *Varia Velazqueña*, 2:73 n.36.

28. A. Palomino, *El museo pictórico y escala óptica; Parnaso español pintoresco laureado* (1715–24; Madrid, 1947), 892.

29. Ibid., 892–93.

30. Ibid., 1145.

31. Ibid., 881.

32. Ibid., 1020.

33. Ibid., 881.

34. For Palomino's training see *Fuentes literarias* (Madrid, 1934), 3:145.

35. *Diccionario de la lengua castellana* (Madrid, 1726), s.v. "bodegón."

36. *Diccionario de la lengua castellana* (Madrid, 1780), s.v. "bodegón." *Diccionario castellano* (Madrid, 1786), s.v. "bodegón."

37. A. Ponz, *Viaje de Espâna* (Madrid, 1783), 6:35.

38. Ibid. (1794), 18:21. Nicolas de la Cruz y Bahamonde's *Viaje de Espāna* (1806–13) also notes "tres bodegones" in the Martínez collection, see *Varia Velazqueña*, 2:164.

39. Ponz, *Viaje* 6:54.

40. M. A. de Orellana, *Biografía pictórica valentina, o Vida de los pintores, arquitectos, escultores y grabadores valencianos,* 2 ed., ed. X. de Salas (Valencia, 1967), 212–13.

41. F. Preciado de la Vega, *Carta a Gio. B. Ponfredi sobre la pintura española* (1765), in *Fuentes literarias* (Madrid, 1941), 5:117–18.

42. J. A. Ceán Bermúdez. *Diccionario histórico de los más illustres profesores de las bellas artes* (1800; Madrid, 1965), 5:157–58. Murillo, too, followed the same course. Ceán Bermúdez, *Diálogo sobre el arte de la pintura* (Seville, 1819), 27–31.

43. Ceán Bermúdez, *Diálogo,* 28.

44. Ceán Bermúdez, *Historia del arte de la pintura* (1825), in *Varia Velazqueña*, 2:196.

45. Pacheco seems to simplify Paleotti's *(Discorso interno alle immagine sacre e profane* [1582], in P. Barocchi, *Trattati d'arte del cinquecento* [Bari, 1961], 2:390, 396) discussion of "pitture ridicole" which "represent gluttony, drunkenness, and dissipation moving the spectator to laughter." On the interrelationship of theories about comedy and comic painting in late cinquecento Italy see B. Wind, "Pitture Ridicole: Some Late Cinquecento Comic Genre Paintings," in *Storia dell'arte* 20 (1974):25–35.

46. José de Siguenza, *Historia de la orden de San Jerónimo* (1600), in *Fuentes literarias* (Madrid, 1923), 1:421.

47. Pacheco, *El arte de la pintura,* 2:136.

48. Ibid.

49. Palomino, *Museo pictórico,* 893.

50. Ponz, *Viaje de España,* 6:181.

51. W. Stechow and C. Comer ("The History of the Term Genre," *Allen Memorial Art Museum Bulletin* 33 [1975–76]:89–94) discuss the evolution of the term *genre* and its narrow application. Cf. my unpublished dissertation ("Studies in Genre Painting: 1580–1630," New York University, Institute of Fine Arts,

1973, 114–120), which points out the ambiguities of the term in eighteenth- and nineteenth-century criticism.

52. For a discussion of van Laer and his "bambocciate" see G. Briganti, *I Bamboccianti* (Rome, 1950). When this chapter was already completed M. Haraszti-Takács's important monograph, *Spanish Genre Painting in the Seventeenth Century* (Budapest, 1983), was published. Her discussion of the term *bodegón* (82–84) also recognizes its ambiguity, although she asserts (83) that "in the first quarter of the seventeenth century, the term *bodegón* was used to designate a type of picture showing peasants, shepherds, simple people having their meals or just talking at a table."

2

Chronology and Attribution

IN 1616, JUST AS VELÁZQUEZ WAS ABOUT TO embark upon his glorious career, Cervantes wrote: 'history doesn't always go in the same path, nor does painting always depict great and magnificent things, nor poetry converse always with the heavens; history allows vile actions, painting weeds and shrubs in its pictures, and poetry sometimes prominently sings of humble things."[1] Velázquez's *bodegones,* so vivid in their realization of the ordinary—a bead of water glistening on a jug, the fragile smoothness of an eggshell, the gleam of burnished brass— also sing of "cosas humildes." But the art-historical demand for a clear and sonorous cantata is muffled by the problems surrounding the paintings. Indeed, the attribution and chronology of Velázquez's *bodegones* still remain moot. Only the *Water Carrier* is cited in seventeenth-century documents; only two paintings, the *Kitchen Scene with Christ in the House of Mary and Martha* and the *Old Woman Cooking Eggs,* are dated.

References to the *Water Carrier,* known also as *El Aguador,* begin as early as the 1620s. It was first mentioned in the inventory of 28 January 1627 of the recently

21

deceased Don Juan Fonseca y Figueroa, chaplain to Philip
IV and Velázquez's first protector in Madrid. In that year,
the painting was bought for 330 reales by don Gaspar de
Bracamonte, the chamberlain to Cardinal Infante don
Fernando, and then passed into the Cardinal Infante's
collection.[2] In 1701 the painting was first recorded in the
inventory of the Palacio Real del Buen Retiro and ap-
peared in the subsequent inventories of 1772 and 1794 of
the new Palacio Real.[3] Already in the eighteenth century
the *Water Carrier* received accolades from the critics. Palo-
mino, for instance, noted its celebrity and remarked upon
its extraordinary naturalism.[4] Ponz praised it along with
other pictures by Velázquez's hand in the Royal Palace.[5]
Foreigners, too, commented upon the painting. The En-
glish traveler Henry Swinburne lauded "The Water Seller
of Seville an admirable old figure."[6] And Dezallier
d'Argenville even related that Philip IV himself hung the
painting in the Buen Retiro, a charming fabrication which
attests to the fame of the painting.[7]

Regrettably, Velázquez's other surviving *bodegones* are
not mentioned in the seventeenth century. However, two
of the paintings, *Three Men at a Table* and *Two Men at a
Table,* at least have eighteenth-century provenances. It is
likely that Palomino saw the *Two Men at a Table* in Madrid,
since he described a "picture of two poor people eating at a
humble little table, where there are different earthenware
vessels, oranges, bread, and other things. . . ."[8] There are,
of course, minor discrepancies. The painting has no bread
and only one orange. But the description on the whole
conforms to the Apsley House painting. The painting was
first in the collection of the Marquis of Ensenada, who sold
it to Carlos III in 1769. It remained in the Palacio Real
until 1813 when it was appropriated by Joseph Bonaparte.
Afterward it was presented to the Duke of Wellington as

part of the spoils of war.[9] The *Three Men at a Table*, however, has a briefer history. It was in the collection of Catherine the Great of Russia in 1797 and may have been in St. Petersburg by 1774, where it was inventoried as "sujet flamand representant une collation."[10]

Other eighteenth-century references prove to be less substantive. Ponz referred to three eating pieces by Velázquez in the Martínez collection in Cádiz, but it is likely that his attribution was mistaken. According to Ponz, one painting presents a table full of fish. In another, "there are four figures also seated to eat; two of them have the same features that two figures have in Velázquez's comic triumph of Bacchus. . . . The table is stacked with a lot of meat and, as in the first piece, hanging fish, birds and dead game. . . ." The third painting contains three seated figures and "a great deal of suspended meat with strings of sausages, pork sausages, black puddings, loins. . . ."[11] Clearly the plethora of still life is unlike the restrained, soberly constructed arrangement that we find in the *Water Carrier* or the *Two Men at a Table*. In addition, since two of the paintings from the Martínez collection are apparently still extant, it is evident that they are not by Velázquez's hand. The crudely painted *Four Men at a Table* in a private collection in England, with its cramped composition and awkward figures, uses Velázquez's grinning topers from *Los Borrachos* as its point of departure. The *Girl and Two Men at a Table* in a private collection in Paris is a more accomplished painting. Yet there are still very awkward passages. The large pitcher, clumsily grasped by the serving girl, seems to be suspended unnaturally in space. The gestures, also, are stiff and self-conscious. This painting, too, is a pastiche, deriving from the Budapest *Luncheon*.[12]

Yet another eighteenth-century reference, the inventory of the O'Crouley collection in Madrid of 1795, cited

"un lienzo con una serrana y dos zagales" as one of
Velázquez's best works.[13] An attempt has been made to
identify this painting with the Budapest *Luncheon*.[14] How-
ever, this is unconvincing. A "serrana" is a mountain girl,[15]
but the girl in the *Luncheon* appears to be a serving maid.
In fact, her little cap, pierced with holes revealing her hair,
is like the one worn by the servant in the *Kitchen Scene with
Christ in the House of Mary and Martha*. The identification of
the *Luncheon* with the O'Crouley painting once more is
compromised by the absence of "dos zagales." A "zagal"
can be either a valiant "mozo" or a young shepherd.[16] We
don't know whether or not the young man in the Budapest
painting is courageous or even if he is actually a shepherd,
but since he is young, he could be a "zagal." But it is
obvious that we cannot confuse the old man with a "zagal."
In my opinion, the O'Crouley painting is lost.

The English connoisseur Buchanan mentioned "A set of
six pictures by this master (Velázquez), principally domes-
tic subjects and interiors. The figures of half the size of life
. . ." were purchased in Madrid in 1809 and dispersed to
several, presumably English, collections.[17] Not one of these
paintings has been identified.[18] Indeed, since Buchanan
was not always accurate in his references, these pictures
may not have been authentic Velázquezes. He cited, for
example, a "Masaccio portrait of Machiavelli" and a Mag-
dalene by Leonardo in the Lucien Bonaparte collection.[19]

Once we dismiss the two specious eighteenth-century
references, as well as Buchanan's cryptic note, we come to
the sad realization that the remaining *bodegones* attributed
to Velázquez possess only nineteenth-century—or even
twentieth-century—provenances. Indeed, the Budapest
Luncheon is first mentioned in 1897 in a private collection
in Edinburgh.[20] The *Old Woman Cooking Eggs* has a slightly
older provenance, since it was first recorded in a private

collection in Yorkshire in 1863.[21] The *Kitchen Scene with Christ in the House of Mary and Martha* has a longer history than most of the *bodegones*. It was in a private collection in Norfolk, probably after 1813, and then in a private collection in London in 1881.[22] The *Head of a Young Man* was noted as a Velázquez when it was acquired by Czar Alexander I in 1814 and has remained in the Hermitage since that time.[23] The history of the *Musical Trio*, however, is less substantial. First in a private collection in Ireland, it was sold by R. Langton Douglas to the Kaiser Friedrich Museum in 1908.[24] *The Supper at Emmaus* surfaced in London only in 1909, and the *Servant* was first published in 1927.[25] Paradoxically, the *Vintager*, a picture whose attribution has been questioned, has an earlier provenance than these two paintings. In 1892 it was lent by Leandro Alvear to the Exposición Histórico-Europea held in Madrid.[26] And the *Old Woman Selling Fruit*, another doubted painting, was on the art market as a Velázquez in 1927.[27] The most recent provenance belongs to the controversial *Young Woman at a Table*, sold in 1942 as a "Spanish picture" and published as a Velázquez as late as 1949.[28]

Clearly the *Water Carrier* (fig. 3), the work of an exceptionally gifted painter, emerges as the canonical *bodegón*. The considerable documentary references to the painting make its authenticity virtually unassailable. The water carrier, his weathered face ravaged by the unrelenting Sevillian sun, stands in hieratic profile dominating the painting. Almost lost in the penumbra of the midground is a drinker in frontal pose. A young pensive boy, his face veiled in shadow, is turned in three-quarter view as he receives a large goblet from the water carrier's hand. This is a sober, carefully constructed composition whose arched semicircle of tightly knit figures is marvelously echoed in the swelling, rounded shapes of the jugs and the glass.

Indeed, Velázquez repeats ovoid and hemispherical shapes throughout the composition in a wonderfully rhythmic and measured way. In the large jug in the foreground, for instance, it is the arc of the jug, the ellipse of its neck, and the semicircle of the handle. The pattern of the jug on the table is made up of circles and ellipses. Even the tear in the water carrier's outer garment is elliptical. Still life and motionless human figures are depicted according to the same laws, always balancing and complementing one another. The ridged surface of the large jug, for instance, is the inanimate counterpart to the wrinkled face of the water carrier. One can well imagine Velázquez, like a seventeenth-century Cézanne, admonishing his models to stand like a jug!

In this painting, Velázquez is not an artist of bravura-brush effects. His surface is dusty and his color is muted. But Velázquez is a master of subtle tonal variation. The warm ocher tones are complemented by the cool greens of the jugs. The delicate salmon pink, found in the jugs, threads its way through the painting, echoed in the water carrier's sleeve and the young boy's collar. The painting also is informed with a wonderful play of texture and detail. The eroded and stained table or the sparkling beads of water shimmering, suspended on the dry clay jug in the foreground, exemplify Velázquez's dazzling naturalism. This concern for the tangibility of things is underscored by the strong light which particularizes the still life and figures.

On the basis of stylistic and documentary evidence it is likely that the *Water Carrier* is the latest of the *bodegones*, perhaps dating as late as 1622. It is clearly the most accomplished of the surviving *bodegones*, and its presence in the Fonseca collection suggests that Velázquez brought the painting to Madrid in 1622 as a gift for his patron.[29]

But despite its presumed late date, the *Water Carrier*, the apogee of Velázquez's juvenilia, remains the yardstick by which we should measure the authenticity of the other *bodegones*.

The *Two Men at a Table* (fig. 6) shares many of the characteristics of the *Water Carrier*. The paint is equally dry, the folds are broad and simple, and the color is a sober harmony of tans, browns, and muted greens, heightened by the glowing orange setting on the mouth of an earthenware jug and the salmon-pink tones in the bowls and napkin. The still life on the table is an eloquent testimony to Velázquez's mastery of texture, brilliantly depicting the lustrous brass mortar as well as the smooth glass of an earthenware jug.

The date of the painting is not certain. Gudiol considered it to be less technically advanced than the other *bodegones* and assigned a date of 1617.[30] López-Rey, on the other hand, suggested that the painting was a work of Velázquez's early maturity dating even two years later than the *Water Carrier*.[31] It is not easy to be so specific about this painting. Those who have struggled with the problems surrounding chronology know that it is difficult to chart the development of a young master. As the young master grapples with new subject matter, compositions, and pictorial effects, there are advances and regressions. Brilliant passages and awkward ones can exist simultaneously. Art historians may wish for a neat orderly development, but the juvenilia of an artist is never so precisely packaged. Problems in dating the *Two Men at a Table* are compounded by the possibility that the background has been repainted and the faces restored.[32]

Nevertheless, it would be an abrogation of responsibility not to deal with problems in chronology, and it seems to me that the painting dates earlier than the *Water Carrier*,

perhaps around 1620. To be sure, there is a sensitive geometry in this painting, as Velázquez created a hyperbolic arc from the orange up through the left sleeve of the young man with his back toward us. And the jugs are artfully complemented by the figures, creating a juxtaposition of human and inanimate objects and bigger and smaller forms. But the composition is less firmly knit, lacking the compactness and the monumentality of the *Water Carrier*. Furthermore, the wonderful pictorial virtuosity of that painting exemplified by the glistening droplets of water suspended upon an earthenware jug, is not yet accomplished in the *Two Men at the Table*.

Since the number 6 is clearly visible along with what appears to be a 1 and 8 which are partially visible, the date of the *Kitchen Scene with Christ in the House of Mary and Martha* (fig. 4) is almost certainly 1618. Despite its nineteenth-century provenance, the date and stylistic characteristics designate the painting as obviously autograph. It shares with the other paintings we have considered, a sober palette of browns, tans, greens, and grays, a dry surface, with a thicker application of paint around the eyes, a sense of arrested movement, and an obvious delight in naturalistic texture. The red pepper is nicely crinkled, the onion skin is delicately thin. The scaly fish, with their glassy eyes staring upward into eternity, are particularly distinct. The still life also possesses the geometric order which informs the *Two Men at a Table* and the *Water Carrier*. Ovoid shapes—the plates, mortar, and jug—predominate, creating a harmony of ellipses in the foreground. The furthest plate on the right, with its two eggs and a spoon held in delicate suspension, is an exemplum of this geometric interest. Yet there are certain awkward passages in this painting. There is a conflict between the mortar and pestle firmly grasped by the young servant,

and the tilting table with its eggs, fish, pepper, onions, and plates which threaten to drop, clattering, to the floor. Furthermore, the background scene representing Christ instructing Mary and Martha is not presented with great assurance. The figures seem to hover in some "terra infirma," and the ambiguity has prompted suggestions that the vignette is either a painting within a painting or a mirror reflection of Christ and Mary and Martha who are actually in the spectator's space.[33] In my opinion, Allan Braham is correct in dismissing these hypotheses.[34] We are looking through an opening in the wall, and the spatial disjunctiveness can be attributed to the uncertainty of a young painter whose artistic training may be considered provincial.

The *Old Woman Cooking Eggs* (fig. 7) is also dated 1618, and it displays the flaws of a young artist and the virtues of a great master that we have seen in the *Kitchen Scene with Christ in the House of Mary and Martha*.[35] It too is informed with a restrained palette of greens, browns, and grays accented by a salmon pink in the green jug, the boy's collar, and sleeve, and the old woman's shawl. In a marvelous pictorial *tour de force* Velázquez depicts the transparency of the material, as her ear is seen through the flimsy cloth. And Velázquez's insistence on naturalistic texture ranges from the fine roots of an onion to the viscosity of a fried egg. The composition is organized in two large geometric units: a broad triangle descending from the head of the boy through the top of the beaker, his hand, and the diagonally placed pestle, and a complementary triangle formed by the stolid cook.[36] Further emphasizing the careful order is an array of circular units, pitchers, a mortar, a bowl, and an onion, placed carefully on the table. Still the work betrays some of the awkwardness that one would expect from a teen-aged artist. Velázquez had

some trouble with the foreshortening of the boy's left arm, and although the table doesn't tip as obliquely as the one in the *Kitchen Scene with Christ in the House of Mary and Martha,* it still tilts upward.

In my opinion, the date of the *Luncheon* (fig. 5) falls between the two securely dated paintings of 1618 and the *Water Carrier.* Of course, Velázquez employed a typically simple lucid order. The knife, radish, and left arm of the young man move into space with a parallel diagonal rhythm. And the still life on the table seems to be distributed in a large, basically ovoid pattern, underscored by the repetition of the elliptical and circular shapes of the glass, bread, plate, and orange. The grayish-blue undertints in the tablecloth and in the beard of the old man recall the tonalities found in the *Kitchen Scene with Christ in the House of Mary and Martha* and the *Old Woman Cooking Eggs.* Yet, in contrast to these paintings, there is greater mastery in the handling of objects in space. The table is more convincing, and in fact dramatic, as it projects upon the picture plane filling pictorial space and almost inviting the spectator to partake in the meal. In addition, in comparison to pictures dated 1618, the composition is more complex. Velázquez added a third pyramidal form, the young serving maid, as a complement to the pyramids formed by the two men.

With its severely cracked surface, the Budapest painting is in poor condition. But two "pentimenti"—one on the raised thumb of the young man and the other on the bowl—are visible. In this respect the painting has a freshness and spontaneity of touch which adumbrates the free handling of the works which Velázquez painted for the court at Madrid. Furthermore, the compact and unified composition anticipates the *Water Carrier.* I would date the Budapest picture around 1620–21, but the old man, his

face enlivened with dense paint, is the same model that Velázquez used for his dignified old Magus in the *Adoration of the Magi* dated 1619.[37]

The *Three Men at a Table* (fig. 1) is in many ways similar to the *Luncheon*. To be sure, Velázquez has substituted some new items in his still life. Two lush pomegranates and a plate of mussels are now the fare. His young serving girl pouring wine has become a toothsome boy grasping a flagon. But obviously the boxlike arrangement of figures seated around a table is analogous. And like the Budapest painting, the table pushes aggressively on the picture plane. The old man with his furrowed forehead and paint-dabbed eyebrow is the clone of the Budapest figure. The young man on the right signals "thumbs up" like his Budapest counterpart. Also similar in both paintings is the disposition of the glass, only three-fourths full of wine, and the bread. Once again Velázquez employed parallel diagonal rhythms, seen in the juxtaposition of the left forearm of the old man, the upper right arm of the young man seated opposite him, and the knife balanced on the table. And once more the still life emphasizes circular and ovoid shapes. Yet there are distinct differences. The dominant tones are yellowish brown, not the bluish gray-green tonality of the Budapest *Luncheon,* nor is the handling as free. The modeling is dependent upon a sharper chiaroscuro. The spatial unification of the *Three Men at a Table* suggests a date post-1618, but since it is harder, more firmly modeled, and more light-charged than the Budapest *Luncheon,* I would place it somewhat earlier than that picture, about 1619.[38]

Datable at about the same period are the *Servant* (fig. 8) in the Art Institute of Chicago and the *Supper at Emmaus* (fig. 2) in the Beit Collection. These two pictures are nearly identical. Mayer initially held that the Chicago

painting was the original, whereas the Dublin picture was
an inferior variant, and there are still those who maintain
a preference for the *Servant*.[39] But to my mind they are
both autograph. Unfortunately the Chicago painting is
not in the best of condition. Moderate flaking was re-
corded on the top and bottom edges of the painting with
particular damage in the maid's turban. The lower right-
hand corner of the painting was severely rubbed.[40] The
painting in Dublin is far crisper. The discarded napkin is
sharply delineated, and even the seam on the table-board
is depicted. However, this painting too has suffered dam-
age. There is some paint loss on the table, and the left side
of the painting was unceremoniously cut at some unre-
corded date. At this time, too, the religious scene, which
was only revealed when the painting was cleaned in 1933,
may have been painted over.[41]

In both paintings the brushwork is broad and dry, and
the color range of muted greens, tans, and grays is punc-
tuated by the flat red of the kitchen maid's apron. The
maidservant is depicted in the still, frozen pose so charac-
teristic of Velázquez's figures. Her centralized pyramidal
form underscores the sober monumentality of the compo-
sition and eloquently reveals once more Velázquez's con-
cern for careful structuring. Indeed, that urge to organize
form is particularly manifest in the still life on the table.
Velázquez has juxtaposed a wide-mouthed basin and a
thin-necked jug, the swell of the upright pitcher and that
of the one turned upside down, the smooth roundness of
overturned earthenware bowls and the shiny membrane
of the garlic bulb. Through the artful placement of still
life—basin, bowls, and pestle—which leads the eye into the
center of the picture, Velázquez has emphasized the stolid
kitchenmaid. Her position as fulcrum for the composition
is emphasized further by the parallel placement of the

jugs, with their lighter tone serving to frame the dark mass of the figure. Finally, and this is only apparent in the *Supper at Emmaus,* the figure is framed further by the vertical of the wall and by the window through which we view the miraculous supper.

These are, in my opinion, accomplished paintings which do not date prior to the *Old Woman Cooking Eggs* or the *Kitchen Scene with Christ in the House of Mary and Martha.*[42] Compare, for instance, the treatment of the religious scene in the *Supper at Emmaus* to that of the *Christ in the House of Mary and Martha.* There is no longer a hint of uncertainty of space and locale in the former. We are clearly looking through a window, its angled shutter directing our eye toward Christ's blessing gesture. Nor does the table tilt as precariously as those in the paintings dated 1618. Indeed, in both the Chicago and Dublin pictures, the still life seems far more secure.

If the chronology of the preceding pictures is the subject of debate, their authenticity at least is never seriously questioned. However, the subsequent group of pictures has generated some serious doubts. As recently as the 1958 catalogue of the Hermitage Museum, the *Head of a Young Man* (fig. 9) was considered to be a work by an anonymous seventeenth-century Spanish painter, probably a variant on the head of the young man on the right in the Budapest *Luncheon.*[43] The Leningrad head is a fine picture. The paint is broadly applied, and the restricted dark tones cast an earthy sheen. The collar, with its subtle undertones of tan and gray, is a particularly handsome passage of painting. Since it moves away from the solid, hard modeling found in the *Three Men at a Table,* but is not yet as free as the fluidly painted Budapest *Luncheon,* I would date this painting about 1619.[44]

It is likely that this head is a study for a now lost painting

similar to the Leningrad and Budapest table scenes, but different in some details. Five versions of the lost picture exist, attesting to the popularity of the prototype. The Moyne collection version, illustrated here (fig. 10), although crude, still presents us with the structured and geometric elements characteristic of Velázquez's compositions. The triangular pattern of light and shade on the neck of the young man, so pronounced in the Leningrad study, is also clearly reproduced in the Moyne collection picture.[45] Of course, it was not unusual for Velázquez to prepare sketches for his paintings. We have evidence of this practice in the luminous head of Apollo, a preparatory sketch for the *Forge of Vulcan,* and we know that Pacheco advocated the practice of making oil sketches of heads before approaching the larger canvas.[46]

The *Vintager* (fig. 11) has never received universal approval. Justi accepted it unquestioningly, relating the boy's toothy grin to Pacheco's anecdote about how Velázquez would bribe a peasant lad in order to depict him "in different gestures and poses, now crying now laughing without shrinking from any difficulty."[47] Subsequent critics have been less accepting. Lafuente included the painting under the rubric "as being of interest in connection with Velázquez's work."[48] Trapier was the most damning, condemning what she considered to be the slack draughtmanship in the figure as well as the mechanical handling of the still life.[49] López-Rey's inclusion of the work as an original in his catalogue and as a "work by a hand other than Velázquez's" in his reproductions, testifies to the confusion surrounding the painting.[50]

To be sure, there are disquieting elements about this painting. The figure seems to lurch awkwardly, and unlike any of the other pictures we have considered, this is an open air scene, punctuated with a glowing blaze of light in

the sky. I believe, however, that this is not really an atypical setting, for the light-streaked sky, illuminating a distant mountain, is similar to Velázquez's landscape in the authentic *Adoration of the Magi* of 1619, now in the Prado. And it is likely that Velázquez painted many landscape and figure scenes. Palomino tells us that among Velázquez's early naturalistic works, including fish pieces, birds, and the *Aguador*, were "beautiful landscapes and figures"— "bellos países y figuras."[51]

Pantorba pointed out that critics of the painting did not take into account the lamentable repaints on the left hand and in the head of the figure which marred their appreciation of the work.[52] Indeed, the dry handling of the paint and the hard shadow are consistent with Velázquez's early pictures. In addition, the centralized placement of the figure, its arrested motion, as well as its cramped right hand, so similar to the hands of the boy in the *Old Woman Cooking Eggs* or the *Three Men at a Table*, further seem to support the attribution. The handling of the figure may be somewhat slack, but this conceivably could be his earliest work, datable ca. 1617 for stylistic reasons and for iconographic ones, which I will discuss later, as well. Therefore we can allow for Velázquez's naïveté as a figure painter. If Velázquez sometimes had trouble drawing the human figure, and it is clear when we note the poor foreshortening of the boy's left hand in the *Old Woman Cooking Eggs* that he did, he was always a master of still life. Indeed, the glistening juicy grapes seem as tactile as any other still life by Velázquez's hand, and further suggest the authenticity of this painting. The subject of the painting, as we shall see, also may support an attribution to Velázquez. But for all of the arguments mustered in its favor the *Vintager* is still a problematically weak picture and its attribution remains moot.

The authenticity of the *Musical Trio* (fig. 12) in Berlin is also dubious. To be sure, the picture has many partisans.[53] The restricted palette, emphasizing ocher tones, and the arrested motion of the figures are but two elements which suggest Velázquez's hand. In addition, the carefully organized composition recalls the analytical precision that we associate with Velázquez. Thus a series of horizontal planes, from the guitar stem, to the table, to the plate, to the guitar held by the central singer, move the eye back into space. And a series of curving and circular forms are used in the still life to underscore the geometric interest. Especially felicitous is the centralized enclosure of the wineglass within the ellipse of the guitar. Here we seem to have a virtuoso attempt at depicting an object seen through the semi-opaque liquid. Any awkwardness apparent in the work can be explained by dating it as the earliest of the *bodegones,* around 1616–17.[54]

X-rays are of particular use in determining this attribution. In this case technology has focused upon the soulful entertainer in the center of the picture. X-rays have disclosed that his cloak and collar were subjected to massive repainting.[55] In part, this may explain a disquieting flatness which is atypical of Velázquez. Another X-ray, one of the head in Leningrad, revealed the head of the central musician in the Berlin painting, and therefore has been advanced to support the attribution of the *Three Musicians.*[56] If the Leningrad head is original, and obviously I think that it is, then the Berlin *Musical Trio* would be authentic too.

Sometimes, however, the eye is quicker than the machine. The existence of the head in the Leningrad sketch does not necessarily authenticate the Berlin picture. Indeed, even with the X-ray, one can tell that the Leningrad head is painted with a greater breadth and élan than its

Berlin counterpart.[57] In addition, regardless of overpainting, the Berlin picture remains an unpleasantly clumsy work which I believe not even a very youthful Velázquez would have painted. One of the precepts of Pacheco's studio was the importance of relief.[58] We can see how Velázquez followed that admonition in all of his authentic pictures, which are informed with firm, solid figures and still life. Here, however, we are confronted with the silhouette-like neck of the violin player and the uncharacteristically flat forms of the guitar and costume of the grinning boy on the left. The hand of the guitar player is swollen and mittenlike; his thumb in particular is ill-defined. Even when Velázquez has trouble foreshortening hands, and the boy's cramped hand in the *Old Woman Cooking Eggs* is an example, they still convey the qualitative attributes of hands. We do not expect such a lack of textural differentiation in a still life from a painter who excels and delights in the contrast of rough and smooth, metal and clay, cloth and wood. In the Berlin painting the cheese and napkin seem cut from the same cloth. Finally the handling of the paint is mechanical and wooden. The incised features on the taut skin of the boy on the left seem all too much like that of a smirking ventriloquist's dummy.

To my mind, the Berlin picture is a seventeenth-century copy after a now lost original. The artist was capable of seeing Velázquez's concern for geometric lucidity, but he lacked the master's pictorial skill. Nevertheless the Berlin painting appears to be the best of the four replicas which are extant.[59]

The *Old Woman Selling Fruit* (fig. 13) in the National Gallery in Oslo also has some partisans. Although Allende Salazar only knew the painting from photographs, he considered it to be authentic.[60] Mayer, on the other hand, thought it was a copy of a now lost original.[61] The salmon,

gray, and blue tones in the old woman's sleeve and shawl
can be linked to Velázquez's tonal preferences, and the
type of the old fruit vendor relates to the crone in the *Old
Woman Cooking Eggs*. There are also some nice pieces of
painting, particularly in the lively play of highlights on the
old woman's face and on the glistening still life in the
basket. But to my mind, this painting has little to recom-
mend it as a Velázquez original or copy and recent criti-
cism correctly has dismissed it.[62] The old woman, for
instance, is only vaguely like those depicted by Velázquez.
She seems in fact a part of that clan of harridans that
appear so frequently in North Italian, Dutch, and
Caravaggesque painting. In addition, the composition is
animated by a lively and jagged rhythm—fingers point,
heads twist about—unlike the quiet measured rhythm
associated with Velázquez's authentic pictures. Further-
more, the surface is slick, particularly on the old woman's
sleeve and basket, and the volume and relief that one
expects to see in an authentic Velázquez is not found here.
The left shoulder of the boy with his finger to his lips and
the bodice of the old woman are particularly flat and
unconvincing. Perhaps even more disturbing are the
clumsy hands. The left hand of the boy holding the
luminous covered dish is poorly articulated. His fingers
are bloated and formless. Similarly, the left hand of the
mischievous boy stealing grapes is poorly drawn. The
attribution remains unresolved. The theme is probably
Dutch, but the handling and the fact that the painting
came from an Italian collection suggest Italy.[63]

A *Young Woman at a Table* (fig. 14), formerly in a private
collection in Los Angeles, is the *bodegón* most recently
attributed to Velázquez.[64] Opinion on the work is di-
vided.[65] The painting does have some elements which are
reminiscent of Velázquez's other *bodegones*. Gray, green,
and brown tones are used, and the features of the girl

recall those of the sulky servant maid in the *Christ in the House of Mary and Martha*. Any awkwardness in the painting, particularly the disproportionate relationship between the girl and the almost menacingly large jug, can be explained by the supposedly fragmentary nature of the canvas—it is 31.5 by 34 cm., far smaller than the next smallest *bodegón*, the Chicago *Servant*, which measures 55 by 104 cm.—and by the presumed very early date of its completion.[66] I have been able to judge the painting only from photographs, but it seems to me that this work is not by Velázquez. To be sure, similarities between the girl and the maidservant in the London picture do exist, but this may demonstrate only that Velázquez used models. Indeed, there is much in the *Young Woman at a Table* that is at variance with Velázquez's authentic pictures. The bread, cap, and left sleeve of the girl have a thick and quilted quality, as this painter demonstrates a much greater interest in paint texture than Velázquez. This painter, too, is notably weak in his depiction of hands. The left hand of the girl is totally hidden from view—I suspect intentionally—and her right hand, an ill-defined blur, is partially camouflaged by the napkin. Her right arm, which initially seemed to project from her abdomen, was painted over with drapery in an attempt to correct this grotesque deformation.[67] The incongruous juxtaposition of the colossal pitcher and the young woman, as well as the suspicion that she is seated on an uncomfortably low stool near the table, are things that really cannot be explained away by dismissing the composition as fragmentary. We have seen that Velázquez is a master of harmonic color, measured rhythm, and carefully juxtaposed shapes. If the *Three Men at a Table* or the *Luncheon* were cut they would not reveal the awkwardness of the *Young Woman*. In my opinion, this is a picture by a painter inspired by Velázquez, perhaps even working with him in Pacheco's studio, but certainly

not by the young master himself. We must remember Pacheco's testimony that the "powerful example" of Veláz-quez's *bodegones* spurred many imitators.[68] This seems to be the work of one of them.

The authentic *bodegones* provide a coherent unit. Painted in a short span, from ca. 1617 to ca. 1622, they reveal a developing subtlety of composition and an increasingly fluid technique. They are also marked by a set of definable characteristics. These include a commitment to, and a real delight in, naturalistic observation, a skillful use of restricted color tonalities, the emphasis upon three-dimensionality of objects, and a sense of still, motionless form. The *bodegones* are youthful works, and in fact, some were even painted when Velázquez was still a teenager. Yet the threads of style woven in these juvenilia become part of the larger pattern found in the mature master. Are not the carefully composed composition and arrested motion of the figures in *Las Hilanderas,* for instance, an outgrowth of Velázquez's early preferences? And the portraits, the dwarves and jesters, for example, or *Philip IV in Brown and Silver,* are paradigms of Velázquez's continued interest in artful restricted color harmonies. The *bodegones* also reveal the hand of a master painter, subtle in technique and, as we shall see, complex in iconography. These pictures sing of "cosas humildes," but the melody is rich and wonderful.

Notes

1. M. de Cervantes, *Los trabajos de Persiles y Sigismunda* (1617), 3:xiv, in *Obras completas,* ed. A. Valbuena Prat (Madrid, 1965), 1668.

2. J. L. Navio, "Velázquez tasa los cuadros de su protector D.

Juan de Fonseca," *Archivo Español de Arte* 34 (1961):64. Cf. ibid., 53–56, for a brief biography of Fonseca.

3. J. López-Rey, *Velázquez, A Catalogue Raisonné of His Oeuvre* (London, 1963), 164.

4. A. Palomino, *El museo pictórico y escala óptica* (1715–24; Madrid, 1947), 893.

5. A. Ponz, *Viaje de España*, vol. 6 (Madrid, 1793), 31.

6. H. Swinburne, *Travels through Spain* (London, 1779), in *Varia Velazqueña*, 2:134.

7. A. Dezallier D'Argenville, *Abrégé de la vie des plus fameux peintres* (Paris, 1762), in *Varia Velazqueña* (Madrid, 1960), 2:119.

8. Palomino, *El museo pictórico*, 893.

9. López-Rey, *Velázquez*, 158, no. 105. Ponz also saw this picture in the royal palace, *Viaje de España* 6:31.

10. M. Haraszti-Takács, "Quelques problèmes des bodegones de Velázquez," *Bulletin du Musée Hongrois des Beaux Arts* 41 (1973):35 n. 24.

11. Ponz, *Viaje de España*, vol 18 (1794), 21.

12. For these two paintings see López-Rey, *Velázquez*, 162, no. 122 and 165, no. 130.

13. Ibid., 162–63. 123.

14. Haraszti-Takács, "Quelques problèmes des bodegones," 36–37.

15. *Diccionario de la lengua castellana* (Madrid, 1726–39), s.v. "serrana."

16. Ibid, 549.

17. W. Buchanan, *Memoirs of Painting, with Chronological History of the Importation of Pictures by the Great Masters into England since the French Revolution* (London, 1824), 2:234, 247.

18. However, Haraszti-Takács ("Quelques problémes des bodegones," 32–34) suggests that the following paintings were part of this purchase: *Musical Trio* now in Berlin; *Supper at Emmaus*, Beit Collection, Dublin; *Christ in the House of Mary and Martha*, National Gallery, London; *Old Woman Cooking Eggs*, National Gallery, Edinburgh; and the *Luncheon* now in Budapest.

19. Buchanan, *Memoirs of Painting*, 2:270, 290. There are other apparent errors of attribution, e.g., a *Cardsharps* by

Caravaggio, "one of the most capital works of the master" (2:114) in a private collection or "A set of six small pictures representing the various dances of the Spanish peasantry, the Fandango, Bolero, etc. etc.", which Buchanan saw in the Royal Palace and attributed to Velázquez (2:244–245). No other source refers to these works, and the silence of the usually garrulous Ponz is telling.

20. Haraszti-Takács, "Quelques problémes des bodegones," 46.

21. H. Brigstocke, *Italian and Spanish Paintings in the National Gallery of Scotland* (Glasgow, 1978), 179 n. 12.

22. N. Maclaren and A. Braham, *National Gallery Catalogues, The Spanish School* (London, 1970), 125 n. 2.

23. B. Pantorba, *La vida y la obra de Velázquez* (Madrid, 1955), 63 no. 2, and V. Kemenov, *Velázquez in Soviet Museums* (Leningrad, 1977), 46 n. 2.

24. Haraszti-Takács, "Quelques problémes des bodegones," 46.

25. Ibid., 47.

26. López-Rey, *Velázquez,* 152, no. 85.

27. W. Gensel, *Velázquez, des Meisters Gemälde* (Stuttgart and Berlin, 1913), 257, S.2.

28. M. S. Soria, "An Unknown Early Painting by Velázquez," *Burlington Magazine* 91 (1949):123–27.

29. Cf. Navio, "Velázquez tasa los cuadros de su protector," 64.

30. J. Gudiol, "Algunas replicas en la obra de Velázquez," in *Varia Velazqueña,* 1:416–17.

31. López-Rey, *Velázquez,* 30.

32. E. du Gué Trapier, *Velázquez,* (New York, 1948), 69.

33. For these theories see Maclaren and Braham, *The Spanish School,* 124 n. 4.

34. Ibid., 122.

35. On the dating and condition of this painting see Brigstocke, *Italian and Spanish Paintings,* 176.

36. This compositional type appears also in the *Adoration of the Magi* of 1619.

37. For a summary of the various dates assigned to this painting, which range from around 1618 to about 1619, see López-Rey, *Velázquez*, 161, no. 120, and Kemenov, *Velázquez*, 47.

38. This painting has usually been dated around 1616–18 and designated as one of the first of the *bodegones*. Cf. López-Rey, *Velázquez*, 26–28, and Kemenov, *Velázquez*, 53.

39. A. L. Mayer, "Das Original der 'Kuchenmagd' von Velázquez," *Der Cicerone* 19 (1927):562. Mayer, however, accepted the Dublin painting in his subsequent catalogue. A. L. Mayer, *Velázquez, A Catalogue Raisonné of the Pictures and Drawings*, (London, 1936), 24 no. 106. Pantorba; in *La vida y obra de Velázquez*, 65, and in *Tutta la pittura del Velázquez* (Milan, 1965), 34, accepted both paintings but admitted his preference for the Chicago version. Two copies of the Chicago painting are extant. See López-Rey, *Velázquez*, 150–57, nos. 100–101.

40. Cf. condition report no 35:380 made by Alfred Jakstas, Chief Conservator, Art Institute of Chicago. I am indebted to Mr. Jakstas for generously sharing this information with me.

41. On the the condition of this painting see López-Rey, *Velázquez*, 127, no. 18.

42. Gudiol, ("Algunas replicas en la obra de Velázquez," 417) dates these pictures around 1618 and Gállego (*Velázquez en Sevilla*, [Seville, 1974], 180) suggests an even earlier date, around 1617.

43. Kemenov, *Velázquez*, 46 n. 2.

44. Ibid., 53, however, dates the work around 1616–17. Cf., however, Haraszti-Takács (*Spanish Genre Painting*, 230), who dismisses the picture as a copy.

45. This pattern is also found in all the other versions. Cf. ibid., 47–51.

46. For the Apollo see López-Rey, *Velázquez*, 145–46, no. 69. On Pacheco's studio practice of making sketches see F. Pacheco, *Arts de la pintura* (1649), ed. F. J. Sánchez Cantón (Madrid, 1956), 2:2, 13. I think we can dismiss the impressionistic full-scale sketch supposedly made for the *Two Men at a Table*, published by Ada di Stefano ("Un Boceto de Velázquez en Roma," *Archivo Español de Arte* 27 [1954]: 257–59). This work is impro-

bably dated around 1630 and is in an unidentified private collection in Rome. A full-scale model, of course, is not consonant with Pacheco's studio practice.

47. C. Justi, *Diego Velázquez und sein Jahrhundert* (Bonn, 1922), 1:137.

48. E. Lafuente, *Velázquez* (Oxford, 1943), 34.

49. Trapier, *Velázquez*, 75–76. Cf. Pantorba, *La vida y obra de Velázquez*, 65–66, for a summary of other critical attitudes.

50. López-Rey, *Velázquez*, 152, no. 85, pl. 187.

51. Palomino, *Museo pictórico*, 893.

52. Pantorba, *La vida y obra de Velázquez*, 66.

53. E. Schleier, *Picture Gallery Berlin: Catalogue of Paintings* (Berlin, 1978), 457.

54. Gudiol, *Velázquez*, 323, no. 2, and López-Rey, *Velázquez*, 26–27.

55. Schleier, *Picture Gallery Berlin*, 457.

56. Kemenov, *Velázquez*, 51 n. 1.

57. Ibid.

58. Pacheco, *Arte de la pintura*, 1:455–56.

59. For these replicas see Schleier, *Picture Gallery Berlin*, 457.

60. López-Rey, *Velázquez*, 165, no. 128.

61. Mayer, *Velázquez*, 26, no. 113.

62. Cf. L. Steinberg, "Review of J. López-Rey, *Velázquez. A Catalogue Raisonné*," *Art Bulletin* 47 (1965):286 n. 40.

63. Cf. *Two Children Stealing an Apple from a Man with a Basket* in Oxford, attributed to Moeyaert. See J. de Wit, *Dutch Pictures in Oxford* (Oxford, 1975), no. 21. For a summary of the various attributions of the Oslo picture see J. López-Rey, *Velázquez*, 165, no. 128, and M. Asturias and P. M. Bardi, *Velázquez* (Barcelona, 1977), 113, no. 165. On the provenance see Gensel, *Velázquez*, 257, S.2.

64. The painting was in the collection of Mr. Bozo Maric of West Los Angeles in 1942 and was published by M. S. Soria, "An Unknown Early Painting by Velázquez," *Burlington Magazine* 91 (1949), 123–27. Jonathan Brown has kindly informed me that the painting is now in a private collection in New York.

65. Steinberg, "Review of López-Rey, *Velázquez*," 285 n. 40,

and Gudiol, Velázquez, 324, no. 10, accept the work. Pantorba, *Velázquez*, 213, no. 124, and López-Rey, *Velázquez*, 157, no. 102, reject it.

66. Soria, "An Unknown Early Painting by Velázquez," 124.

67. Ibid., 125, fig. 2.

68. Pacheco, *Arte de la pintura*, 2:137. López-Rey, *Velázquez*, 157, no. 102, suggests that the Sevillian painter Francisco Lopez was responsible for the picture.

3

Velázquez and Tradition

THERE CAN BE NO DOUBT THAT THE *BODE-gones* display certain distinct characteristics. Selecting strong light which sharply defines mundane objects and genre types, Velázquez imbues these images with a geometric organization and a serene stillness. His restricted palette, his dry surfaces occasionally enlivened by a dense application of paint, and above all his remarkable naturalism, convey an uncanny sense of material texture.

Yet it is not easy to account for Velázquez's style and subject matter. Many foreign sources have been suggested, and each camp has its vociferous partisans. For some, it is the example of Caravaggism that Velázquez followed. For others, it is the art of Aertsen and Beuckelaer which spurred the creation of *bodegones*. Still others graft the North Italian genre paintings by Campi and Passarotti to Caravaggism and the Flemish example. Misled by fortuitous similarities of subject matter or by superficial resemblances in stylistic devices, many names have been culled. Few are actually acceptable. In addition to stylistic and thematic considerations we must take into account the accessibility of these foreign works for the young Velázquez in Seville.

The *bodegones* have been linked frequently to Caravaggism. For example, a recent history of Baroque art claims: "The primary influence on the young Velázquez, however, was Caravaggio's style. Caravaggio's methods are dominant in Velázquez's early religious pictures, portraits, and, above all, in his *bodegones*."[1] This is by no means a novel idea. There are, in fact, early references which suggest a connection between the two artists. Pacheco praised Caravaggio's concern for the live model and claimed that Velázquez too followed this practice.[2] And in the early eighteenth century, Palomino considered Velázquez to be Caravaggio's worthy competitor in "la valentia del pintar."[3] It has been suggested also, and I believe with good reason, that Carducho's criticism of Caravaggio's naturalism "with his affected and superficial imitation" is actually a less than veiled reference to Velázquez.[4]

It is possible that works by and after Caravaggio were known to Velázquez in his formative years. According to Mancini, Caravaggio, down on his luck in his early years, fell ill and paid his bills with paintings that the prior of the Hospital of Consolation soon took to Seville.[5] Bellori referred to several paintings by Caravaggio which were taken to Spain. Among them was the monumental *Crucifixion of St. Andrew,* which was brought to Valladolid by the Conde de Benavente, presumably upon his return from Naples in 1610.[6] And probably in 1617 the Count of Villamediana brought with him from Italy when he returned to Spain a half-length *David,* as well as a portrait of a young man with an orange blossom.[7] Pacheco noted several copies in Seville of Caravaggio's *Crucifixion of St. Peter* from the Cerasi Chapel.[8] None now survive, but the existence of other copies of this picture in Valencia, Barcelona, and the Escorial is but one indication of Caravaggio's popularity in Spain.[9] Still another painting, a copy of

Caravaggio's *Supper at Emmaus,* possibly by the Messinese *Caravaggista* Alonso Rodríguez, was in León.[10]

How significant, then, were these works for the young Velázquez? It is not likely that Velázquez saw any of these paintings outside of Seville and its environs. Travel in Spain is still not an easy affair, and in the seventeenth century it was fraught with great hardship. One recoils with horror at the account of Rubens's difficult twenty-day journey from Alicante to Valladolid, a distance of just over two hundred miles.[11] Surely if Velázquez had undertaken such a trip, it would have been documented. But there are no references to Velázquez's travel until his departure for the court in the spring of 1622.[12] Evidently the presence of these paintings in Valladolid, in the Count of Villamediana's collection in Madrid, or in far-off León had no impact upon the *bodegones.*

It is now no longer tenable to believe that Caravaggio's paintings were brought to Seville by prior Camillo Contreras, since he died in Rome in 1601 and presumably did not take his Caravaggios outside of that city.[13] As for the copies of Caravaggio's works in Seville, the replica of the *Crucifixion of St. Peter* may have been admired for its force and naturalism, but it is different from the *bodegones* in presentation of subject, composition, and color.

Obviously, there is a general resemblance between Caravaggio's and Velázquez's concern for naturalism. And it is common to point out the similarities between two specific works, Caravaggio's *Supper at Emmaus* of ca. 1600 (fig. 15) and Velázquez's *Three Men at a Table.*[14] Velázquez and Caravaggio use half-length figures placed close to the picture plane in a boxlike composition. Fictive and real space are integrated by the outward glance of the smiling young man on the right in the Velázquez, and by a device such as the outflung arms of the astonished disciple in the

Caravaggio. Both artists demonstrate a remarkable affinity for the precarious placement of objects on the table. In the Caravaggio, the basket of fruit balances dangerously on the edge, whereas in the Velázquez it is the knife and bread that protrude. A strong light falling from the left in both compositions underscores the palpability of the still life and creates emphatic shadows.

Half-lengths, illusionistic projection, and tactile naturalism, however, are not the sole province of Caravaggio. Caravaggio's surface, hard and enamel-like, differs from Velázquez's dry and leathery finish. Velázquez's muted palette, dependent upon a narrow range of browns, greens, and tans, is unlike Caravaggio's dramatic use of color, where the vibrant red of Christ's costume highlights the center of the composition. Indeed, Caravaggio is overwhelmingly dramatic in comparison to Velázquez. His characters gesture explosively; his light and dark contrasts are bold. Velázquez, on the other hand, curtails action. Arms are locked in, restrained, rather than flung out, and his lighting effects are less aggressive, with subtler transitions. Compare, for instance, the heads of the two figures on the right. Caravaggio employed a broad strip of light on the face and a large strip of shadow on the neck, whereas Velázquez created a patchier, modulated effect. The right eye, for example, is a pool of shadow in a field of light. The light on the man's aquiline nose ranges in intensity from a bright strip on the bridge to a softer tone near the nostrils, and ultimately a delicate shadow on the right side.

To my mind, Caravaggio's nascent reputation in Spain is not primarily responsible for Velázquez's naturalism. The presence of known paintings by and after Caravaggio in Seville is not primarily responsible for Velázquez's naturalism. And even if we allow for the remote possibility that

Velázquez saw unrecorded and now lost paintings by Caravaggio in Seville, it still does not account for Velázquez's naturalism. Perhaps more plausibly, Caravaggio's work affirms and justifies a style which, as we shall see, Velázquez seems to have developed independently.

If Velázquez's link to Caravaggio remains uncertain, so too does his purported connection to the *Caravaggisti*. To be sure, there are traditional but overworked comparisons that suggest tantalizing similarities. A case in point is the alleged relationship between Velázquez's *Supper at Emmaus* and the *Cook* in the Corsini Collection, which is attributed to the "Pensionante del Saraceni."[15] In both paintings we find a self-absorbed kitchen servant behind a table, a basket hanging on the wall, and a strong light streaming down from the left. But the Pensionante's light is sharper; his color dominated by cool grays. It is fair to say that the young Velázquez never saw this picture because the "Pensionante" was working in Rome.[16]

Of course, paintings by the *Caravaggisti* made their way into Spain. And followers of Caravaggio actually worked there.

Orazio Borgianni, for example, worked in Spain in the late 1590s and again from 1604 to 1605.[17] Even upon his return to Rome, he maintained his contacts with the Spanish colony, dedicating some of his engravings to Francisco de Castro, the Spanish ambassador to Rome.[18] The majority of Borgianni's paintings, however, are in Valladolid, obviously removed from the young Velázquez.[19] But let us suppose that Velázquez saw a Borgianni. A comparison of his work with the *bodegones* reveals the improbability of any influence. The early *Crucifixion* (fig. 16), for example, formerly in Madrid but now in Cadiz, with its rapid touch and rivulets of spectral light on the landscape demonstrates Borgianni's attachment to the Ve-

netian-Bassanesque ambience which also affected El Greco.[20] If Borgianni left any traces of influence in Spain it was not in Seville, but rather in Toledo on the art of Luis Tristán.[21]

According to Mancini, Bartolomeo Cavarozzi sent many of his paintings to Spain.[22] He also worked there from 1617 through 1619.[23] Because his associations are with the court of Madrid, his sweet, sentimental Caravaggesque pictures are of dubious import for Velázquez.[24]

Although works by and after Grammatica, Saraceni, and Caracciolo were in Spain by at least the end of the second decade of the seventeenth century, it is unlikely that they would have had an impact upon Velázquez's *bodegones*. Grammatica's painting, the *San Bernardo with the Crucified Christ and the Virgin,* may have been in Spain as early as 1616, but it was, and for that matter still is, in the convent of Las Bernardas in Madrid.[25]

In 1614 Saraceni painted three works for the cathedral of Toledo.[26] Even if Velázquez had made the long arduous journey from Seville to see these paintings, the *bodegones* are certainly not dependent upon Saraceni's example. Saraceni's *Martyrdom of St. Eugene,* for instance, is informed with a deep, rather intricate architectural and landscape space. The surface is slick and oily, and the tenebrism is enlivened by bright whites similar to Saraceni's contemporary *Preaching of St. Raymond Nonnato,* now in S. Addolarata in Rome.[27]

A *Beheading of St. John the Baptist* dated about 1615 and attributed to Caracciolo is now in the Museo de Bellas Artes in Seville, and the Cathedral possesses a replica of his *Madonna and Child with St. Anne* in Vienna.[28] The painting in the Cathedral can be eliminated since it dates from the 1630s.[29] The painting in the Museo de Bellas Artes is more problematical. In my opinion, Moir has

assessed it correctly as a copy.[30] The painting is weak, particularly when compared to the insolent elegance of the *Salome* in the Pitti Palace, which serves as its prototype. Yet, even if it were by Caracciolo, we do not know how and when the painting arrived in Seville. In any case, other than a shared interest in chiaroscuro effects and figures brought close to the picture plane, this picture, with its slick surface, has little in common with the *bodegones*.

If Velázquez's Caravaggism seems tarnished, Flemish prototypes, although championed volubly, are equally lackluster. Of course, Flemings and things Flemish were by no means foreign to Spain. Political and commercial ties with Flanders were maintained throughout the Golden Age.[31] At the beginning of the seventeenth century the large Flemish merchant colony in Seville was actively plying its trade.[32] Doubtless more than corn, linen, and gunpowder were transported. Paintings too must have been a part of the cargoes. Indeed, Van Mander tells us that works by Scorel, Heemskerck, Cocxie, and Coninxloo were taken to Spain.[33]

Northern painters also came to Spain, enriching a tradition already strongly tied to the North. Antonis Mor worked in Madrid as the court portraitist for Philip II from 1552 to 1553 and again from 1559 to 1560. His austere and dignified portraits adumbrate Velázquez's mature court style.[34] But they bear no relationship to the *bodegones* and obviously remain outside the scope of this study. In Seville, itself, the Northern artists Pedro de Campaña (Peter de Kempener), Hernando Sturmio, and Frans Frutet were all well established by the middle of the sixteenth century. But they are artists of large altarpieces and not of intimate genre scenes, and their bright clear color and linear classicism could hardly have been important for the *bodegones*.[35]

However, pictures by Northern artists who did not travel to Seville, or for that matter to Spain, are nevertheless suggested as prototypes for Velázquez. Long ago, Justi, in his remarkable monograph, suggested a general interdependence between the *bodegones* and the kitchen pieces popularized in Flanders by Aertsen.[36] Since then many more specific connections have been advanced. The *Old Woman Cooking Eggs,* for example, has been related to Aertsen's *Pancake Baker* (fig. 17) in Rotterdam.[37] Aertsen's composition employs half-length figures looming on the picture plane. Similar to Velázquez's inner-directed young boy and old cook, Aertsen's figures are curiously impassive and self-absorbed. And even a specific type can be related. Aertsen's pancake maker, an old woman wearing a shawl and rendered in profile, suggests Velázquez's egg-cooking crone. Aertsen's textural mastery anticipates Velázquez's own handling: his pancakes are delicately golden and fluffy, the waffles placed on an oval plate, have a nubby rectangularity which contrasts with the plate's smooth metallic glimmer. And Aertsen's tilting of objects in space—the pancakes, waffles, and bread all slant upward—corresponds to Velázquez's arrangement of bowls and platters.

But we must emphasize the obvious differences between the two artists. To begin with, Aertsen does not close off his paintings with a mysterious void. He is concerned instead with deep space, opening up both sides of the composition with a landscape vista. Furthermore, Aertsen creates a surface which is rhythmically complex. Animated waffles curve, indeed almost writhe on the plate, and the sleeves of the pancake cook and of the woman holding the plate are similarly motile, alive with wriggling folds. Aertsen's handling is also different. His palette is dominated by bright flat reds and greens, whereas Velázquez uses earthy browns and subtle grayish-green tonalities.

The comparisons drawn between Northern art and the *bodegones* are seductive, but they nevertheless remain unsubstantiated. The relationship of isolated motifs cannot prove an influence. One can compare, for example, the projecting table and palpable portrayal of still life in Heemskerck's *Family Portrait* in Kassel to similar devices in Velázquez's paintings in Leningrad and Budapest.[38] But Velázquez's *bodegones* are different in color, theme, and application of paint. One can also relate the *bodegones* to certain themes found in Northern art. Velázquez's eating pieces can be linked to paintings like Aertsen's *Peasant Meal* in Vienna. The portrayal of an everyday street scene in the *Water Carrier* may suggest Beuckelaer's *Egg Seller*.[39] However, the parallels are not specific enough to prove that Velázquez actually borrowed from Northern art.

Because there is no record of Spanish provenance for these works, their impact is necessarily minimal. The *Pancake Maker* is a case in point. It has a long and continuous history in the North, where it was first recorded in 1615 in the Van der Geest Collection in Antwerp.[40]

Of course, Velázquez could have seen paintings of this type. Carducho's description of a painting of *Christ in the House of Mary and Martha* which contained "a great deal of food, meat, capons, turkeys, fruit, plates, and other kitchen items" may refer to a specific work in the manner of Aertsen and Beuckelaer and suggests that paintings like this were at least in Madrid.[41] But even if Velázquez's subjects parallel certain Northern themes, they are stylistically removed. His palette and surface, especially, are demonstrably different and suggest that he either adopted what he found visually exciting or that his sources lie elsewhere.

Perhaps prints provide some of the answer. Many years ago, Mayer suggested that Matham's Aertsenesque pastiche of the *Supper at Emmaus* (fig. 18) was related to

Velázquez's *Kitchen Scene with Christ in the House of Mary and Martha.*[42] Indeed, the juxtaposition of the sacred scene in the background with the two asymmetrically placed genre figures in the foreground is remarkably similar. But Matham's composition is cluttered in comparison to Velázquez's. Dominating the foreground, a huge fish with a bloated shining belly sprawls on a cutting board. The table is burdened with a plethora of gills and fins. And the deep extension into background space—unlike the austere closed wall and tiny aperture in the Velázquez—reveals a dog and subsidiary anecdotal figures who adjust curtains and tend a fire. If Velázquez used this print as a point of departure, he siphoned off the distinctly Flemish preference for animated details, focusing on a simplified, clarified image.

Matham's print may have found its way to Spain, but it is more likely that Jan Vermeyen's so-called *Spanish Supper* (fig. 19) was known by Velázquez. Known as Juan el Barbudo in Spain, Vermeyen worked for the Spanish monarchy, and made a number of etchings with specifically Spanish subject matter.[43] The etching of the *Spanish Supper* is a genre scene, remarkably similar to Velázquez's *Three Men at a Table* or the *Luncheon*. Velázquez's use of half-length figures, the boxlike composition, and the projection of the table on the picture plane, are adumbrated by the Vermeyen print. And Vermeyen, like Velázquez, presents a carefully arranged banquet still life. Radishes (protruding from the table like those in the *Luncheon*), sausages, beans, and figs create a parallel diagonal rhythm anticipating Velázquez's concern for order. The light, falling from the left as in Velázquez's paintings, casts dense shadows. Even the theme, a tavern party spiced with zesty leers and coarse gestures, presages the vulgar ambience of Velázquez's two eating pieces.

An exact relationship between the print and the paint-

ing is not present. But we know that a source is not usually taken over pot, crock, and barrel. In addition, we must remember Pacheco's testimony that Velázquez worked exclusively from the live model.[44] Indeed, familiar types populate the *bodegones*, reappearing like actors in a small repertory company. The bearded old man, for example, appears twice. In the painting in Leningrad we find him eating a turnip; in the Budapest eating scene he receives a drink.[45] The old woman admonishing the servant in the *Kitchen Scene with Christ in the House of Mary and Martha* resembles the crone cooking eggs in the Edinburgh painting. A print or a painting could suggest a composition or a theme, but the literal source is always obscured by Velázquez's method of working. It is important to recognize, however—and this is a point to which I shall return later—that already by the sixteenth century a precedent for Velázquez's themes and formal devices exists in Spain.

Besides the Flemings, the sixteenth-century genre painters of Northern Italy have been noted as yet another source for the *bodegones*. Spain and North Italy were closely tied in the Golden Age. The political arm of Spain grasped the Milanese territories in 1535, relinquishing them only in 1714 in the War of Spanish Succession.[46] Conversely, North Italian merchants, particularly the Genoese, were major contributors to Spanish commerce and were the principal brokers in royal financial matters.[47] The Genoese were especially influential in the city of Seville. After all, it was Genoese capital which provided much of the basis for Sevillian transatlantic trade. Holding considerable property in and around the city, they built ornate palaces as testimonials to their wealth.[48] In a report of 1563 we are told that "everything here goes as the Genoese desire and order it," a telling assessment of Genoese power in Seville.[49]

Political and financial ties to North Italy were comple-

mented by an interest in North Italian painting. It was probably Genoese intervention which brought Luca Cambiaso to Spain as court painter for Philip II.[50] Obviously, the elegant and sterile mannerism of the Genoese Cambiaso need not concern us here. Of more importance for our purposes are the genre paintings of the Cremonese artist Vincenzo Campi, since they have been suggested as a source for some of the *bodegones*.[51] Although Baldinucci's report that Vincenzo visited Spain is unfounded, Campi did send a number of paintings to the court, which were held in high esteem.[52] Most of his pictures were undoubtedly religious pieces like the dramatic *Christ Nailed to the Cross* now in the Prado.[53] But it is possible that Vincenzo also sent some of his genre paintings to the Spanish court. Indeed, the popularity of these genre pieces is attested by the copy of Vincenzo's *Cheese Eaters*, which may have entered the royal collection in the early seventeenth century.[54] There is no record, however, of Vincenzo's paintings in Seville.

Campi's *Cheese Eaters* (fig. 20) can be linked to the *Three Men at a Table* in its theme, half-length figures, and use of three men of varying ages ranging from youth to senescence. Like Velázquez, Campi too is interested in establishing contact between the spectators and the figures who gaze out at us with an amused brio. But Campi's brushwork, which is rough and scumbled, differs from Velázquez's. There may be similar punning and comic allusions in both paintings, but since Velázquez probably did not know the Campi, these parallels are no more than fortuitous.

Similarly, the resemblance between Campi's *Fruit Vendor* (fig. 21) and the *Vintager* is apparently coincidental. Both figures do indeed raise a bunch of grapes, but in almost all ways the paintings are different. Campi's predominant

colors are bright green and orange and not browns and grays. Campi depicts a stolid healthy "contadina" surrounded by a bountiful harvest; the *Vintager* focuses on a grinning *campesino* with a solitary basket of grapes. Campi's skyscape is serene, but in the *Vintager* the sky is dramatically streaked with light. Most importantly, Velázquez could not have known this Campi since it apparently remained in Cremona through the eighteenth century.[55]

The suggestion that Bartolomeo Passarotti's genre scenes were of some import for the *bodegones* is also unfounded.[56] Passarotti's *Butcher Shop* (fig. 22) does possess a limited color range dominated by brown tonalities, and his figures establish a direct contact with us. Yet the paint is coarsely applied, and the active curvilinear rhythms betray an obvious dependence upon Flemish prototypes. Nor is it likely that Velázquez would have even known Passarotti. Pacheco's *Arte de la pintura* is crammed with names of Italian artists, but fails to mention Passarotti. Undoubtedly his genre paintings remained inaccessible.[57]

It is certain, however, that Velázquez knew the work of the Bassani. Incredibly prolific, their workshop was responsible for over six hundred paintings.[58] By the early seventeenth century many of their works had found their way to Spain, and the corporate name of Bassano was applied to anything Bassanesque, including pieces by Jacopo, his sons Francesco, Giambattista, Leandro, and Gerolamo, as well as the "bottega." The numerous works in the Spanish royal collection caused Siguenza to proclaim that there were far too many to record.[59] Significantly, at least six works by Bassano were in Seville. These paintings, which unfortunately remain anonymous, were praised extravagantly by Pacheco for their lively naturalism.[60] Indeed, for Pacheco, Bassano was a "gran pintor"

whose work was a paradigm of "fuerza y relievo."[61] Surely, the young Velázquez had learned to appreciate Bassano in the Pacheco workshop. However, it was neither Bassano's color nor his application of paint which influenced Velázquez. A typical Bassano, Francesco's *Nativity* (fig. 23) in Madrid, reveals animated, almost kaleidoscopic light and dark contrasts with multiple light sources—the angelic host, the candle, and the miraculous child. In this disruptive pattern of light and dark, we see an umbrous St. Joseph; a Virgin, whose head and shoulders sparkle in light, while her right hand is lost in shadow; a brightly illuminated Christ child; two shepherds and an ox who press close to the crib, their surfaces awash in a broken patchy light and dark; and finally two shepherds who are more fully illuminated. How different is Velázquez's approach. The *Kitchen Scene with Christ in the House of Mary and Martha,* for instance, with its broader areas of light and dark—notice the carefully modulated strip of light and shadow on the forearm of the servant—and dusty muted tones, differs from Bassano's wet and flickeringly phosphorescent surfaces.

Yet, despite these differences, Bassano's influence is plausible. Bassano's naturalism—his vivid texture of humble objects—certainly was exalted as a paradigm for the adolescent Velázquez. Pacheco, especially, singled out Bassano in his chapter devoted to genre and animal painting. Bassano was an accomplished painter not only of "all kinds of animals, birds and fish, but of copper kettles and different glasses."[62]

Obviously a painter specializing in genre scenes would profit from Bassano's example, and certainly the proliferation of Bassanesque paintings made it easy to assimilate motifs. Therefore, it is not surprising that the tilted metal bowl rimmed with light in the *Old Woman Cooking Eggs*

finds its counterpart in the bowls of a painting like Francesco Bassano's *Forge of Vulcan* in Paris. And Velázquez's interest in reflected lights on utensils again recalls the Bassani. The upward tilt of objects in space which characterized Velázquez's first works like the *Old Woman Cooking Eggs*, the *Kitchen Scene with Christ in the House of Mary and Martha*, and the *Supper at Emmaus* also may be the result of reliance upon a Bassanesque prototype. For example, in Francesco Bassano's allegory of the element of water (fig. 24) now in Sarasota, the evident bird's-eye view is accompanied by tilting tables, buckets, and fish. Velázquez may not have seen these specific works, but surely he was familiar with the extensive Bassanesque repertoire.

Pacheco's claim that Bassano was a master of "relievo"—a quality of naturalistic painters which superseded even "grace and delicacy"—may have had an impact on Velázquez's own concern for chiaroscuro effects and modeling in the *bodegones*.[63] A specific Bassanesque lighting effect, the light-streaked sky, appears in the *Vintager*. Perhaps, too, Velázquez understood and incorporated the mood of introspective quietude which informs some of Bassano's figures. The self-absorbed metal worker in the *Forge of Vulcan* (fig. 25) in Poznan or the stolid boy in the *Pastoral* formerly in Cologne find their counterparts in the still, solemn water carrier and the immobile youth of the *Old Woman Cooking Eggs*. Possibly even Bassanesque types were lifted and transformed by Velázquez. A case in point is the figure of the cooking woman in Leandro Bassano's *November* now in Vienna. Her shawled head, seen in profile, adumbrates Velázquez's egg cooker.

In light of the evidence, Pacheco's admiration for Bassano's work, and the availability of Bassanesque works in Seville, Velázquez's relationship to Bassano appears more than fortuitous.

If Bassano was esteemed in Pacheco's workshop, other Spanish painters working in Seville were also receptive to Bassanesque motifs. It has already been suggested that the pictures of Juan de Roelas had some impact upon the young Velázquez.[64] Except for a stay of little more than a year in Madrid from 1616 to 1617, Roelas worked in Seville from 1606 through 1620. His works are characterized by a marked Venetianism, coupled with sometimes stunning chiaroscuro effects.[65] The *Liberation of St. Peter* of 1612 in the church of San Pedro in Seville is an example (fig. 26). A flickering light, enriched by the candle in the lantern and the halo radiating from the angel's head, is reminiscent of Bassano. The enormous *Martyrdom of St. Andrew,* now in the museum at Seville, dates from about the same time. Here Bassanesque types, like the workmen struggling with the ladder, are conflated with a silvery atmosphere recalling Veronese. These are grand altarpieces, and their monumental rhetoric is alien to the stillness of the *bodegones.* Yet they demonstrate a Sevillian response to Venice, particularly Bassano, and they serve to enhance and reinforce Velázquez's own interest in Bassanesque modes.[66]

Even closer to Velázquez are the Bassanesque works of Pedro de Orrente. Known as the "Spanish Bassano," and with good reason since it is likely that he was in Italy from 1604 to 1612 with an extended period in Leandro Bassano's studio, Orrente was active not only in Murcia, Toledo, and Valencia, but also probably in Seville.[67] Since Pacheco specifically singled him out as Bassano's Spanish acolyte in his chapter on genre and animal painting, it is indeed likely that his works were known in Seville.[68] Orrente was a prolific artist, but his signed paintings are scarce and his dated ones even rarer. This necessarily complicates the delicate problem of influence. Neverthe-

less, Orrente was already an established master in his mid-thirties by the time Velázquez was beginning to paint *bodegones,* and one can assume that influence flowed from the older to the younger artist. Orrente's multifigured religious scenes like the *Exodus* in the Prado reveal not only Bassano's penchant for a romantic burst of light in a darkened sky, but also a flickering activity of light and shade coupled with a teeming hubbub of figures. But Orrente also painted more intimate scenes which reveal an affinity to Velázquez's *bodegones.* The *Jacob and Esau* dated 1612 is a case in point. The streaked sky, the planar arrangement of the cat, steps, and dog, and the tactile still life with its burnished copper buckets and tilted pail are all devices which reappear in Velázquez's early works.

Even closer to the *bodegones* is the *Supper at Emmaus* (fig. 27) now in Budapest, where Orrente depicts a genrelike religious scene reminiscent of Velázquez's earthy representations of the divine. Orrente's composition is carefully organized. The planarity of the mortar and pestle, dog and cat, pitcher and basin in the foreground is continued in the middle ground by the table and the innkeeper, who is seated in a fixed profile reminiscent of the pose of the old woman cooking eggs. The disciples and Christ create a triangle in depth anticipating Velázquez's figures in the eating scenes in Budapest and Leningrad. The arrangement of the still life on the table also is recalled in these paintings. The bread, goblet, and glass are organized in a planar fashion. The knife is turned off axis, and the light falls from the left, allowing for palpable cast shadow. The table, as in many of Velázquez's early kitchen pieces, tilts slightly upward. Like Velázquez's *bodegones,* too, is the surface, for Orrente does not use Bassano's rich surface effects. Instead the color is muted, and the handling is broad, smooth, and taut. Even Orrente's disposition of

light and dark—the hands of the innkeeper or those of Christ can be read in strips of light and dark—reminds one of Velázquez's handling. It is tempting to imagine that the young Velázquez had a painting like this in mind when he began as a painter of *bodegones*.[69]

Of course, Velázquez's sources extend beyond the tight circle of Spanish Bassanesque painters. The suggestion that Velázquez profited from the work of the sculptor Juan Martínez Montañez has merit.[70] At the time that Velázquez was Pacheco's apprentice, the latter was polychroming Montañez's works.[71] Since Sevillian documents refer to Velázquez himself as a "pintor de imaginería"—a painter skilled in gilding and polychromy—he was undeniably familiar with the work of Seville's greatest sculptor.[72] It is particularly Montañez's single devotional figures, sober and realistic, which seem to have the greatest similarity to Velázquez's early work. The directness of Montañez's naturalism is exemplified by the *St. Dominic* of 1609. Here the textured beard of the penitent saint, his expressive cheekbones, protruding veins, astonishingly red lips, and colored eyes present the sculptural equivalent of Velázquez's pictorial interest in texture and naturalism. The broad, simplified, flat folds of drapery, which create rectilinear patterns, call to mind Velázquez's own interest in large ample draperies. And the image of quiet reflection and stillness is comparable to the arrested motion of Velázquez's figures.[73]

It is natural to assume that the most significant artistic influence on the young Velázquez would be exerted by his teacher, Pacheco. But for a brief time, possibly no longer than ten months, Velázquez probably studied with Francisco de Herrera.[74] Although Herrera was presumably the author of now lost *bodegones,* his surviving works from the second decade of the century, all religious pieces, reveal

an awkward and mannerist style very different from Velázquez's.[75] Even if Velázquez did study with Herrera, it is extremely unlikely that Herrera could have taught him much. Velázquez's major period of study, from 1611 through 1615, was with Pacheco. In these formative years of adolescence, Velázquez doubtless learned the fundamentals of art. I maintain that he learned even more. Indeed, much of what we see in the *bodegones* can be explained in terms of Velázquez's association with Pacheco.

Pacheco was by no means a great artist. This cruel quatrain tells us much about his inadequacies:

> Who painted you thus, O Lord?
> So dry and so insipid?
> You will say it was pure love,
> But I say Pacheco did it![76]

But this does not preclude his abilities as a teacher. Nor should this deter us from viewing some of Pacheco's paintings as examples to be followed by the young pupil. Could the apprentice have failed to notice, for instance, how Pacheco emphasized chiaroscuro effects in combination with a modulated pattern of light and dark in the *Crucifixion* (fig. 28) of 1614? And surely Pacheco's *St. Sebastian Cured by St. Irene* (fig. 29), dated 1616, intrigued the young Velázquez. Here the slow, almost frozen gestures, the broad simple folds, the clear establishment of planes combined with a slight upward tilt of space, and the device of narrative seen through a window calls to mind such Velázquezes as the *Kitchen Scene with Christ in the House of Mary and Martha* and the *Supper at Emmaus*. To be

sure, there are differences between the master and the pupil. Pacheco's handling is tighter and flatter than Velázquez's, and his figures are thinner. In addition, unlike Velázquez's depiction of two facets of one moment, we find Pacheco employing a continuous narrative. St. Sebastian's martyrdom takes place in the background, and the saint is healed by the tender mercies of St. Irene in the foreground.[77] Nevertheless, at the very time that Velázquez was in the workshop, Pacheco was using similar compositional and lighting devices.[78]

Any assessment of the master-pupil relationship necessarily must depend upon what can be gleaned from Pacheco's treatise, *El arte de la pintura.* Long-winded and sometimes contradictory, it still provides a firsthand account of Pacheco's artistic practices and beliefs, a document which reveals the methods and principles which Velázquez could have absorbed in the workshop.[79] Pacheco's stress on draftsmanship, harmony, and naturalism is common in art-theoretical vocabulary.[80] However, it is the inflection of this vocabulary which provides an insight into Velázquez's manner. Following Renaissance precepts, Pacheco praised relief. Significantly, it is the naturalistic artists who sedulously practice this mode.

> The most important of the three parts into which we divide coloring is the last one, RELIEF which I will speak of in this chapter: I say that it is the most important, because some time you will find some good painting which lacks freshness and mellowness of color, but if it possesses force and relief, and appears round like a solid volume and lifelike and deceives the eye as if it were coming out of the picture, then the absence of these two other qualities is forgiven.[81]

Thus Velázquez's *bodegones* can be sanctioned because of the plasticity of the objects which are represented. Similarly Velázquez's muted palette and bold lighting effects are necessary components of a painting which stresses relief. Indeed, Pacheco reiterated Leonardo's dictum that the ignorant painter solely desired "freshness of color."[82]

The treatise is studded with advice and admonitions. Of primary importance is Pacheco's advocacy of a naturalism which must represent things with as much clarity and truth to nature as possible.[83] To support his argument, Pacheco relied upon the authority of antiquity: "According to Aristotle, in judging two paintings, one adorned with beauty of color and not very lifelike, and the other fashioned out of simple outlines, but very like the truth, the former would be inferior and the latter superior."[84] Velázquez's *bodegones,* lifelike despite their limited color range, serve as visual testaments to this conceit. The *bodegones* also may reflect Pacheco's ideas about brushwork. Their deliberate, taut handling without brushy effects may be a result of Pacheco's contempt for painters of "borrones" and his praise for carefully finished works.[85]

When we consider brushwork, color, light, and composition, a logical explanation for Velázquez's early style is suggested by his Hispanic ambience. Indeed, the canonically conservative aspects of his style, particularly the immobile figures devoid of emotional immediacy, point to a painter trained and shaped in a primarily insular environment. Even Velázquez's genre subjects can be explained in terms of the Spanish tradition.

Obviously genre pictures were painted in Spain prior to Velázquez. A case in point is Juan Estéban de Ubeda's *Meat Market* (fig. 30). Signed and dated 1606, this painting was completed over a decade before Velázquez's work, and yet

the subject matter and formal devices already presage the master. Like Velázquez, Estéban juxtaposes youth and age, figures and foodstuff. His grinning boy anticipates the smirking adolescents found in the *Musical Trio*, the *Three Men at a Table*, and the *Luncheon*. Yet compared to Velázquez, Estéban is a crude drudge. His figures are flat and unconvincingly occupy space. The hanging shanks of meat, the mangy rabbits, and the thin fowl are awkwardly rendered. But one cannot deny similarities to the *bodegones*. Estéban foreshadows Velázquez in his concern for naturalistic texture and appearance, as reflected light sparkles over the carafe and the melon pits are meticulously scrutinized. Estéban also employs a composition with three-quarter-length figures set off against a dark background. Tables tilt upward. Still life aggressively confronts us on the picture plane. Although Estéban's arrangement of the still-life objects is not as crystallized as Velázquez's exercises in formal clarity, there is an incipient quality of order. On the right, planar recession is suggested by the placement of fennel, rolls, towel, and melon. Estéban's interest in simple geometric shapes—the towel with its crisp rectangular folds juxtaposed to the circular rolls, the sliced melon forming an artful hemispheric shape—is also apparent. Even though Velázquez probably did not know this painting, it is meaningful that he and Estéban share common modes.[86]

It is likely that other paintings of this type were once extant. Pacheco's broad reference to painters of comic pictures, fish, and hunting scenes suggests a Spanish tradition of some substance.[87] It is unfortunate that we can no longer discern it. After all, these paintings were the ephemera of their times. Fickle taste, the vicissitudes of time, and priggish morality doubtless have been detrimental to the history of Spanish genre painting. Yet it is clear

that Velázquez, although he was the greatest Spanish practitioner of genre, was not its first.

Fortunately, more genre prints have survived. We have already noted the formal and thematic similarities between Vermeyen's *Spanish Supper* of 1545 and Velázquez's *bodegones* in Budapest and Leningrad. A year later, Vermeyen etched another genre scene, a jocular and vulgar *Dance of Peasants* (fig. 31). The pissing cat on the branch and the merrily capering dog underscore the humorous mood. The peasant, glancing upward while playing the viol, adumbrates the transfixed gaze of the guitar player in the *Musical Trio*. But by no means was Vermeyen the only printmaker to produce genre scenes for a Spanish clientele. Small realistic prints accompany editions of the popular *Romanceros* and *Canciones*, those ubiquitous songbooks of the Golden Age.[88] A case in point is the serenading musician depicted in *Flor de varios romances nuevos y canciones* of 1589.[89] The *Pliegos del cordel*, the inexpensive chapbooks of the period, also contained genre vignettes.[90] One example, a man seated at a table dated 1600, indicates that eating scenes were familiar to Spanish patrons.

Indeed, Velázquez's world of shabby entertainers, street ruffians, and kitchen interiors had already been explored vividly by Spanish writers of the Golden Age. Since Justi's monograph, this has been an oft-repeated observation.[91] But it requires amplification and modification.

The times were evidently right for popular low-life representations. Women in the court of Philip III donned ragged clothes and dressed "a lo picaresco."[92] *Lazarillo de Tormes*, that exciting and corrosive incunabulum of the picaresque novel, went through only seven Spanish editions from 1554 through 1595, yet within the subsequent eight years there were ten reissues.[93] Alemán's *Guzmán de Alfarache* sustained sixteen printings from 1599 through

1601. By 1604 there were twenty-four editions and fifty thousand copies.[94] In the first decade of the seventeenth century, Quevedo wrote his mordant picaresque novel *El Buscón,* and Francisco Lopez de Ubeda's adventure of a female picaresque, *La picara Justina,* was published in 1605.[95] Cervantes' *Exemplary Novels,* a self-styled "billiard table" of amusements published in 1613, culminated this interest in low life.[96]

Surely the Sevillian air was abuzz with the literary exploits of the street rogue. But we must dismiss the forced attempts at proving a one-to-one influence. For example, the egg-cooking scene in *Guzmán de Alfarache* is certainly not the subject of Velázquez's painting in Edinburgh, for Aléman describes an old woman cooking a rotten omelet whose untimely chicks crackle between the teeth of the young anti-hero.[97]

Although there are no specific parallels to be drawn between the *bodegones* and the contemporary literature of roguery, they do share a common *Weltanschauung.* Consider, for instance, the admonition in the prologue of *Don Quixote*: "to see that your sentences are couched in plain, expressive and well ordered words . . . setting forth to the best of your ability your ideas without being intricate or obscure."[98] This literary advice established the standard for the clear, tough prose and piquant naturalistic observations of the novel. And Cervantes' statement is equally applicable to Velázquez's style. Straightforward and pithy, the *bodegones* are its pictorial equivalent.

Velázquez's genre themes also parallel the singular and intense vision of low life found in Cervantes and other picaresque novels. Water carriers appear in *Lazarillo de Tormes* and in Cervantes's *La ilustre fregona.*[99] Tavern scenes abound. Indeed, as the frontispiece to the *Picara Justina* proclaims, drinking, music, and eating are "el aguar de la vida picaresca," the baggage of the picaresque life.[100]

And the bustling Sevillian street ambience, those very streets where Velázquez himself wandered as a youth, is remarkably visualized. Cervantes' tale of *Rinconete and Cortadillo* from the *Exemplary Novels,* for example, presents a sharply drawn picture of youths surviving in the Sevillian flash underworld. The thieves' courtyard contains a literary still life reminiscent of a Velázquez. "On one side was a three-legged stool, and on the other a pitcher with a broken spout on top of which stood a jug that was in equally bad shape."[101] Their dinner anticipates one of Velázquez's eating scenes: ". . . a large bunch of radishes and some two dozen oranges and lemons, and then a large earthenware pot filled with fried codfish."[102]

We can only speculate about Velázquez's response to this type of literary naturalism. But we know that a member of the Pacheco circle, Baltasar del Alcázar, was enthusiastically practicing his own fresh and credible imagery devoted to food, clothing, wine, and his mistress.[103] His *Cena jocosa,* a tavern scene with an elaborate description of the smells and textures of wine and food, is but one example of his skillful naturalism.[104]

A Spanish proverb proclaims: "O Sevilla—qué maravilla." Velázquez learned to paint *bodegones* in marvelous Seville. Here, naturalism was encouraged in literature and the visual arts. Here, Pacheco taught about the significance of relief. Here are the immediate, accessible sources for Velázquez's triumphantly realized visions of plebeian reality.

Notes

1. J. Held and D. Posner, *17th and 18th Century Art* (New York, n.d.), 179.

2. F. Pacheco, *Arte de la Pintura* (1649), ed. F. J. Sánchez Cantón (Madrid, 1956), 2:13.

3. A. Palomino, *El museo pictórico y escala óptica* (1724), ed. M. Aguilar (Madrid, 1947), 893.

4. V. Carducho, *Diálogos de la Pintura* (1633), ed. D. G. Cruzada Villaamil (Madrid, 1865), 204. Cf. R. Enggass and J. Brown, *Italy and Spain 1600–1750* (Englewood Cliffs, 1970), 173, and E. Holt, *A Documentary History of Art,* vol. 2 (Garden City, N.Y., 1958), 208.

5. G. Mancini, *Considerazioni sulla pittura,* ed. A. Marucchi and L. Salerno (Rome, 1956), 1:224, 2:112–13 n. 886.

6. G. P. Bellori, *Vite de' pittori, scultori et architetti* (Rome, 1672), 214. The painting is now in the Cleveland Museum of Art. See A. Tzeutschler-Lurie and D. Mahon, "Caravaggio's Crucifixion of St. Andrew from Valladolid," *Bulletin of the Cleveland Museum of Art* 64 (1977):3–24 for a study of its provenance, iconography, and replicas. Another painting in Valladolid depicting a decapitated bishop saint was attributed to Caravaggio in an inventory of 1653. J. Ainaud ("Ribalta y Caravaggio," *Anales y Boletín de los Museos de Arte de Barcelona* 5 [1947]:381) suggested that this painting, too, came in 1610.

7. Bellori, *Vite.* The painting of David was associated, without proof, with the *David and Goliath* now in Vienna by a follower of Caravaggio. See W. Friedlaender, *Caravaggio Studies* (Princeton, 1955), 203. On the Count of Villamediana see H. Soehner, "Velázquez und Italien," *Zeitschrift für Kunstgeschichte* 18 (1955):35 n. 77.

8. *Arte de la pintura,* 2:13.

9. A. Moir, *Caravaggio and His Copyists* (New York, 1976), 93.

10. A Moir, "Alonzo Rodríguez," *Art Bulletin* 44 (1962):209 n. 47, fig. 5.

11. M. Jaffé, *Rubens and Italy* (Oxford, 1977), 68.

12. For the documents on Velázquez's early years in Seville see *Varia Velazqueña* (Madrid, 1960), 2:213–21.

13. M. Cinotti and G. A. dell'Acqua, *Caravaggio* (Bergamo, 1983), 211.

14. M. Kahr, *Velázquez: The Art of Painting* (New York, 1976), 16–17. Cf. Haraszti-Takács *(Spanish Genre Painting,* 63–65), who also emphasizes the importance of Caravaggio.

15. On the "Pensionante" see Cavina, *Carlo Saraceni*, (Milan, 1968), 65–66 n. 34 and 67–68 n. 47.

16. Nor did he see the *Fruit Vendor* now in Detroit, a painting which has been related to the *Water Carrier*. For Velázquez and the "Pensionante" see H. Soehner, "Die Herkunft der Bodegones de Velázquez," *Varia Velazqueña*, 1:242–43.

17. A. Moir, *The Italian Followers of Caravaggio* (Cambridge, 1967), 1:44.

18. A. E. Pérez Sánchez, *Borgianni, Cavarozzi y Nardi en España* (Madrid, 1964), 12.

19. Ibid, 16–18. The paintings are reproduced in ibid., pls. 7–16.

20. Ibid., 15.

21. Ibid., 19.

22. *Considerazioni sulla pittura*, 1:306, 2:213 n. 1635.

23. Pérez Sánchez, *Borgianni, Cavarozzi y Nardi*, 20.

24. For these paintings see ibid., 20–24.

25. A. E. Pérez Sánchez, *Caravaggio y el naturalismo español* (Seville, 1973), no. 26.

26. Ibid, nos. 31–33.

27. For this picture see A. Cavina, *Carlo Saraceni*, 116 and fig. 88. Saraceni's two other paintings in Toledo, the *Giving of the Chasuble to San Ildefonso* and the *St. Leocadia in Prison*, are not in very felicitous condition. See Pérez Sánchez, *Caravaggio*, 32–33.

28. For the painting in the museum see Pérez Sánchez, no. 15. The painting in the cathedral is discussed in Pérez Sánchez, *Pintura italiana del siglo XVII* (Madrid, 1970), 110.

29. For the dating see Moir, *Italian Followers*, 1:165. E. Borea ("Caravaggio e la Spagna: Osservazioni su una mostra a Siviglia," *Bolletino d'Arte* 59 [1974]:45) is misleading in not qualifying the statement that the painting was in Seville "anche ai tempi di Velázquez." I must disagree with Borea's attribution (p. 48) of the *Denial of St. Peter* in Seville Cathedral to Sofonisba Anguisciola. Like others (cf. Pérez Sánchez, *Caravaggio y el naturalismo español*, no. 50), I believe that it is by a Northern *Caravaggista*. It is reminiscent of the *Morra Players* in Siena attributed to Giovanni del Campo, an artist who was actually in Spain in the

1630s. For del Campo see G. J. Hoogewerff, *De Bentveughels* (The Hague, 1952), 151 and also 71–78, 81–88, 90–92, and pl. 9. This painting also has been attributed to Grammatica. See Moir, *Italian Followers,* 1:88 n. 59.

30. Ibid., 1:164 n. 32.

31. A. Ortiz, *The Golden Age of Spain, 1516–1659* (New York, 1971), 5–6.

32. M. Moret, *Aspects de la société marchande de Seville au début du XVIIᵉ siécle* (Paris, 1967), 46–47.

33. C. Van Mander, *Dutch and Flemish Painters* (1604), ed. C. Van de Wall (New York, 1969), 165, 216, 263–64, 317.

34. For Mor see M. J. Friedlaender, *Early Netherlandish Painting,* vol. 13 (New York and Washington, 1975), 64–65.

35. For Campaña see D. Angulo Iñíguez, *Pedro de Campaña* (Madrid, 1951), especially 12–13 and 20–22. For Frutet see N. Sentenach, *The Painters of the School of Seville* (London, n.d.), 59. For Sturmio see D. Angulo Iñíguez, *Pintura del Renacimineto,* vol 14 of *Ars Hispaniae* (Madrid, 1954), 210. If Sturmio had an impact on seventeenth-century Sevillian art, it was on the majestic, sweet, and withdrawn saints of Zurbarán. For this suggestion see J. Brown, *Francisco de Zurbarán* (New York, n.d.), 21.

36. C. Justi, *Diego Velázquez und sein Jahrhundert* (Bonn, 1922), 1:134.

37. Soehner, "Velázquez und Italien," 4–5.

38. This connection is suggested in ibid., 6–7. The painting is now given to Heemskerck. See J. Bruyn and M. Thierry de Bye Dolleman, "Maerten Van Heemskercks *Familiengroep* te Kassel: Pieter Jan Foppesz. en zijn gezin," *Oud Holland* 97 (1983):13–24.

39. Soehner, "Velázquez und Italien," 10.

40. R. Genaille, "L'oeuvre de Pieter Aertsen," *Gazette des Beaux-Arts* 44 (1954):284. For other Aertsen provenances see ibid., 280–88. On Beuckelaer see K. P. F. Moxey, *Pieter Aertsen, Joachim Beuckelaer and the Rise of Secular Painting in the Context of the Reformation* (New York and London, 1977), 72–105. However, recent research by Duncan Kinkead on Sevillian collections may demonstrate that there were more Northern pictures than

we now suspect in Seville. I am indebted to Jonathan Brown for calling my attention to this.

41. *Diálogos de la pintura*, 265. However, this is also reminiscent of Bassanesque pictures.

42. A. Mayer, "Velázquez und die niederlandischen Küchenstücke," *Kunstchronik und Kunstmarkt* 30 (1918/1919):236–37. I. Bergstrom (*Maestros españoles de bodegones y floreros del siglo XVII* [Madrid, 1970], 94 n. 9) suggests that Matham created his own composition in the manner of Aertsen.

43. For Vermeyen see A. E. Popham, "Catalogue of Etchings by Jan Cornelisz. Vermeyen," *Oud Holland* 44 (1927):174–82. Cf. also K. G. Boon, *Thieme-Becker Künstler Lexicon* (Leipzig, n.d.), 34:278–80, and K. Renger, *Graphik der Niederlande 1508–1617: Kupferstich und Radierungen von Lucas van Leyden bis Hendrick Goltzius* (Munich, 1979), nos. 13, 21.

44. *Arte de la pintura*, 2:13.

45. He also appears as the bearded Caspar in the *Adoration of the Magi* of 1619.

46. For this see H. Kamen, *The War of Succession in Spain, 1700–1715* (Bloomington, Ind., 1969), 23–24.

47. R. Pike, *Enterprise and Adventure: The Genoese in Seville and the Opening of the New World* (Ithaca, 1966), 9.

48. Ibid., 12.

49. Ibid., 8.

50. On Cambiaso in Spain see B. Suida-Manning and W. Suida, *Luca Cambiaso* (Milan, 1958), 26–28, 224–31.

51. Soehner, "Die Herkunft der Bodegones de Velázquez," 240; G. Kubler and M. S. Soria, *Art and Architecture in Spain and Portugal and Their American Dominions, 1500–1800* (Baltimore, 1969), 253.

52. F. Baldinucci, *Notizie dei professori del disegno* (1681–96; Florence, 1846), 2:488. Cf. A. Campi, *Cremona fedilissima* (Cremona, 1585), 197, who reported that Vincenzo only sent pictures to Spain.

53. See S. Zamboni, "Vincenzo Campi," *Arte Antica e Moderna* 20 (1965):130–31 and fig. 47b.

54. See. A. E. Pérez Sánchez, "Sobre bodegones italianos, napolitanos especialmente," *Archivo Español de Arte* 40 (1967):311. I cannot agree, however, with Pérez Sánchez's attribution (ibid.) to Campi of a kitchen scene acquired by the Dirección General de Bellas Artes.

55. Zamboni, "Vincenzo Campi," 133.

56. For this alleged relationship see Soehner, "Die Herkunft der Bodegones de Velázquez," 243, and K. Gerstenberg, *Diego Velázquez* (Munich, 1957), 22.

57. His *Butcher Shop* and *Fish Vendor* now in the Galleria Nazionale in Rome were initially in the Palazzo Antici Mattei. See N. Carpegna, *Catalogo della Galleria Nazionale Palazzo Barberini, Roma* (Rome, 1955), 48. Pérez Sánchez's ("Sobre bodegones italianos, napolitanos especialmente," 312) attribution of a *Butcher Shop* in the Museo Casa de Oquendo of San Sebastian to the Passarotti workshop is unacceptable. Like Posner *(Annibale Carracci: A Study in the Reform of Italian Painting around 1590* [London, 1971], 1:154 n. 12), I believe that the picture is Emilian and may date from the 1620s.

58. E. Arslan, *I Bassano* (Milan, 1960), 1:327–86.

59. D. Fitz-Darby, *Francisco Ribalta and his School* (Cambridge, 1938), 7.

60. *Arte de la pintura,* 2:134.

61. Ibid., 1:456, 475.

62. Ibid., 2:134.

63. Ibid., 1:456.

64. Trapier, *Velázquez,* 8.

65. For Roelas see D. Angulo Iñíguez, *Pintura del siglo XVII,* vol. 15 of *Ars Hispaniae* (Madrid, 1971), 76–82.

66. Trapier *(Velázquez, 3–33),* unlike the majority of art historians who look beyond the confines of Spain, attempts to relate the early Velázquez to the Sevillian tradition.

67. D. Angulo Iñíguez and A. E. Pérez Sánchez, *Historia de la pintura española escuela toledana de la primera mitad del siglo XVII* (Madrid, 1972), 231. It is interesting to note that Velázquez's patron Fonseca also had four Orrentes in his collection. Ibid., 264.

68. *Arte de la pintura*, 2:134.

69. For this painting see M. Haraszti-Takács, *Spanish Masters* (New York, 1966), no. 17. See also Angulo Iñíguez and Pérez Sánchez, *Historia de la pintura española*, 322. The genrelike aspects of this painting allowed Orrente to transform the composition into a gambling scene which now exists in a private collection in Barcelona. See ibid., 347–48 and fig. 268. Although M. Soria ("Velázquez and Tristán," *Varia Velazqueña* [Madrid, 1960], 1:456–62), has suggested that Luis Tristán, yet another Spanish Bassanesque, had some impact upon Velázquez, his comparisons are unconvincing.

70. Trapier, *Velázquez*, 7.

71. See B. Proske, *Juan Martínez Montañez* (New York, 1967), 36, 37, 42, 44, 45, 46, 50–51, 58, 60, 64–65, 73, and 78 for Pacheco's connection with Montañez through the first and second decades of the seventeenth century.

72. *Varia Velazqueña*, 2:217, 220.

73. Later in his career, Velázquez may have recalled Martínez Montañez's *Coronation of the Virgin* (Proske, *Juan Martínez Montañez*, pl. 22) of 1609 for his own version of the theme.

74. See J. López-Rey, *Velázquez' Work and World* (London, 1968), 21, for a discussion of the problem of Velázquez's first apprenticeship.

75. For Herrera see J. Thacher, "The Paintings of Francisco de Herrera the Elder," *Art Bulletin* 19 (1937):325–80.

76. Kubler and Soria, *Art and Architecture in Spain*, 229.

77. López-Rey *(Velázquez' Work and World*, 34) has called attention to this point.

78. For Pacheco's artistic career see P. Muller, "Francisco Pacheco as a Painter," *Marsyas* 10 (1961):34–44. See also M. Barbadillo, *Pacheco, su tierra y su tiempo* (Jerez, 1963), 103–6.

79. The treatise, completed in 1638, and published only in 1649, was written from the first decade of the seventeenth century through the 1630s. See J. Brown, *Images and Ideas in Seventeenth-Century Spanish Painting* (Princeton, 1978), 34.

80. Cf. A. Blunt, *Artistic Theory in Italy, 1450–1600* (Oxford, 1964) for an analysis of similar art-theoretical concerns in Italy.

81. *Arte de la pintura,* 1:455–56.

82. Ibid., 459.

83. Ibid., 1:222, 299; 2:213.

84. Ibid., 1:212.

85. Ibid., 1:471.

86. For Estéban see J. Cavestany, *Floreros y bodegones en la pintura española* (Madrid, 1936–40), 36, 74.

87. *Arte de la pintura,* 2:137.

88. For these see A. Rodríguez Moniño, *Manual bibliográfico de cancioneros y romanceros,* 2 vols. (Madrid, 1973).

89. Ibid., 2:135.

90. For these see A. Rodríguez Moniño, *Diccionario bibliografico pliegos sueltos poeticos* (Madrid, 1970).

91. C. Justi, *Diego Velázquez,* 1:135. The most recent writers to ássert this connection are M. Haraszti-Takács, "Quelques problemes des bodegones de Velázquez," *Bulletin du Musée Hongrois des Beaux Arts* 41 (1973):40–42, and Kahr, *Velázquez,* 19.

92. R. Bjornson, *The Picaresque Hero in European Fiction* (Madison, 1977), 69.

93. Ibid., 67.

94. Ibid., 258 n. 1.

95. M. Bataillon, *Le roman picaresque* (Paris, 1931), 24–25.

96. M. de Cervantes, *Obras completas* (Madrid, 1965), 770.

97. J. A. Gaya y Nuño ("Picaresco y tremendismo en Velázquez," *Goya* 37/38 [1960]:97, and "Peinture picaresque," *L'Oeil* 84 [1961]:56) and R. Spear *(Caravaggio and His Followers,* 19) have accepted uncritically the episode as a source for the *Old Woman Cooking Eggs.* But cf. M. Alemán, *Guzmán de Alfarache,* ed. S. Gili y Gaya (Madrid, 1962), 1:iii, 109–10.

98. *Obras completas,* 1034.

99. *La vida de Lazarillo de Tormes,* ed. J. Cejador y Frauca (Madrid, 1926), vi, 253. *Novelas ejemplares,* ed. F. Rodríguez Marín (Madrid, 1914), 1:267–68.

100. Reproduced in Bjornson, *The Picaresque Hero,* 68.

101. *Novelas ejemplares,* 1:170.

102. Ibid., 194.

103. On Alcázar and Pacheco see *Poesías de Baltasar del Alcázar* (Seville, 1856), ix.

104. Ibid., 84–89. Cf. his witty dialogue between Gout and Love, 80–84.

4

Naturalism and Metaphor

PALOMINO TELLS US THAT PACHECO'S HOUSE
was "un carcel dorada"—a golden cage.[1] It was in this
opulent environment that the young Velázquez came into
contact with the learned men of Seville. Among them were
Roderigo Caro, the third duke of Alcalá, Fernando Enri-
quez Afán de Ribera, and Francisco Medina. Caro was a
passionate antiquarian. His collection included statues,
coins, medallions, and inscriptions on fragments of stone.
A writer as well as a collector, Caro carefully recorded the
history of Seville's Roman origins in his scholarly tract
Antiguedad y principiado de Sevilla, published in 1634. But
Caro also had a flip side. His *Días geniales o lúdicros,*
completed in 1626, is a dialogue in the manner of Sueto-
nius that considers the history of "homo ludens." Includ-
ing children's games and songs, it is a light and fascinating
introduction to an alternative form of scholarship which
consciously was created to divert "un poco el animo."[2] The
duke of Alcalá was also a renowned collector of antiquities,
and his library was enormous, containing, according to
Caro, "so many volumes of all the sciences and humanistic
letters, manuscripts and ancient medals that it competes

with the most illustrious in the world."[3] As an art patron,
the duke commissioned Pacheco to paint a series of elabo-
rate mythologies for his palace. These scenes, which exalt
the duke's virtues, clearly reveal the emblematic and sym-
bolic concerns that the Pacheco circle so thoroughly en-
joyed.[4] Finally, the poet and teacher Francisco de Medina,
who once was a tutor for the Alcalá family, also turned his
attention to scholarship and collecting. According to Pa-
checo he "had a rich museum of rare books, and unusual
things from antiquity and our own times."[5]

In this gilded cage, no doubt the adolescent Velázquez
was encouraged to develop a taste for emblem, metaphor,
and humanistic erudition. We cannot dismiss this as an
important facet of Velázquez's education. But this gilded
cage also housed a *bodegón* painter—a common, motley
bird devoted to plebeian reality. The paradox is striking
yet specious. The *bodegón,* even with its perch of palpable
reality, is informed with the conceits, metaphors, and puns
which assuredly delighted not only the Pacheco circle
specifically, but also the seventeenth-century man of intel-
lect in general. Indeed, it is now apparent that seven-
teenth-century genre painting can no longer be viewed as
a simple mirror of nature. Emblematic, sensual, allegoric,
or witty, the Baroque genre scene encompasses a wide
range of allusions.[6] Velázquez's early works reveal a similar
penchant for this type of expression.

The *Vintager,* for example, may be a paradigm of the
passionate interest in antiquity—the "sagrada antiguedad"
as Caro described it—that flourished in the Pacheco circle.
Has Velázquez recreated a painting by Zeuxis of a boy
carrying grapes described in Pliny's *Natural History?*[7] Not
only was Zeuxis revered by Pacheco as a master of "re-
lievo"—that quality which was fundamental to artistic
practice—but this specific episode is retold in Pacheco's

chapter devoted to genre and still-life painting.[8] Yet Pliny, and Pacheco echoes him, records Zeuxis's displeasure with his depiction of the boy with grapes. "When the birds flew down to settle on them, he was vexed with his own work, and came forward saying, with like frankness 'I have painted the grapes better than the boy, for had I been perfectly succesful with the latter, the birds would have been afraid.' " It does seem likely that Velázquez would not allow himself to make a similar mistake. The face of his boy has a lively grimace; his body is thrust forward. His animated spirit easily can repel whatever real birds are attracted by his plump, glistening fictive grapes. In this way, not only has Velázquez emulated Zeuxis, but he also has attempted to surpass him. The *Vintager* is just the type of learned pictorial exposition—a competitive rekindling of the art of antiquity—which one would expect from a young man in Pacheco's workshop.[9] Indeed, the iconography of this work is the strongest argument for its attribution to Velázquez.

If the *Vintager* appears to be a patent illustration of Caro's dictum that the example of antiquity lends authority to anything contemporary, perhaps too, but in a less obvious way, this conceit ultimately lies behind Velázquez's eating scenes in Budapest and Leningrad.[10] In his chapter on genre and still-life painting, Pacheco described pictures with "ridiculous figures with diverse and ugly subjects which provoked laughter."[11] He added: "Do we find perhaps some antique painter who was inclined to paint these ordinary and comic things? It appears so; Pliny mentions one called Dionisio, with a nickname Anthropographos, who painted only figures with amusing authority. . . . And in the same way Peiraikos (Pireicos) also painted humble things like barbershops, stalls, meals. . . ."[12] Are Velázquez's eating scenes then a distant echo of the "comidas" of

Pireicos, works which "produced great pleasure and elevated the artist to the quintessence of glory"?[13] I would argue that these paintings are at least that—and more. In fact, they seem to suit perfectly Pacheco's designation of pictures of "figuras ridiculas con sugetos varios y feos para provocar la risa."

In the *Three Men at a Table* Velázquez depicts a tavern party with a vulgar trio of revelers. The young man on the right knowingly smiles and gestures thumbs up. His companions are an old man who fixedly grasps a turnip and a mischievously grinning boy raising his wine flask in triumph. Recent attempts to link this painting to eucharistic symbolism, an interpretation which, needless to say, I find difficult to swallow, do not take into account the coarse types and comic mood.[14] Indeed, this mood is defined by the carefully selected still-life accessories which reveal the painting's underlying bawdy content.

Bread and wine need not always be eucharistic symbols. Bread, for example, also held erotic connotations, no doubt the result of the alleged lubricity of bakers. The sixteenth-century writer Gonzalo Fernandez de Oviedo claimed: "Very apt is the baker's profession for the frays of Cupid. . . ."[15] And the indefatigable paroemiologist Juan de Mal Lara, explained: "Aristotle presents a problem in which he asks: 'Why are bakers more learned in actions of love than others?' It is because the activity causes ardor."[16] By the seventeenth century, "pan" was sometimes used synonymously with carnal enjoyment. In Góngora's *El doctor Carlino,* for instance, the amorous Gerardo lightly declares "A Lucrecia tengo en pan," a metaphor for sexual possession.[17]

Next to the bread is a glass of wine, which is similarly linked to lasciviousness. In fact, a juxtaposition of wine and bread appears in a number of late sixteenth-century

paintings that highlight the sensual aspects of the drink. In Passarotti's cheerfully obscene *Merry Company*, for example, wine and bread are placed side by side on a parapet—an emblematic footnote to the couple above indulging their sexual desires.[18] Obviously, Spaniards as well were familiar with the erotic symbolic connotations of wine. As far back as the late medieval *Libro de buen amor*, wine was viewed as the complement of lechery.[19] And in Luca Dantisco's *Destierro de ignorancia*, a compendium of moralizing proverbs published in Barcelona in 1592, wine is indissolubly linked to lechery.[20]

The knife, slit pomegranate, and mussels complete the salacious paraphernalia on the table. The knife, a familiar sexual metaphor, and the pomegranate, a fruit associated with the lustful god Pan, have notoriously bawdy connotations.[21] Mussels were employed as a metaphor of prodigal sensuality in literature and the visual arts from antiquity through the seventeenth century. Juvenal wrote: "What decency does Venus observe when she is drunken . . . and eats giant mussels at midnight . . . ?"[22] And Brueghel used an enormous mussel as the centerpiece for his allegory of lust.[23] Many others have alluded to the lascivious properties of the mussel.[24] In Spain, the lexicographer Covarrubias characterized it as "a small mollusk eaten by poor people which provokes lechery."[25] But it is not only the still life which contains bawdy connotations. Indeed, the still life is complemented by the young man's gesture and a turnip held firmly by the old man. The *thumbs up* sign not only signifies hearty approval, but it may relate to the conceit that wickedness exits from the thumb, already described in the sixteenth century in Beneventano's *Adagio y fabulas*.[26] The turnip's obvious phallic shape is the subject of numerous Golden Age double-entendres. Thus in a *Romance* published in Valencia in 1596, the phallic

qualities of the turnip are noted, and in a poem attributed to Góngora, an obscene riddle revolves around the turnip's suggestive form.[27] Indeed, Quevedo, that master of the risqué pun, wittily wrote in *Matraca de las flores y la hortaliza*: "They prepare the turnips aiming them at the bawd mothers and aunts."[28]

One need turn only to the smoldering pages of the provocative Golden Age novel, Delicado's *La lozana andaluza,* to understand that eating and drinking are traditional erotic metaphors.[29] The three men zestfully enjoy this type of meal. One of them, perhaps the smirking young man with the wine flask, owns the ruffled collar which hangs conspicuously on the back wall. This piece of costuming, probably the infamous "alçacuello," was associated with youthful hedonists and dandies.[30] And the tavern setting is the logical place for their bawdy gathering, since this environment was linked to lasciviousness in Spanish Golden Age proverbs.[31] The inn also, according to Alonso López Pinciano, the arbiter of Golden Age comic theory, was a particularly suitable locale for ribald comedy and thus an appropriate gathering place for "figuras ridiculas."[32]

Of course there is a broad international interest in bawdy subject matter in the last decades of the sixteenth century and the first decades of the seventeenth century. Ribald food pieces like Carracci's *Butcher Shop* (fig. 32), Campi's piquantly obscene *Fish Vendors* (fig. 33), and Frangipane's so-called *Allegory of Autumn* (fig. 34) all contain overt sexual metaphors. Carracci conflates the characters and buffoonery of the Commedia dell'arte with traditionally risqué references to meat.[33] Campi's vulgar eating scene contains fish, cheese, bread, and wine, bawdy metaphors which doubtless pleased his patron, the cheerfully lusty Hans Fugger.[34] And Frangipane's painting is redo-

lent with sexual symbolism, including a slit fruit.[35] In Holland, Frans Hals's *Merry Company* exemplified this type, combining items traditionally associated with debauchery—sausages, bread, and oysters—with an explicitly vulgar gesture made by the clownish Hanswurst.[36]

Spain was no exception, since it too had a taste for erotic subject matter. In prints such as Vermeyen's *Spanish Supper* with its mingling of smirking figures and phallic radishes or in a painting such as Estéban's ribald *Meat Market*, informed with sexual puns on meat, melon, and pomegranate, this appetite is evident.[37] In literature too, Fernando de Rojas's corrosive and sensual *La Celestina* provides a similar ambience. In Act 9 we find the bawd, Celestina, the scheming Sempronio, and two prostitutes, Elicia and Areusa, drinking, quarreling, and talking of love. Celestina advises the lovers, Sempronio and Elicia, to "kiss and make up and I'll enjoy watching you, which is the only pleasure I've got left. At the table everything from the waist up is allowable, but when you leave it I won't make any conditions since the law doesn't. I know from my girls that you lads will never be accused of disappointing them, and old Celestina will mumble the crumbs from the table."[38]

Obviously Velázquez has not illustrated the voluptary banquet of *La Celestina*, but what is clear is that Velázquez's interest in erotica is not unusual for Golden Age Spain.

Indeed, Spain was a hotbed of licentiousness, and travelers, well aware of Spanish passion, called attention to the Spaniards' penchant for amorous adventures. In 1585, for example, Hendrick Cock wrote: "Public prostitution is so common in Spain that many first go to the bordellos upon entering a city before they go to church."[39] Our vision of Spain has been distorted by Poe-like images of grim-hooded inquisitors ruthlessly extirpating anything

with the slightest taint of licentiousness. Actually, the Inquisition generally abstained from intrusion into morals. Its main concern was for the suppression of presumed heretical writings, Bibles with commentaries, and books which it thought attacked the faith. In fact, instead of being placed on the Inquisitorial Index, *La Celestina,* that exemplary tale of love and passion, was used as a school book until 1640.[40] And Ubeda's *La picara Justina* burlesqued Inquisitorial practices. Thus Justina mocks flagellants, scorning a particularly ardent one with lumps of mud.[41] Since thirty thousand prostitutes circulated with more or less impunity at the court of Philip IV, we can naturally expect a good deal of Golden Age sexual low life and high jinks.[42]

It is now impossible to trace the extent of artistic erotica in Spain, but salacious imagery had a fairly wide diffusion in the literary arts. Many popular songs, romances, and chapbooks contain scatological snatches.[43] So too do the more learned, but no less prevalent, picaresque novels. In *Guzmán de Alfarache,* for example, there is a coarse vignette describing the confrontation between the young picaro, Guzmán, and the nude wife of his master.[44] Or at the conclusion of Ubeda's *La picara Justina* we read a provocative description of the anti-heroine's wanton ardor.[45] The literary members of the Pacheco circle were a bit more timid than Ubeda, but they too could turn a sensual phrase. Baltasar del Alcázar, for example, offered his amorous services to a beautiful widow in *Consejos a una viuda.*[46] In *Días geniales o lúdicros,* Caro described carnal customs such as nude dancing, and various obscene hand and finger gestures—some of which still survive in our less genial days.[47]

Since Spanish erotica seems to cast such a wide net, it is difficult to provide a specific patron for Velázquez's work.

The *Three Men at a Table* is a painting of high quality, and I would prefer to believe that it was commissioned by a witty and learned connoisseur rather than sold on an uncertain art market. It is tempting to imagine Caro as its owner, but any Sevillian admirer of bawdy fun could have been a customer.[48]

We have noted already the stylistic affinities between the Budapest *Luncheon* and the *Three Men at a Table*. But there are also iconographic similarities. All the trappings of a bawdy banquet again are present. Provocatively juxtaposed in the foreground plane are the now familiar bread and wine. An angled knife juts into the bread, and this visual metaphor of penetration is underscored by the witty representation of the red, swelling radish indecently thrust through the hole in the shimmering salt cellar. Of course, such puns are not uncommon in the erotic art of the period. In Frangipane's so-called *Allegory of Autumn*, for example, a lewdly grinning satyr pokes his finger into a melon. Or in Caravaggio's lyrical and suggestive *Lute Player*, the stem of a swelling pear propped against two figs rests between the pages of the opened music book. Its flutter is caused by no external wind, and it is parted solely to emphasize the visual pun.[49] Such explicit punning is also found in Spanish literature. In an anonymous Golden Age ballad, for instance, an amorous woman cajoles the penis *cum* radish, "Legumbre mia," to enter and cover her divine target with its leafiness.[50]

Compatible with this conceit are the orange and the fish. Fish are notorious for their erotic, particularly phallic, associations.[51] One has to turn only to Quevedo to discover that the lover metaphorically employs "pescado" to connote his sexual desire.[52] Like those of fish, the carnal associations of the orange must have been implanted in the erotic consciousness of the period. In Germany, the

bawdy Hans Sachs envisioned an earthly garden of "Vo-
luptas" with "pomegranates, figs, and oranges."[53] In Spain,
oranges were linked to the carnal excesses of carnival, and
with licentiousness in general, for lascivious women play-
fully hurled the fruit at one another during the celebra-
tions.[54] And in the Spanish version of Alciati, published in
1549, the orange is singled out as the fruit of Venus.[55]

It is likely that Velázquez's substitution of the serving
maid for the grinning adolescent may reinforce a licen-
tious conceit. It was fairly common for such "mozas" to be
viewed as disreputable whores. Spanish proverbs are rich
with references to their ribald behavior.[56] In the *Picara
Justina* we learn that their duties are twofold—serving
wine and servicing the customers. "Be sure one of you
always stands at the door, well equipped, with ornaments
and embellishments; for a beautiful serving girl at the
door of an inn is the best advertisement, especially if she is
near candlelight in the evening."[57]

The tavern is also the setting for the *Musical Trio*, where
the three entertainers can be read as "figuras ridiculas."
Like the other paintings we have considered, this picture
too can be comprehended on a number of levels. Ostensi-
bly we seem to have a realistic record of performers. The
boy seems to have ceased his playing to drink, and the two
older musicians conclude their serenade, emotionally
transfixed by the power of the music. Their guitars are
characteristic of the instruments played by the itinerant
"saltambanchi," described by Covarrubias "con una
guitarra o vihuela de arco cantan alguna canción."[58] The
monkey peering out at us from above the boy's shoulder
may be the typical pet accompanying such wandering
entertainers. In *Don Quixote,* for instance, the wily show-
man Master Pedro roamed the hilly country between
Belmonte and the Sierra de Cuenca with his pet ape.[59]

Indeed, performances by a troupe of the commedia dell'-arte active in Spain in the last decades of the sixteenth century included guitar players and a performing monkey.[60]

Yet the monkey and the ape are beasts with a multiplicity of symbolic associations. From the late Middle Ages, the ape was considered an attribute of the sense of taste, and it appears in this guise in engravings by Crispin de Passe and Marten de Vos as well as in Ripa's famous iconological handbook.[61] Since the monkey in Velázquez's painting seems to be holding a piece of bread in his hand—perhaps aping the boy holding the wine glass—the sense of taste may be at least part of the subject.[62]

On the other hand, such interpretations explain neither the piquant use of the bread and the wine which strategically occupy the center of the table, nor the tavern ambience which suggests the genre of "figuras ridiculas." More appropriate to this type is another kind of monkeyshine, the ape's proclivity toward inebriation. Indeed, the ape appears in prints, paintings, and even popular proverbs as the example of this vice.[63] Cervantes recalls this tradition in *Don Quixote,* where the addled Don advises Master Pedro to get "monkey drunk," a slang expression for a drunken carousal.[64] The staid lexicographer Covarrubias, less inclined to monkey business, nevertheless described the ape's insatiable craving for wine, manifested by "mona alegre," "a tipsy monkey that sings and dances and makes merry with everyone."[65] It is perhaps an excess of wine that is responsible for the lunatic grin which breaks across the simian features of the boy.

The monkey is also a lubricious creature, and tales of its licentious behavior were legion from antiquity through the seventeenth century. The Roman writer Aelian, for instance, referred to rapacious baboons indiscriminately

attacking women and even children. These accounts were
embellished in the Renaissance by scientists such as Con-
rad Gesner and Girolamo Cardano. Indeed, Cardano
noted a wild simian that "loves children and women . . .
and will try openly to cohabitate with the latter. . . ." It is
not surprising that the ape quickly became a paradigm of
sexuality in prints and popular literature.[66] One Spanish
manifestation of this tradition is El Greco's so-called *Span-
ish Proverb*. Here an ape, blowing on coals, appears to be
related to the conceit of "love magic."[67]

Combined with simian sexuality, music is a frequent
companion of lust in Renaissance and Baroque art. Erotic
merry company scenes and numerous bawdy prints relate
how music inspires lubricity.[68] Even Spanish proverbs re-
cord the association of lasciviousness, in this case bawdy
women, with musical entertainers. Thus Correas noted
how they come to a bad end: "A la puta i al juglar . . . les
viene a mal. . . ."[69] Velázquez also informs his painting with
the standard erotic metaphors—bread, wine, and a knife
which penetrates a round cheese. Perhaps in this ribald
pun, Velázquez has painted a visual corollary to the prov-
erb "Ansí es el queso sin corteza, como la doncella sin
verguenza."[70]

I believe that the *Two Men at a Table* is also one of those
ugly subjects which Pacheco considered under the rubric
of "figuras ridiculas." But here Velázquez does not seem to
be interested in sexual metaphors. Instead, he acerbically
chronicles the effects of dissipation upon two picaresque
types. One drinker, unable to sit upright, is already tipsy.
His comrade, dressed in a tattered ocher jerkin, leans
heavily on the bench, requiring support as he soddenly
drains his cup. His bedraggled costume which is even
bursting its seam at the elbow may be another sign of his
inebriation, since this type of ragged dress traditionally is

associated with the vice. The elegant duchess in *Don Quixote,* for example, warns Sancho that a prodigous drinker is often found under such a "mala capa."[71]

The bowl and mortar on the table are overturned and useless, complementing the young drinkers' state of crocked inactivity.[72] The glowing orange, a fruit associated with carnival and its hedonistic excesses, equally embellishes this theme.[73] There is a long pictorial tradition devoted to tippling, and numerous Renaissance and Baroque popular prints and genre paintings depict drinkers in various states of inebriation.[76] These are comic images. Indeed, the Italian theologian-theorist, Cardinal Paleotti, called such pictures of drunkenness and dissipation "pitture ridicole."[75] Comic literature also has delighted in poking fun at drunken immoderation. Perhaps Quevedo's corrosive description of ridiculous besotted Sevillian thugs in *El Buscón* provides its most trenchant Spanish manifestation.[76] Velázquez's picture of the consequences of dipsomania apparently conforms to a popular type and is an entirely suitable subject for a painter of "figuras ridiculas."

The *Old Woman Cooking Eggs* reveals a different theme. With unstinting realism, Velázquez has evoked all the smells and tactile sensations of a humble Spanish kitchen. Pots gleam, fried eggs glisten with a vitreous sheen, and light shimmers over the transparent purple membrane of a pungent onion bulb. Yet there is more to this egg-cooking scene than meets the eye, though its content is not so easy to crack. Indeed, the fascinating egg lore of this age only serves to scramble the interpretation.

To be sure, the emblem book *Ova Paschalia,* published in 1634, portrays a figure cooking eggs as a symbol of hypocrisy. But this is a monk warming his egg by candlelight and only the most agile of iconographers can connect this with Velázquez's painting.[77] And surely the associations of the

egg with the Virgin Mary, hope, or alchemy have nothing to do with the painting.[78] However, the confrontation of a youth with an old woman cooking eggs is a setpiece in two picaresque novels, Alemán's *Guzmán de Alfarache* and Quevedo's *El Buscón*. For Quevedo it is a tiny vignette, almost an aside, as the young Pablos, while cataloguing the flaws of the low cuisine served at the school of the penurious Dr. Goat, described the old blind cook preparing eggs on Friday.[79] But in *Guzmán de Alfarache* we find a far more elaborate and sharply etched image of a youth's encounter with an egg-frying harridan.

I arrived at an inn sweaty, dusty, footsore, sad, and above all with a longing to eat, my teeth sharp and my stomach weak. It was noon. I asked what was there to eat? They told me that they had nothing but eggs. It wouldn't have been so bad if they were plain eggs. But that cunning cook . . . had the leftover hatched eggs mixed in a box with the good ones so as not to lose them. . . . She saw me as a ruddy-cheeked, round-faced, innocent youth. I appeared to her a docile boy and that anything would serve me well enough. She asked me, "From where do you come, sweetie?" I told her I was from Seville. Then coming closer to me she gave me a chuck under the chin and said, "and where are you going, little fool?" Oh God! How with that stinking breath it seemed that I drew old age and all its evils upon me. And then if my stomach had had something in it, it would have been vomited at that point as my guts almost kissed my lips.

I told her that I was going to the court, and that I wished to have something to eat. She made me sit down on a wobbly little bench and on top of a block she placed a baker's long-handled broom and a saltcellar made from the foot of a pitcher, a fragment full of water for chickens, and a halfloaf of bread blacker than her tablecloth. Then she

served an omelet on my plate, which could be called more
appropriately a smear of eggs. The bread, jar, water,
saltcellar, salt, tablecloth, and cook were all the same.[80]

As we have noted already, Velázquez did not use this
passage as a source. But what is important is that Veláz-
quez and Alemán share a common theme and a similar
intention, a juxtaposition of coddled naïveté and hard-
boiled craftiness seasoned with the slightest flavor of eroti-
cism.[81] And this juxtaposition is underscored by the psy-
chological disjunction between the two figures.

Eggs are the appropriate fulcrum for the theme of
initiation. Not only are eggs a part of the youthful Guz-
mán's awakening, but also in *Don Quixote* a young novice is
given two eggs by the wily shameless Teresa Panza.[82]
Spanish proverbs also communicate this idea. For Correas,
"Lo nuevo"—the new, and in our case the youth—should
receive an egg.[83] Since one aspect of youthful initiation is
sexual, Velázquez may suggest a subcurrent of eroticism in
his depiction of a glimmering flagon of wine, the shadow
of the knife penetrating the dish, and by the visual pun of
the erect pestle in the mortar.[84] Covarrubias also reminds
us that women used onions when they wished to move
men to tenderness.[85]

Actually, the theme of the initiation of youth and its
attendant consequences is part of the collective cultural
consciousness of the era. Found in both literature and the
visual arts, it is a recurrent subject in the picaresque novel
as well as in prints and paintings.[86] In a print after Rubens,
dated 1620 (fig. 35), for example, the message is expressed
through the contrast of an apple-cheeked boy and a wiz-
ened crone who holds a wicker basket and a candle.
Echoing the authority of Lucretius, an inscription reads:

Quis vetet apposite lumen de lumine tolli?
Mille licet capiant deperit inde nihil.
Who is going to forbid light to be taken
 from the light that is placed near?
Even though one can take a thousand times
 nothing can extinguish it.

Here the torch is literally passed from one generation to the next, but the enlightenment is bittersweet, since the flame of knowledge and experience glistens with greed and lust.[87]

Another type of kitchen scene is portrayed in the *Servant*. There is no less emphasis on tactile sensations, and even in the painting's lamentably deteriorated and abraded state, one can still discern Velázquez's delight in depicting the smooth glazes on the pitchers and the burnished metal of the mortar and pestle. But it is unlikely that Velázquez merely is recording a glimpse of kitchen low life, even though in the Golden Age it was not unusual to find Moors working at simple kitchen tasks.[88] Because of the Hispanic antipathy towards Moors, who were considered lazy, lubricious, and figuratively subhuman, it is fair to say that the painting may be at least a document of Spanish prejudice.[89] Indeed, Velázquez's depiction of the Moor reinforces this conceit, as he seems to create a paradigm of the lazy black. The Moor stares blankly at her tilted brass pot. Her head down, her hand inertly resting on the table, she seems to require a transfusion of energy to move the pitcher. This critical attitude toward the Moor is more readily apparent in his variant, the *Supper at Emmaus*. Here Velázquez depicted an obvious symbolic contrast between Christ's divine revelation to his disciples and the oblivious Moorish servant surrounded by her

lowly jugs and bowls. Moorish inability to accept the tenets of Christian faith was axiomatic. Quevedo, for instance, mercilessly lampooned their distorted heretical concept of Christianity in *Confesión de los Moriscos*. The entire "confession" is replete with linguistic blunders: saints Pedro (Peter) and Pablo (Paul) are transformed into Perro (Dog) and Palo (Stick), and the Moors, substituting "pestilencia" (pestilence) and "pescados" (fish) for "penitencia" (penitence) and "peccados" (sin), pray for Jesus to deliver them.[90] Moorish infidelity is also a theme of popular proverbs in the Golden Age. In Correas, for instance, we discover that Moors are equivalent to dogs; their souls are unredeemable and they die without the benefit of the sacraments: "A moros . . . los llaman (perros) porque no tienen leike salve el alma; mueren como perros sin sacramentos."[91]

Ultimately it is the sacrament—its affirmation by Christ and its denial by the Moor—which is central to Velázquez's iconography. The church viewed the supper at Emmaus as an example of the presence of Christ in the Eucharist. Thus, in the *Evangelical Historiae Imagines*, by the Jesuit Geronimo Nadal, the supper at Emmaus, like the Last Supper, was an antetype of the Mass itself with Christ distributing broken bread to the disciples.[92] Surely it is not fortuitous that Christ breaks bread in Velázquez's painting. Nor is it accidental that the Moor wears a cap. Her head remains covered, which alludes to her ignorance of and exclusion from Christ's divinity, and thus relates to the equally unaware figures in *Supper at Emmaus* scenes by Caravaggio, Moretto, Romanino, Titian, and Veronese.[93]

The humble crockery on the table is yet another side of the polarity between the sacred and profane. Covarrubias reminds us that there is a clear distinction between modest kitchenware and consecrated vessels, which is comparable

to the difference between the sinner and the sanctified. "There are vessels that are served to us in mass from credences, and these are called vessels of honor. Other beakers are for the kitchen and unclean things, and these are contemptible and retired from the presence of the Lord. These (vessels) are similar to the souls of the righteous and those of sinners."[94] Covarrubias concludes with a reference to the second chapter of St. Paul's second epistle to Timothy: "But in a great house there are not only vessels of gold and silver, but also of wood and of earth; and some to honor and some to dishonor. If a man therefore purge himself from these, he shall be a vessel unto honor, sanctified and meet for the master's use, and prepared unto every good work."

The contrast between the miraculous and the mundane was not new. In the late sixteenth and early seventeenth century, Aertsen and Beuckelaer frequently exploited this device.[95] Indeed, a *Way to Emmaus* by an anonymous follower of Aertsen depicts the antithesis between Christ and the licentious activities of the servants.[96] But more accessible to Velázquez were prints such as Matham's *Supper at Emmaus* and paintings from Bassano's atelier. Matham overtly contrasts the worldly, gross kitchen with its bloated fish in the foreground and the shining presence of Christ in the background. In Leandro Bassano's *Market Scene* (fig. 36) in Vienna, for example, the Queen of Sheba and her retinue proceed with stately grace in the midground, whereas the foreground is given over to the activities of fishmongers. Or in the *Prodigal Son,* a collaborative work by Jacopo and Francesco Bassano now in the Doria Gallery, the clutter of servants washing and cooking—one even flays a carcass—is contrasted with the moving acceptance of the wayward sinner in the midground.

Yet Velázquez need not have looked beyond Spanish art for this iconographic device. Orrente, for example, in his

Blessing of Jacob, recalls Bassano's methods, crowding the foreground with a still life and presenting the religious scene in the midground. The idea of contrast to heighten an effect is also common in the literature of the Golden Age. *Don Quixote* is a novel of obvious contrasts—Sancho is fat and pragmatic, the Don, lean and idealistic. And antithesis and inversion are major elements in Quevedo's style.[97] For instance, in the corrosive *Sueño del infierno,* written in 1608, the truly devout are set against the impious.[98]

Velázquez employed a similar device in the *Kitchen Scene with Christ in the House of Mary and Martha.* This story, appropriate for a painter of kitchen paraphernalia, invokes the harried bustle of serving maids. But there is also a profound morality in this tale of kitchen drudgery. Thus for the learned theologian of the Golden Age, Malon de Chaide, the episode was a paradigm of forgiveness and charity.[99] It is also a story which lends itself to the device of juxtaposition, since Christ himself expressed his clear preference for the spiritual rather than the materialistic, as recorded in Luke 10:40–42.

> But Martha was cumbered about much serving and came to him and said Lord dost thou not care that my sister hath left me to serve alone? Bid her therefore that she help me.
> And Jesus answered and said unto her Martha, Martha, thou art careful and troubled about many things:
> But one thing is needful: and Mary hath chosen that good part, which shall not be taken away from her.[100]

As in the *Supper at Emmaus,* Velázquez contrasted the everyday affairs of the kitchen in the foreground with Christ, who appears in the background as the benevolent

teacher with the rapt Magdalene at his feet. An exasperated Martha seems to remonstrate with Christ about Mary's apparent sloth, and thus she serves as a bridge between this lofty, spiritual plane and the mundane realm of the truculent kitchen servant. It is clear that this sulking maidservant is the very antithesis of domestic virtue. Indeed, she exemplifies the type of bad housekeeper condemned in the widely read *La perfecta casada,* written by the lyric poet Luis de León in 1583. Her large and pendulous earrings, an excess vilified by Fray Luis as immodest, are but one sign of her impropriety.[101] For the bad housekeeper "everything turns to gall and wormwood."[102] On the contrary, the good housekeeper finds "her satisfaction in industry."[103] An old woman points to the pouting servant, perhaps to reinforce the message that one should cheerfully serve the Lord. Here we are reminded of St. Paul's admonition (Colossians 3:22–24): "Servants, obey in all things your masters. . . . And whatsoever ye do, do it heartily, as to the Lord, and not unto men . . . for ye serve the Lord Christ."[104]

The *Water Carrier,* the last of Velázquez's Sevillian pieces, a special painting taken as a gift to his friend and protector, the learned humanist Fonseca, is an exemplification of the symbolic and metaphoric concerns which inform Velázquez's early works. Velázquez's grave and dignified figure, his maguslike face webbed with wrinkles, departs from water carriers found in contemporary literary descriptions, for these characters are rough and surly, quicker to come to blows than to dispense their water. For example, the notorious rogue and swindler Lazarillo de Tormes, prospered as a water carrier.[105] Or in Cervantes' exemplary novel, *La ilustre fregona,* the truculent water carriers battle and scream.[106] The moralist Diego Gracián associated them with pimps; and Quevedo, with character-

istic pungency, derided an "aguador" as a ragged scoun-
drel.[107] Similarly, an example in the visual arts, a print in
the series of *Cris de Paris* (fig. 37) by Abraham Bosse,
emphasizes the shabbiness and intemperance of the water
carrier. The inscription boldly proclaims his allegiance to
guzzling wine.[108]

Nor is it likely that the *Water Carrier* is an image of
"genre pur," a matter-of-fact portrayal of a well-known
figure in Seville called "El Corzo," whom Justi claimed was
a familiar local tradesman.[109] To be sure, the inventory of
El Buen Retiro palace taken in 1701 referred to the paint-
ing as a portrayal of "El Corzo."[110] But "El Corzo de
Sevilla" was actually a famous and rich merchant. Indeed,
as the archetype of the wealthy businessman, he became
the subject of a number of aphorisms recorded by Cor-
reas. "Also 'El Korzo' is a proverb that refers to some one
very rich. 'Es un Korzo de Sevilla:' 'Es más rriko ke el
Korzo.' "[111] Correas even published a minibiography of "El
Korzo": "He was a native of Corsica, and in Seville he
prospered with voyages to the Indies without ever losing
anything at sea."[112] "El Corzo," in fact, seems to be a
sobriquet applied to any wealthy person. Thus, in
Gongora's "comedia" "Las firmezas de Isabela," the
wealthy Toledan merchant Fabio is called "El Corzo de
Toledo."[113] Clearly, Velázquez did not portray a shipping
tycoon, yet his water carrier possesses both gravity and
heroic dignity. Such a depiction may parallel emerging
ideas ennobling the common man and his humble labor.
In fact, during the first three decades of the seventeenth
century, a consistent effort was made to extol the virtues
of the underclass.[114] Pedro Fernández Navarrete, the cha-
plain to Philip IV, declared the laborer the backbone of
Spain and argued for special privileges on his behalf.[115] In
Los bienes del honesto trabajo, published in 1614, Pedro de

Guzmán, counsel of the Holy Office, glorified work, even the humblest laborer's task. For Guzmán, work fed virtue and men even can profitably "drink from the work of their hands."[116] Spanish playwrights, too, consciously attempted to elevate the common laborer. In Lope de Vega's *El villano en su rincón,* for instance, the humble sage, Juan Labrador, proclaims that the true kings are those who work with their hands. "I am a king Feliciano in my little corner; they are kings that live from the work of their hands."[117]

Inextricably tied to the noble portrayal of the common man is the doctrine of "limpieza de sangre." This is an unhappy chapter in Spanish history. Although the Jews were expelled from Spain in 1492, there was a lingering, malignant doubt that the expulsion was not complete. Throughout the seventeenth century the Inquisition continued to discover Jews, sometimes in astonishing numbers. In Seville, for example, forty-two were unmasked at an *auto de fe.* The suspicion that Jewish blood coursed through the veins of the upper class was very real in the seventeenth century. It was the working class which presumably was untainted by Jewish blood.[119] As true "old Christians" they could boast rightfully of the dignity of a "hidalgo." In Tirso de Molina's *La villana de la sagra* of about 1612, for example, we are told that the simple laborer "possesses purity *[limpieza]* and valor."[120] And in Tirso's *La Santa Juana I,* the humble worker Juan Vasquez is described as "honorado y cristiano viejo."[121]

The social context may explain in part why Velázquez chose to portray such a humble workman in such a noble way. But by now we are accustomed to viewing Velázquez's paintings in terms of multivalent meanings, and the *Water Carrier* is no exception.[122] Even the fig in the glass can be interpreted in more than one way. Figs were used to

freshen water, and it was common as well, as Correas tells us, to drink water with figs.[123] But figs were also an emblem of conscientious labor.[124] And in Valeriano's *Hieroglyphica* we read that figs reveal "graciousness among men."[125]

I suggest that the *Water Carrier* can be interpreted as a paradigm of benevolence. Indeed, the water carrier seems to have already poured the precious gift of water into a chalicelike glass. A water carrier depicted in Montenay's *Emblémes ou devises chrestiennes* (fig. 38) transcends his shabby ragged costume with a similar ceremonial grandeur.[126] Here, he serves as the archetype of Christ's admonition, recorded in Luke 6, to offer love. Velázquez's water carrier, unlike Montenay's figure, does not give comfort to an enemy. But the text of Luke 6, which serves as the emblem's point of departure, is redolent with the sanctity of giving. Thus in 6.30 we read, "Give to every man that asketh of thee," and in 6:35, "do good, and lend."

Whether or not Velázquez knew that a water carrier was associated with the emblematic concept of benevolence remains uncertain. But surely one can assume that he was familiar with stoic ideas concerning water and generosity. One finds these associations in both literature and the visual arts. Quevedo, for instance, wrote poignantly about gaining God's merciful love with the simple act of giving a glass of water to one who thirsts. And the moralist Damian de Vegas wrote of the promise of the reward of heaven "to one who would give a glass of water to his fellow man."[127] In Seville itself, the idea of giving a drink of water as an act of beneficence finds a brilliant portrayal in Murillo's *Moses Striking the Rock*, painted for the Hospital of Charity.[128] And, of course, the giving of a drink of water to sate the thirsty is an essential part of the iconography of the Seven Acts of Mercy. In fact, Velázquez's painting, which emphasizes the presentation of the chalicelike cup to the youth,

may contain a faint echo of this iconography. Didron's seminal study on the theme of the Acts of Mercy demonstrates that this specific act of charity was directed to the young.[129] And in Teniers's depiction of the Seven Acts of Mercy it is a youth in the center of the picture who slakes his thirst.

But ultimately Velázquez seems to be responding to stoic ideas concerning water and generosity. Not only were Seneca's works widely translated in Spain (the Duke of Alcalá, one of Pacheco's supporters, was the patron of an edition of the *Moral Essays*), but the great modern interpreter of Stoic philosophy, Justus Lipsius, was in constant contact with Spanish humanists.[130] In fact, in a letter written in 1593, the Sevillian humanist Benito Arias Montaño lauded Lipsius and included among his Sevillian disciples Canon Pacheco, the uncle of Velázquez's teacher, Francisco.[131] It is clear that many other Sevillians also were keenly interested in Stoic philosophy. Olivares, Velázquez's great benefactor in Madrid, was among them, as the dedication of Navarrete's *Siete libros de L. A. Seneca* demonstrates.[132] And it is likely, since a portrait of Lipsius hung in his collection, that Fonseca, Velázquez's first protector in Madrid, was also an adherent of Senecan philosophy.[133] A reading of Seneca's long tract on benefaction and gratitude, *De beneficiis,* reveals not only the importance, even the grandeur, of water, but also its association with generosity. Seneca explicitly used the offering of a drink of water as a metaphor of generosity. Thus it was clearly beneficial and virtuous to give water "to a man when he is parched with thirst. . . ."[134] Indeed, for Seneca, simple water was worth as much as the most ostentatious of gifts: ". . . plain water given at the right time serves as a remedy, so a benefit no matter how trivial and commonplace it may be . . . gains much in value and wins more gratitude than a gift that, though costly, has been laggard. . . ."[135] Yet the

metaphoric use of water and its benefits for acts of generosity is not found only in antiquity. The brilliant philosopher Justus Lipsius also used the metaphor. In a letter to the Sevillian theologian Benito Arias Montano, Lipsius effusively praised his "corazón bueno y generoso" and compared the Sevillian's gracious magnanimity to "agua abundante."[136]

Giving and receiving thus seem central to Velázquez's picture. True liberality transcended social class, for Seneca wrote, "Nature bids me do good to all mankind."[137]

In this light we must return to the court inventory of 1701. Surely it is erroneous to interpret literally the reference to "El Corzo." But the simple inventory statement does suggest the meaning of the picture, for the proverbial "Corzo" was well known for his "good and compassionate deeds."[138] Thus it was not the Corsican businessman that Velázquez had in mind, but the ideal that "El Corzo" embodied. Velázquez's splendid "Water Carrier," as well as his early religious scenes *cum* genre pieces, the bawdy taverns or the pictures that reflect antique and emblematic conceits, all require an "agudeza," an acuity of mind to read the image properly. Indeed, like their great literary equivalent, Cervantes' sprawling *Don Quixote*, these paintings are informed with a rich lore of proverbial references and are redolent with multiple meaning. Velázquez's juvenilia are a vibrant visual testimony to the "carcel dorada" and the Golden Age which enclosed it.

Notes

1. A Palomino, *El museo pictórico y escala óptica* (1724), ed. M. Aguilar (Madrid, 1947), 893.
2. R. Caro, *Días geniales o lúdicros*, ed. Jean Pierre Etienvre

(Madrid, 1978), 2:258. For Caro's life and works see Ibid., 1:ix–cvii. Cf. also J. Brown, *Images and Ideas in Seventeenth-Century Spanish Painting* (Princeton, 1978), 35–37.

3. Brown, *Images and Ideas,* 38.

4. For the ceiling see Ibid., 77–80.

5. Ibid., 27.

6. The literature on the iconography of genre painting is growing. Important contributions include: E. de Jongh, *Zinne en minnebilden van de zeventiende eeuw* (Amsterdam, 1967); D. Posner, "Caravaggio's Homo-erotic Early Works," *Art Quarterly* 34 (1971):301–24; B. Wind, "Pitture Ridicole: Some Late Cinquecento Comic Genre Paintings," *Storia dell'Arte* 20 (1974):25–35; and B. Wind, "Annibale Carracci's *Scherzo:* The Christ Church *Butcher Shop,*" *Art Bulletin* 68 (1976):93–96; S. Alpers, "Realism as a Comic Mode: Low-life Painting Seen through Bredero's Eyes," *Simiolus* 8 (1976):115–42; H. Miedema, "Realism and Comic Mode: The Peasant," *Simiolus* 9 (1977):205–19; E. de Jongh, *Tot lering en vermaak* (Amsterdam, 1976); E. de Jongh et al., *Die Sprache der Bilder* (Braunschweig, 1978); and most recently P. Sutton, *Dutch Genre Painting* (Philadelphia, 1984).

7. *Natural History* 35:66, in *The Elder Pliny's Chapters on the History of Art,* ed. K. Jex-Blake and E. Sellers (Chicago, 1968), 111.

8. F. Pacheco, *Arte de la pintura,* 1:457, 2:138.

9. In his self-portrait in *Las Meninas,* painted at the apogee of his career, Velázquez once more emulates an ancient artist. The palette he holds contains black, yellow, red, and white, the colors that Apelles used in his immortal works. See Pliny, *Nat. Hist.* 35:50, in K. Jex-Blake and E. Sellers, 97. For further associations with Apelles see M. Kahr, *Velázquez: The Art of Painting* (New York, 1976), 133–35, and J. Brown, *Images and Ideas,* 93–94.

10. Caro, *Días geniales,* 1:lxxix.

11. Pacheco, *Arte de la pintura,* 2:135.

12. Ibid., 136. For antique painters of comic themes see my unpublished doctoral dissertation, "Studies in Genre Painting: 1580–1630," New York University, 1973, 1.

13. Pacheco, *Arte de la pintura,* 136.

14. Kahr *(Velázquez,* 19) views the painting's still life as a contrast between the bestial (knife, mussels, turnip) and the spiritual (bread, wine, and pomegranate). J. Moffit in his review of Kahr's book *(Art Journal* 38 [1979]:214) considers the painting to be a representation of the *Supper at Emmaus.* Cf. also J. Moffit, "Observations on Symbolic Content in Two Early *Bodegones* by Diego Velázquez," *Boletín del Museo e Instituto Camón Aznar* 1 (1980):82–95.

15. G. Fernandez de Oviedo, *Las quinquagenas de la nobleza de España* (early 16th Century; Madrid, 1880), 183.

16. J. de Mal Lara, *Filosofía vulgar* (1568), ed. A. Villanova (Barcelona, 1958), 2:142.

17. L. de Góngora, *Obras completas,* ed. J. Mille y Giménez and I. Mille y Giménez (Madrid, 1961), 859. See also B. Alemany y Selfa, *Vocabulario de las obras de don Luis de Góngora y Argote* (Madrid, 1930), 723.

18. On the erotic significance of wine see B. Wind, "Vincenzo Campi and Hans Fugger: A Peep at Late Cinquecento Bawdy Humor," *Arte Lombarda* 47/48 (1977):112 n. 13 and 113 n. 21.

19. Juan Ruiz, *Libro de buen amor,* ed. M. Criado de Val and E. W. Naylor (Madrid, 1965), Copla 296, 77.

20. L. Dantisco, *Destierro de ignorancia* (Barcelona, 1592), 19.

21. Wind, "Annibale Carracci's *Scherzo,"* 95 n. 10, and "Vincenzo Campi and Hans Fugger," 112 n. 13.

22. Juvenal, *Satires* VI, Loeb Classical Library (London, 1957), 107.

23. Reproduced and discussed in C. de Tolnay, *The Drawings of Peter Brueghel the Elder* (New York, n.d.), pl. 28, 68.

24. For more on mussels see Wind, "Annibale Carracci's *Scherzo,"* 93 n. 6.

25. S. de Covarrubias, *Tesoro de la lengua castellana o española,* (1611), ed. M. de Riquer (Barcelona, 1943), 97.

26. F. Arce Beneventano, *Adagio y fabulas* (1533), ed. T. Trallero Bardaji (Barcelona, 1950), 185.

27. *Poesía erótica,* ed. J. Díez Borque (Madrid, 1977), 171, 198.

28. F. de Quevedo y Villegas, *Obras completas,* ed. F. Buendia (Madrid, 1964), 2:313.

29. M. Criado del Val, "Antifrasis y contaminaciones de sentido erótico en *La lozana andaluza*," *Homenaje a Dámaso Alonso* (Madrid, 1960), 1:436, 438.

30. On this collar see R. M. Anderson, "The Golilla, A Spanish Collar of the 17th Century," *Waffen und Kostumkunde* 11 (1969): 3, 5 fig. 7.

31. G. Correas, *Vocabulario de refranes y frases proverbiales* (1627), ed. L. Combet (Bordeaux, 1967), 76, 184.

32. A. López Pinciano, *Philosophia antigua poética* (1596), ed. A. C. Picazo (Madrid, 1953), 3:76–77.

33. Wind, "Annibale Carracci's *Scherzo*," 93–96.

34. Wind, "Vincenzo Campi and Hans Fugger," 108–14.

35. B. W. Meijer, "Niccolo Frangipane," *Saggi e Memorie de Storia dell'Arte* 8 (1972):165, 175.

36. S. Slive, *Frans Hals*, vol. 1 (London, 1970), 34–36.

37. The obscene significance of the meat market is of course discerned in Carracci's comic *Butcher Shop*; see Wind, "Annibale Carracci's Scherzo," 93–96. Meat held similar connotations in Spain. In Cervantes' *Coloquio de Cipión y Berganza* for example, butchers are notorious for their association with loose women *(Obras completas*, 2:216). And Quevedo referred to a house of prostitution on Francos street as a butcher shop. See J. Deleito y Piñuela, *La mala vida en España* (Madrid, 1967), 46.

38. *The Celestina*, trans. L. B. Simpson (Berkeley and Los Angeles, 1955), 108.

39. P. W. Bomli, *La femme dans l'Espagne du siècle d'or* (The Hague, 1950), 343. Cf. ibid., 344–45 for other accounts of Spanish brothels.

40. For a history of Inquisition censorship practices see H. C. Lea, *A History of the Inquisition in Spain* (New York, 1922), 3:480–546.

41. J. Puyol, ed. (Madrid, 1912), 2:270–71.

42. Deleito y Piñuela, *La mala vida en España*, 38.

43. *Poesía erótica*, ed. J. Diez Borque, 23.

44. M. Alemán, *Guzmán de Alfarache* ed. S. Gili y Gaya (Madrid, 1942), 2:vi, 86–89.

45. J. Puyol, ed., 2:281–82.

46. *Poesías de Baltasar del Alcázar* (Seville, 1856), 64–67. Two paintings of a man making the vulgar gesture "dar higa," attributed to Loarte, but to my mind without solid foundation (see A. Mendez Casal, "El Pintor Alejandro Loarte," *Rivista Española de Arte* 4 (1934):190–91, pl. 3 show that anonymous Spanish masters continue a penchant for vulgar sexuality beyond Velázquez.

47. 2:85, 104–5.

48. According to Haraszti-Takács *(Spanish Genre Painting,* 89–90, 96), however, the many copies extant of Velázquez's more raucous *bodegones* suggest that the pictures were on public display as signboards or on walls in hostels and therefore easily accessible. But the plethora of copies of Caravaggio's *Card Sharps* (Moir, *Caravaggio and his Copyists,* 105–7), painted for Cardinal del Monte, indicates that genre paintings can be copied even when sequestered in private collections. Conversely, Carracci's *Butcher Shop,* which Haraszti-Takács (ibid., 55) suggests was also a signboard, was not copied.

49. On Caravaggio's erotic works see D. Posner, "Caravaggio's Homo-erotic Early Works," 301–24.

50. *Poesía erótica,* ed. J. Diez Borque, 119.

51. Wind, "Vincenzo Campi and Hans Fugger," 108 n. 7.

52. C. Cela, *Diccionario secreto* (Madrid, 1975), 2:401.

53. W. Theiss, *Exemplarische Allegorik* (Munich, 1968), 85.

54. J. C. Baroja, *El carnaval* (Madrid, 1965), 67 n. 2; H. Mérimée, *Spectacles et comédiens à Valencia (1580–1630),* (Toulouse and Paris, 1913), 92.

55. *Los emblemas de Alciati* (1549; Madrid, 1975), 228. Cf. also Cervantes, *Don Quixote* 1:xxxii *(Obras completas,* 1170) on lascivious goings-on under an orange tree.

56. G. Correas, *Vocabulario de refranes y frases proverbiales,* 120, 340.

57. Puyol, ed., 1:103. On candles and prostitution see B. Wind, "Close Encounters of the Baroque Kind," *Studies in Iconography* 4 (1978):122. It is obvious that the now lost *Luncheon,* known only from its various copies, contains a similar salacious content. In addition to the familiar sexual conceits—bread, wine, mussels, a knife, and a turnip—Velázquez adds a lemon, a

fruit which Góngora wittily and lasciviously characterized. See *Poesía erótica,* ed. J. Diez Borque, 198.

58. Covarrubias, *Tesor de la lengua castellana,* 433.

59. 2:25, *Obras completas,* 1358–62.

60. N. D. Shergold, "Ganassa and the 'Comedia dell'Arte' in Sixteenth Century Spain," *Modern Language Review* 51 (1956):362.

61. H. W. Janson, *Apes and Ape Lore in the Middle Ages and the Renaissance* (London, 1952), 240–41, 255 n. 13.

62. Ibid., 255 n. 15.

63. Ibid., 246–48.

64. 2:25, *Obras completas,* 1366.

65. Covarrubias, *Tesor de la lengua castellana,* 811.

66. Janson, *Apes and Ape Lore,* 261–86.

67. Ibid, 283 n. 73.

68. See A. P. Mirimonde, "La musique dans les allégories de l'amour," *Gazette des Beaux Arts* 69 (1967):326–28, idem, "Le symbolisme musical chez Jerome Bosch," *Gazette des Beaux Arts* 77 (1971):22–25.

69. Correas, *Vocabulario de refranes,* 7.

70. Ibid., 53. Cheese had a variety of sexual implications in the slang of the period with particular reference to copulation. See Wind, "Vincenzo Campi and Hans Fugger," 112. The motif of the knife sticking into cheese is also used in Dosso Dossi's ribald so-called *Allegory of Hercules.* For the erotic implications of this painting see Wind, "Vincenzo Campi," 112 n. 14. It is interesting to note that around 1620 the Dutch painter Buytewech depicted a scene similar to Velázquez's picture. Like Velázquez, Buytewech included an ape, a musician, and a youth lifting a wine glass. E. Haverkamp-Begemann *(Willem Buytewech* [Amsterdam, 1958], 69–70 and fig. 108) noted that the painting may be an allegory of the senses and a moral commentary on excess.

71. 2:xxxiii, *Obras completas,* 1391.

72. Velázquez returned to the theme of drunken inertia in his portrait of the court fool Calabazas now in the Prado. The jester is posed with one leg locked under the other, and his hands

tightly clenched. His face is creased with a foolish grin, and his eyes are clouded. A glass of wine sits at his feet, doubtless the cause of his torpor.

73. Baroja, *El carnaval*, 67 n. 2.

74. B. Wind, *"Studies in Genre Painting: 1580–1630,"* 71–76.

75. B. Wind, "Pitture Ridicole," 29–30.

76. 2:x, *Obras completas*, ed. F. Buendia (Madrid, 1961), 2:347.

77. On this treatise see G. Richard Dimmler, "The Egg as Emblem: Genesis and Structure of a Jesuit Emblem Book," *Studies in Iconography* 2 (1976):85–106.

78. On egg symbolism see Maria Lioba-Lechner, "Ei," *Reallexikon zur deutschen Kunstgeschichte*, vol. 4 (Stuttgart, 1958), 893–903.

79. 1:iii, *Obras completas*, 1:295.

80. M. Alemán, *Guzmán de Alfarache*, 1:iii, 108–10.

81. For this theme in *Guzmán* see T. Hanrahan, *La mujer en la novela picaresca de Mateo Alemán* (Madrid, 1964), 99.

82. 2:1, *Obras completas*, 1447.

83. Correas, *Vocabulario de refranes*, 42.

84. On the erotic significance of the mortar see M. Criado del Val, "Antifrasis y contaminaciones de sentido erótico en *La lozana andaluza*," 448.

85. *Tesor de la lengua castellana*, 397. For further associations of onions with sexuality see Wind, "Vincenzo Campi and Hans Fugger," 113 nn. 21, 22.

86. Cf., for example, *Lazarillo de Tormes*, 1:76–107, where the innocent Lazarillo living "como niño"—like a child—is introduced to the wonders, terrors, and deceits of the world by an aged docent.

87. H. Evers, *Rubens und seine Werk* (Brussels, 1943), 234. Cf. also a print by an anonymous Caravaggist depicting a deceived youth. An admonishing inscription proclaims: "Fur demon mundus (senex fraudemque caro parat inventae) tria sunt haec fugienda viro." "Theft, the devil, worldliness (the old prepare these deceits for the young) are the three things that mankind must flee." See J. Pierre Cuzin, *La diseuse de bonne aventure de Caravage* (Paris, 1977), 28–29.

88. Cf., for example, the black servant described in Cervantes' *El celeso extremeño* (*Obras completas,* 906–7).

89. On Spanish antipathy to Moors and Moriscos, see L. Combet, *Recherches sur le "refranero" castillan* (Paris, 1970), 270.

90. *Obras completas,* 1:101.

91. *Vocabulario de refranes,* 13.

92. C. Scribner, *"In Alia Effigiae:* Caravaggio's London *Supper at Emmaus," Art Bulletin* 59 (1977):378–9.

93. Ibid., 376.

94. *Tesor de la lengua castellana,* 995. Cf. a similar sentiment in Malon de Chaide, *La conversión de la Magdalena* (1588; Madrid, 1947), 2:42.

95. See B. Wind, "Annibale Carracci's *Scherzo,"* 93, and J. A. Emmens, " 'Eins aber ist nötig.' Zu Inhalt und Bedeutung von Markt und Küchenstücken des 16. Jahrhunderts," *Album Amicorum J. G. Van Gelder* (The Hague, 1973), 91–103. But for an alternative view see K. Moxey, "The 'Humanist' Market Scenes of Joachim Beuckelaer: Moralizing Exempla or 'Slices of Life,' " *Jaarboek van het Koninklijk Museum voor Schone Kunsten—Antwerpen* (1976), 109–86.

96. A. Grosjean, "Toward an Interpretation of Pieter Aertsen's Profane Iconography," *Konsthistorisk Tidskrift* 43 (1974):121–43.

97. D. Bleznick, *Quevedo* (New York, 1972), 94–100.

98. *Obras completas,* 1:157.

99. *La conversión de la Magdalena,* 3:xlvi, 65.

100. Cf. Moxey, "The 'Humanist' Market Scenes of Joachim Beuckelaer," 149–50, on the traditional treatment of contrast in this theme.

101. Luis de León, *The Perfect Wife,* trans. A. P. Hubbard (Denton, Tex., 1943), 11:52.

102. Ibid., 1:9.

103. Ibid., 8:41. Cf. also Francisco Santos's criticism of lazy servants recorded in Bomli, *La femme dans L'Espagne du siècle d'or,* 194.

104. For this interpretation see G. Kubler and M. S. Soria, *Art and Architecture in Spain and Portugal and Their American Domin-*

ions 1500–1800 (Baltimore, 1969), 254. Jonathan Brown has informed me that Leo Steinberg in a recent lecture provided an alternative interpretation of the picture, viewing it as an allegory of temperance.

105. 6:253.

106. *Obras completas,* 929–30.

107. *Diccionario de la lengua castellana* (Madrid, 1726), 1:127.

108. N. Villa, *Le XVII^e siècle vu par Abraham Bosse* (Paris, 1967), pl. 91.

109. C. Justi, *Diego Velázquez und sein Jahrhundert* (Bonn, 1922), 1:139.

110. J. López-Rey, *Velázquez: A Catalogue Raisonne' of his Oeuvre* (London, 1963), 163.

111. *Vocabulario de refranes,* 111.

112. Ibid.

113. *Obras completas,* 731.

114. N. Salomon, *Recherches sur la théme paysan dans la "Comedia" au temps de Lope de Vega* (Bordeaux, 1965), 780–842.

115. Ibid., 203.

116. *Los bienes del honesto trabajo* (Madrid, 1614), 53, 58–59.

117. Salomon, *Recherches sur la thème paysan,* 266.

118. On the Jewish question see M. Herrero-García, *Ideas de los españoles del siglo XVII* (Madrid, 1928), 611–14.

119. Salomon, *Recherches sur la thème paysan,* 819–31.

120. Ibid., 830.

121. Ibid.

122. L. Steinberg, "The Water Carrier of Velázquez," *Art News* 70 (1971):54, and J. Gállego, *Velázquez en Sevilla* (Seville, 1974), 132, suggest that the painting is a scene depicting the three ages of man. For Steinberg the passing of the cup from the water carrier to the youth is a metaphoric equivalent for the passing of knowledge from one age to the next. To be sure, there are three men of differing ages, but I know of neither a visual nor a literary tradition which connects water with the ages and with the ritual of youthful initiation.

123. López-Rey, *Velázquez,* 163; Correas, *Vocabulario de refranes,* 427.

124. G. de Tervarent, *Attributs et symboles dans l'art profane, 1450–1600* (Geneva, 1958), 181.

125. Moffit, review in *Art Journal* 38 (1979):214.

126. G. de Montenay, *Emblèmes ou devises chrestiennes* (1571), ed. C. N. Smith (Yorkshire, 1973), 73.

127. For the sentiments of Quevedo and Vegas see M. J. Salas, *Historia de la assistencia social en España en la edad moderna* (Madrid, 1958), 67–68.

128. On Murillo's painting see D. Angulo Iñíguez, *Murillo, su vida, su arte, su obra* (Madrid, 1981), 2:78.

129. M. Didron, "Les oeuvres de miséricorde," *Annales Archéologiques* 21 (1861):199.

130. H. Ettinghausen, *Francisco Quevedo and the Neo-Stoic Movement* (Oxford, 1972), 9–13, and A. Ramírez, *Epistolario de Justo Lipsio y los españoles* (St. Louis, 1966), 8–22.

131. Ramírez, *Epistolario*, 73.

132. K. Blüher, *Seneca in Spanien* (Munich, 1969), 324.

133. J. López Navio, "Velázquez tasa los cuadros de su protector D. Juan de Fonseca," *Archio Español de Arte* 34 (1961):65.

134. *On Benefits* 3.8 in *Moral Essays*, vol. 3 (Loeb Classical Library, 1925), 143.

135. Ibid., 2.2.55.

136. Ramírez, *Epistolario de Justo Lipsio*, 56–57.

137. *On the Happy Life* 24, in *Moral Essays*, vol. 2 (Loeb Classical Library, 1925), 163.

138. Correas, *Vocabulario de refranes*, 111. When this chapter was completed, my attention was called to "Image and Meaning in Velázquez's Water Carrier of Seville," *Traza y Baza* 7 (1979):5–23. Moffit also discusses the emblematic character of the painting, considering the work as an illustration of prudence and good counsel with personal reference to Velázquez within Pacheco's studio. I will not belabor the chain of assumptions that brought Moffit to these conclusions. To be sure, the dignity of the water carrier certainly is an aspect of prudence, but regrettably Moffit does not discuss the relationship of the painting to Fonseca or the implications of "El Corzo."

5

Excursus: Imitators and Innovators

THE *WATER CARRIER* IS MOST LIKELY VELÁZ-
quez's last genre picture. When Velázquez left the dusty
streets of Seville to be the first painter to tight-lipped
Philip IV in 1623, it was the portrait, and particularly the
portrait which catered to the narcissism of power, that
superseded all. Indeed, the portrait held a central place in
court aesthetics, its exalted position heralded by none
other than the great court playwright Calderón. Thus in
Calderón's *Dar lo todo y no dar nada* the three portraitists of
Alexander the Great, Timanthes, Zeuxis, and Apelles, are
referred to as representatives of the highest of the arts:
"Ejerceis el mejor arte/ más noble y de más ingenio."[1] And
in the same play, the shepherdess Campaspe is instructed
about the portrait: "Quisiera saber qué cosa es retrato" she
asks ingenuously. In turn, her companion, a cultured
princess, wonders if she has ever seen a painting. Cam-
paspe replies that she has seen "paises" and "batallas" of
"gran naturaleza" in the country, but never before has she
seen a portrait.[2] The portrait, then, appears to be the
product of an urbane, cultivated court society.

Accordingly, two presumed genre scenes by Velázquez

115

seem, in fact, to be portraits. Ponz claims to have seen a picture in the Royal Palace of "un muchacho de cuerpo entero con un perro" that was in the same style as the painting of two boys eating and drinking, probably the work now in Apsley House.[3] However, in my opinion it is unlikely that this now lost painting of the boy and dog was a genre scene. Unlike the other genre pictures it is a full-length, and its format, juxtaposing a child and an animal, reminds one of the formula used in many sixteenth- and seventeenth-century portrait images. Titian's Clarice Strozzi and Velázquez's portrait of the young prince Carlos for the Torre de la Parada come to mind. Ponz is not the most reliable of chroniclers, and perhaps his description is just a slip of the pen. The splendid *Needle-woman* of the 1640s fortunately still exists.[4] I believe that the picture may very well be a portrait with emblematic connotations. Indeed, embroidery was associated with propriety in the Golden Age. Thus the sisters of the picaresque hero Estebanillo González are the very models of decorum as they work on their embroidery.[5] And in *Don Quixote* the wanton Altisodora was to become the exemplar of rectitude by taking up needlework.[6] The connotation of virtue that needlework held would be particularly appropriate for Velázquez's sitter, who may have actually been the painter's daughter Francisca.[7]

If service at court terminated Velázquez's activity as a genre painter, there were other Spanish artists who carried the tradition forward. But with the exception of Murillo, none matched the verve and brilliance of Velázquez. Indeed, the oeuvre of many of these genre painters, for obvious reasons, remains largely uncharted.

Pacheco remarked, perhaps with the pride of a father-in-law who delights in boasting of his son-in-law's accomplishments, that Velázquez's "powerful example" as a genre painter inspired many other artists. Indeed, even he

was moved to paint an amusing eating scene. This now lost painting was probably similar to the *Luncheon* or *Three Men at a Table*.[8] The existence of multiple copies and variants of Velázquez's genre scenes attests to their popularity.[9] For instance, the *Four Men at a Table* in Oakley Park (fig. 39), a comic eating scene recalling Velázquez's "figuras ridiculas," combines stock motifs such as the table placed on the picture plane and boxlike composition with two figures culled from *Los Borrachos*. The painting must postdate 1630, and in its crude vitality, it suggests that a broad popular market existed in Spain for cheap, exuberant genre pictures, side by side with the more cultured patronage that admired the splendidly crafted genre pictures by Velázquez.[10]

Unless a happy accident reveals a document or signature associated with pictures of this type, it is unlikely that we will ever be able to determine their authorship. It is difficult also to assign the name of an artist to those genre pictures which are in the manner of Velázquez and were attributed to him at one time or another. Consequently a pastiche of the Budapest *Luncheon,* now in a private collection in Paris, is given to Loarte without any firm reason.[11] Similarly, a *Shepherd* and *Shepherdess* attributed to Velázquez by Curtis, an attribution maintained even as late as 1933 when the pictures were sold at auction at Anderson Galleries, and a *Tavern Scene* in a private collection in Los Angeles, also cited by Curtis, cannot be confused now with Velázquez's juvenilia.[12] And the stiff and awkward *Gamblers in a Brawl* in the Galleria Pallavicini, presumably painted in 1630, the time of Velázquez's first Roman sojourn, has been correctly dismissed from the oeuvre of the master.[13] Yet a specific artist's name cannot be attached to these pictures.

If problems in attribution continue to bewilder us, the interest in multivalent meaning, puns, innuendo, and

literary references—in sum the sentiment of "agudeza" which permeates Velázquez's *bodegones*—apparently remains a constant in many Spanish genre pictures. The *Shepherd* and *Shepherdess*, for instance, probably reflect the interest in pastoral life so prevalent in the literature of the Golden Age. Cervantes' long paean to the delights of the glen, shepherd's pipe, and the Arcadian spring in *Don Quixote* is but one manifestation of this preference.[14] As for the *Tavern Scene*, it, like Velázquez's eating scenes, probably contains suggestive erotic connotations. A provocative still life of bread, a knife, a slit melon, and eggs is juxtaposed to a serving maid clasping a wine jug, and a young boy who glances longingly at her.

If Velázquez's concern for metaphor is also apparent in the works of other Spanish genre painters, we must remember that this interest is characteristic of the period and is not necessarily directly dependent upon Velázquez. Indeed, it is not easy to determine the pervasiveness of Velázquez's influence beyond the immediate circle of "pasticheurs." As we have seen, Velázquez's *bodegones* seem to depend upon a wide variety of sources. Many of these sources, particularly the Spanish genre tradition, are still imperfectly known. But these sources were doubtless available to Spanish genre painters contemporaneous with Velázquez, and therefore the general accessibility of sources further clouds Velázquez's specific influence.

It is not my intention to deal with the cadre of Spanish genre painters who may have been inspired by Velázquez. This excursus will focus only on two artists, Antolínez and Murillo. Antolínez had direct contact with Velázquez in Madrid, and it is not at all surprising that his one surviving genre painting reflects the master's luminous *Las Meninas*. Murillo represents a brilliant effloresence of Spanish genre painting in the middle of the seventeenth century in

Seville, the city where Velázquez first established his repu-
tation.[15]

Jose Antolínez's *Picture Seller,* dated circa 1670 (fig.
40) and now in Munich, is the one remarkable genre scene
painted in Madrid.[16] Antolínez, strongly influenced by
Venetian art, specialized in dazzling *imaculadas.* The *Pic-
ture Seller,* however, with its grayish-brown tones, leading
to a light-drenched window, refers to Velázquez's *Las
Meninas.* But in contrast to Velázquez's painting, which
emphasizes the dignity of the artist as royal portraitist and
worthy successor of Apelles, who looks out at us with
noble poise, Antolínez provides us with the antithesis.[17] A
ragged figure, his palettes stacked on the wall to his right
and brushes and paint box lying at his left, holds a cheap
imitation of a Scipione Pulzone *Madonna.*[18] His broad grin
has reminded at least one scholar of one of Velázquez's
buffoons.[19] And the comic nature of the scene has re-
minded yet another writer of prints of picture vendors by
Mitelli and Parigius.[20] Because of the witty mood of the
painting, I think it unlikely that it was a signboard for a
picture dealer.[21] Indeed, I suspect that Antolínez is bur-
lesquing a type of hack painter who cranked out derivative
religious icons for rapid and cheap sale. The acerbic
pointing figure in the background may indeed be An-
tolínez himself.[22] Such a pictorial gibe would not be incon-
sistent with his character. A haughty and vain man, he
considered himself superior to his contemporaries in both
insight and ability. In fact, he disparaged artists who he
thought wasted themselves on undignified efforts. For
example, those who painted stage sets—and the important
painter Francisco Rizi was among them—were subject to
his scorn. And as a response to those artists who ques-
tioned his judgment on painting he depicted a *Doubting
Thomas.*[23] Accordingly, those doubters of his acumen were

equated with the skeptic who disbelieved Christ's divinity. Perhaps like the now lost *Doubting Thomas*, the Munich picture was also directed at his critics, a kind of pictorial riposte to those whom he may have deemed as unimaginative drudges; as such, the painting would hardly be representative of a commitment to genre scenes by eminent artists at the court.

If Madrid did not provide a hospitable artistic climate for genre painting, in Seville, under the aegis of its brilliant native son Murillo, genre flourished. Indeed, unlike Velázquez, whose career as a genre painter was apparently curtailed upon his appointment as court painter, Murillo painted genre scenes throughout his long career. The popularity of these pictures is attested by numerous copies and by the plethora of sentimentalized images of children ascribed to Murillo in the nineteenth century.[24] Yet these wonderful paintings make up less than five percent of Murillo's oeuvre. Murillo's prime patrons were the wealthy Sevillian religious orders and thus whatever skill he demonstrated as a genre painter had to be subordinated to images of Scripture and sacred story.

Although it is difficult to date Murillo's work precisely, the outlines of his chronology are fairly clear. Scholars accept a development from a more linear style, with emphasis upon chiaroscuro effects, to a lighter more rapidly painted and atmospheric style. The canon of Murillo's genre oeuvre, with the exception of a few paintings, has remained remarkably uniform since Mayer's *Klassiker der Kunst* volume was published in 1913. Here, the many Murillesque pictures which Curtis had accepted uncritically were removed from the master's oeuvre. But much is still problematical. The sources, and more particularly the iconography, of Murillo's genre scenes remain unresolved, and perhaps these few pages will provide a rough map for this still uncharted terrain.

In part, we can see Murillo's genre as a logical extension of the Spanish genre tradition exemplified by Velázquez's juvenilia and continued by that cadre of anonymous painters who provided cheap and easily salable pictures for the market. Murillo, like other Spanish artists, Velázquez in particular, displays a real delight in naturalistic textures. Like Velázquez too, Murillo is an artist of carefully controlled rhythm and static form. And at least one of his pictures seems to conform to the genre of "figuras ridiculas." In the *Old Woman and a Boy* of the 1650s in Dyrham Park (fig. 41), Murillo has painted a grinning, tough, and impudent child calling attention to the old woman eating from a bowl.[25] She casts a worried look at this jeering boy and retains a tight grip on her food. Here Murillo may be dependent upon a specific literary source now unknown to us, but it is a source which seems to refer to the mocking mood so prevalent in the early picaresque novel. In any case, the harsh emphasis of this painting seems to be the exception rather than the rule in Murillo's oeuvre.[26]

Indeed, in most of his genre paintings Murillo seems distinct from Velázquez. His later, atmospheric, almost vaporous, style clearly has nothing to do with the leathery surfaces found in the early work of Velázquez. Perhaps Italian art, seen through the filter of a Spanish intermediary like Herrera el Mozo lies behind this approach.[27] Many of Murillo's genre subjects also differ from those of Velázquez as two decidedly antithetical views of the Sevillian demimonde emerge. With the exception of the magisterial *Water Carrier,* most of Velázquez's genre scenes present us with a more raucous world of eating, drinking, and sexual innuendo and belong to the category of "figuras ridiculas." Venal old men and women, tough and wary youths inhabit this realm, whereas Murillo most often depicts sentimental images of ragged street youths. These portrayals of plump children and charming fruit and flower vendors, fre-

quently painted through a veil-like atmospheric film, are distant not only from "figuras ridiculas" but also from the squalid reality of the Sevillian streets. In reality street vendors were neither pretty nor delicate. Their reputation was unsavory and they were often punished unmercifully. Such is the case of La Gamarra, who sold her vegetables above the price ceiling. She was marched through the streets with pieces of squash tied around her neck and sentenced to two hundred lashes.[28] In the desperate crowding of the Sevillian "hacera" or row house it would be difficult for real children to be like Murillo's plump and rosy-cheeked cherubic types. A survey taken in 1667 revealed one courtyard with twenty-two children under the age of ten.[29] In this teeming and often hostile environment children were quickly sent to the streets to beg, to sell their bodies as prostitutes, or to make themselves useful in some other way to the underworld subculture.[30] Other, even larger problems affected Seville's children. At the very time that Murillo was painting his cheery ragamuffins, epidemics and unrest raged through Seville. Plague swept Seville in 1649 and as many as three hundred thousand people died. Poignant stories are recorded. Swollen bodies lay in heaps near churches. Four small children, dead in their bed, were placed on the steps of Seville cathedral.[31] In 1652 a riot provoked by famine erupted. Mobs roamed the city demanding bread. Homes were looted, offices were ransacked, and many were killed and wounded.[32] There is no reference to any of these depressing realities in Murillo's images of Sevillian street life.

Nor are Murillo's cheerful children like the cunning sharpers found in the earlier picaresque novels. These children, abused with regularity, suffered the tangible horrors of their squalid existence. Murillo's children call to mind a more genteel pícaro who emerges at the end of the

seventeenth century, such as the eponymous hero of Francisco Santos's *Periquillo,* published in 1668. Unlike his roguish picaresque predecessors, whose parents were whores, pimps, or thieves, Periquillo is a foundling brought up by a pious couple. They encourage his conscientious study. All the cunning villainy that distinguished the earlier novels has vanished and Periquillo becomes the vehicle for Santos's pious moralities.[33]

In part, this sentimentalized view of childhood may be due to what appears to be an emerging pan-European interest in the joys and innocence of children. French sources are particularly rich in revealing this attitude and can serve as a paradigm for European thoughts about the issue in general. Increasingly through the seventeenth century attitudes toward the child changed from disdain or blithe disregard to open coddling.[34] Mme de Sévigné, for example, loved to play with her granddaughter: "I have been playing . . . for an hour now; she is delightful . . . I have to kiss her straight away."[35] Thus the child becomes an adored and adoring playmate and is not a fortuitous annoyance. Perhaps too, Murillo's images of children relate to the idea that childhood is a joyful escapist time, free from care. One finds such a conceit in Dutch genre paintings by Leyster and Molenaer, and it is possible that these scenes reflect a current attitude about the happy-go-lucky pleasures of childhood.[36]

The *Boy Hunting Fleas* (fig. 42), now in the Louvre, is probably the earliest of Murillo's genre pieces. Dated about 1645, the painting is characteristic of the early style in its sharp chiaroscuro and vivid textural effects.[37] Strong light entering in a diagonal shaft from the window on the left boldly illuminates the figure against the dark wall. The boy casts a palpable shadow. The reality of the other objects is similarly defined by Murillo's attention to detail.

The eroded and deteriorating stone window, the large ridged earthenware jug in the foreground, and the nappy texture of the straw basket are all rendered with a wonderful facility. The painting also serves as an exemplum in terms of composition and mood for the later genre scenes. Murillo's delicate boy, pretty despite his dirty feet and ragged clothes, is a type that we will encounter often. And the way Murillo places his figure in space, angling the form in a gentle zigzag, is a favorite compositional device.

The theme of flea hunting is not rare in the seventeenth century. It was particularly popular in Northern Europe. Sometimes the motif held sensual connotations, but it was also associated with the sense of touch.[38] Dirck Hals, for example, depicts touch as a child hunting for fleas.[39] And it is possible that Harmen Hals as well portrayed the sense of touch in his *Peasant Hunting for Fleas*.[40] Perhaps Murillo too, following Northern prototypes, illustrated this sense. Murillo sold some of his genre scenes to Northern patrons, and since the art dealer Christopher van Immerseel had at least one series of senses by Jan Brueghel and one by Gerard Seghers, we do know that there was a market for Northern representations of this theme in Seville in the 1630s and 1640s.[41]

Although it is possible that Murillo's painting reflects the iconography of the senses, the picture also can be seen in relationship to Sevillian street culture. Even the stray prawns scattered around the feet of the boy contribute to the sense of reality, since prawns were apparently the usual fare of the Sevillian street urchin.[42] Of course, such ragged youths were common fixtures in Seville, and an entire literature was devoted to the adventures and misadventures of the young anti-hero. Yet these late-sixteenth and early-seventeenth-century pícaros are hard and feral. Murillo's boy is sweet, delicate, and soft.

The *Two Boys Eating Fruit* (fig. 43), now in Munich,

distinguished by its warm color and strong light and dark contrasts, is stylistically similar to the *Boy Hunting Fleas* and is likely an early work.[43] We are confronted here with a picture of childhood happiness. Such a joyful scene must have enjoyed a great popularity since a number of old copies of this picture are still extant.[44] Murillo's depiction of greedy pleasure in eating also may be suggested by the descriptions of the gluttonous delights of picaresque freedom. Lope de Vega could write: "Oh, blissful Picardy!/ To eat beneficially on foot!/ When have you seen a pícaro die of apoplexy?/ Oh, to sleep delightfully and simply/ without care and without rule/ In the kitchen in the winter/ and in the grain in the summer."[45] And Murillo's commitment to the veneer of naturalism—a crumpled sere leaf, soiled and tattered garments, dirty feet, and even two flies that have alighted on a juicy melon—is apparent. Yet unlike the starving waifs who inhabited the Sevillian slums or the tough and rapacious gluttons of the early picaresque novel, these are plump urchins who recall Dutch images of carefree, joyous children.

Two pendant paintings, the *Boy with a Dog* (fig. 44) in Leningrad and a *Girl Selling Fruit* (fig. 45), now in Moscow, continue the motif of sweet childhood innocence. The lighter, higher-keyed tonalities and broad brushwork indicate a date later than the Munich painting, posssibly in the 1660s.[46] This more atmospheric fuzzy style also complements the sweet and tender images of the children. To be sure, youthful streethawkers and basket boys efficiently moved merchandise throughout the city and carried goods to the newer neighborhoods of Seville. Yet these streethawkers and basket boys had to be strong enough to carry produce, and tough and cynical enough to avoid exploitation.[47] Murillo's more delicate and innocent youths apparently belong to the idealized children's world.

Murillo returned to the realm of basket boys and street-

hawkers in two paintings now in Munich, the *Young Fruit Vendors* and the *Street Boys* (fig. 46), which probably date in the 1670s.[48] The thematic and compositional patterns that Murillo established in his early work remain unchanged. As in the early works, we seem to be presented with an escapist view of the carefree world of children. And as in the early works figures zigzag into space and complementary diagonals balance the composition. In the *Street Boys* the youth craning his neck to receive his sweet treat reprises the grape eater of the *Two Boys Eating Fruit* of the 1640s. Indeed, as in the earlier painting, the tightly knit composition is unified further by a space-traversing glance. Murillo portrays dirty feet and retains an interest in texture—the basket is sharply defined—but this picture is much richer in atmosphere.

The *Young Fruit Vendors* (fig. 47) is similarly lush. To be sure, Murillo has paid careful attention to the texture of the wicker basket and to the surfaces of the luscious and sumptuous fruits. In this way he continue conventions of Sevillian genre painting that were explored many years before. But the broad brushwork and Titianesque clouds, tinged with reddish hues, reflect developments in Sevillian painting of the later decades of the seventeenth century. The mood too, sentimental and reveling in the delightful sweetness of childhood, seems appropriate to late seventeenth-century escapism.

The vigorously painted *Boy Leaning on a Parapet* (fig. 48) in the National Gallery of London, probably from the 1670s, is also infused with the hearty joy of carefree childhood. It is an idealized and anomalous image, the boy's wide grin and plump cheeks contrasting with his disheveled costume.[49]

The *Woman Removing Lice from a Child,* in Munich (fig. 49), also exemplifies this idealized escapist theme. Like

most of Murillo's genre scenes this painting is difficult to date. Its warmer tones relate it to the palette of the 1650s. And the pose of the boy is a stock type. But the handling is broad and atmospheric, and therefore may suggest a date around 1670.[50]

At first glance the painting seems to be a scene of humble poverty. This is a meager interior. One small jug rests on the tiny wooden table. A large umber water cistern lies near it. The boy suffers from the filthy conditions of poverty and requires delousing. But he is a well-fed child who can even afford to own a cute beribboned dog. Indeed, poverty is superseded here by a concern for the child. The act of delousing a child, in fact, is traditionally associated with maternal solicitude.[51] And the spindle, prominently placed in the foreground, is yet another emblem of domesticity. Not only does it have this connotation in Dutch art, but Covarrubias informs us that spinning is the occupation of homeloving and industrious women.[52] Thus unlike the real Seville, where poor children were turned out into the street, this painting is an idealized manifestation of the tender protection of mother love.[53]

The fantasy of loved children merges easily with Murillo's other escapist images of the 1670s. The *Flower Girl* (fig. 50) in Dulwich is a case in point. Her dark, exotic features and her burnooselike shawl suggest that she is a gypsy.[54] Yet her sunny smile and unabashed cheerfulness belies the actual treatment of gypsies in seventeenth-century Spain. Indeed, as late as 1692 the law, following an earlier pragmatic of 1633, proclaimed that it "wished to extinguish totally the name of 'gipsy' " in addition to prohibiting their language and dress.[55] Murillo's bewitching gypsy girl apparently derives from literary idealizations of the type as a paradigm of love and beauty. Consider, for

example, the paragon of lovely gypsies, Cervantes' Preciosa in *La gitanilla*. She is "such a pretty creature that were she made of silver or of sugar icing she could not be better."[56] "Pearls drop from her hands and flowers fall from her mouth. . . . A thousand souls are entrapped by the ringlets of her hair. And even Cupid has surrendered his arrow, laid down by her feet."[57] Like this consummate image of the power of gypsy love, Murillo's flower girl, inviting, coquettish, and darkly beautiful, offers roses in her shawl, the flowers of love.

The *Three Boys* (fig. 51), also in Dulwich, is dated at about the same time as the *Flower Girl*.[58] But unlike that painting which is richly and loosely handled, its wet and freely brushed surfaces glistening with paint, the *Three Boys* is smoother and dryer. To be sure, the painting possesses the cool green and grayish tones of the late style. And the composition, like that of the *Woman Removing Lice from a Child,* is a carefully arranged pyramid built upon the zigzagging movement of figures into space. But it is Murillo's ability to shift his manner from smooth to broadly brushed that confounds art historians attempting to date his pictures with precision. Yet a tangible clue does exist which may allow us to date this painting with more exactitude than most. The smiling urchin who precociously engages the spectator is a repetition in both type and pose of the pointing boy perched atop a horse in Murillo's *Moses Striking the Rock* for the Hospital de Caridad of 1670.[59] An old tradition suggests that the boy in the Moses painting is Murillo's son, whom he could also have used as a model for his genre scene. If this is indeed Murillo's son Gaspar, who was born in 1661, a date of around 1670 is highly likely.[60]

In the *Three Boys*, Murillo once again depicts a fanciful vision of the basket boy. These presumably poor street

boys even have a metal pitcher which glistens incandes-
cently in the foreground. And Murillo has inserted a
sentimental narrative touch as the black boy, his jug rest-
ing on his shoulder, asks for a piece of the pie jealously
guarded by the barefoot streethawker. Unlike the indolent
black servant in Velázquez's *Supper at Emmaus,* excluded
from the miracle of the Eucharist, Murillo's black boy
arouses our pity with his forlorn and hungry gaze, con-
trasted to the greedy selfishness of the street boy. The
ragged youth on the left, possibly Murillo's young son
Gaspar, tugs at the black boy's pants and engages the
glance of the spectator, drawing us to the poor boy's
plight. The emphasis is on charity, an entirely appropriate
theme for a painter who worked for the Hospital de
Caridad and was a lay member of its order.[61]

In the *Two Gallegas at a Window,* dated in the 1670s (fig.
52) and now in Washington, Murillo again involves the
spectator, but this time in a jocular way.[62] One amused
woman, her eyes laughing, smirks behind her shawl. The
other, younger, her shoulders provocatively bared, looks
invitingly at the spectator and smiles warmly. According to
tradition these women were notorious Sevillian courte-
sans.[63] Their appearance at the window can be related to a
common practice of solicitation characterized by the
phrase "putas en ventana."[64] And, of course, as a popular
proverb tells us, it was common to find "putas" in pairs.[65]
Yet typical of Murillo's gloss of reality, that mellow and
fanciful world that he so expertly creates, this image
presents an essentially deceptive view of Seville's "lost
women." Many were beaten; diseased prostitutes were
turned out of the brothel, and old ones were summarily
dismissed—their advanced age a liability.[66]

The *Young Girl* of the 1670s and in a private collection in
London also may have amatory significance.[67] She glances

coyly, and her garment has slipped to reveal a soft shoul-
der. Her self-conscious pose of lifting the veil is reminis-
cent of the prostitute depicted in Vecellio's *Habiti antichi et
moderni di tutto il mondo* published in 1598.[68] Young prosti-
tutes were, in fact, common in Seville. According to law a
girl could begin working at the age of twelve after she had
lost her virginity.[69] A popular song records: "And nearby a
fresh/ Young girl told me/ That, being pretty and young/
She ground her mill/ Yesterday she earned six ducats."[70]
Murillo's interest in erotica may remind one of Velázquez's
juvenilia. But unlike the hard and leathery putative adults
of the earlier master, Murillo's work is playfully erotic. His
picture seems more like the glittering amatory images of
children produced by late seventeenth-century painters.
In Cerquozzi's late works of the 1650s and 1660s, for
example, his elegant and ravishing still lifes are peopled
with pretty, erotic boys and girls.[71]

Yet even within this potentially salacious context,
Murillo remains an artist who beautifies reality. This is a
pretty child viewed through the soft haze of Murillo's late
style. Similarly, two gaming scenes, *Boys Playing Dice* (fig.
53) in Munich, dated in the 1670s, and the *Ballgame* (fig.
54) in Dulwich Castle of Ca. 1670, present an idealized
image of Sevillian street life.[72] The ragged boys belong to
Murillo's cadre of pretty street hustlers. The composi-
tional formulas—a kneeling figure creating a zigzag pat-
tern, the juxtaposition of a vertical figure against a vertical
of architecture or rocky outcropping, and the compact
format organized by measured rhythms of glance and
gesture—are motifs that are typical of many of Murillo's
genre scenes. I believe that Murillo is repeating an icono-
graphic formula as well. There may be a comment on the
hazards of fortune—dice are notoriously associated with
chance, and bread, held by the boys in both paintings, was

also sometimes linked with luck in seventeenth-century popular usage.[73] In the Munich picture the ivy, which has intruded from the rocky outcropping and adorns the jaunty headdress of the engrossed dice player on the right, may further underscore the theme of chance. Perhaps Murillo is alluding to a popular proverb linking ivy to the fleeting hold men have on prosperity.[74] But the mood of these paintings is not one of cutthroat gambling. Even the Dulwich painting, which suggests the temptation of the staid and innocent boy who cautiously glances at the grinning street hustler, is gentle and mellow.[75] Indeed, unlike the scheming sharpers that one encounters in early seventeenth-century gaming scenes, these are joyful and untroubled children. They recall Claudine Bouzonnet Stella's image of youthful gamblers in her series devoted to the games and pastimes of children published in 1657.[76] Here, even though one child has resorted to cheating, the charming children still manage to maintain their innocence. A loser finds consolation in playing with his dog, his beloved "toutou." And the tenor of Stella's series, like so many of Murillo's images, emphasizes the joyful innocence of childhood. This mood is eloquently summarized in print number 49 of the series, a gay dance of children described as "sweet and pure," a veritable image of a lost *siècle d'or*.[77] Perhaps too, this is what Murillo has envisioned in his charming images of childhood, a golden age of innocence re-created for patrons faced with the depressing dross of Spanish decline.[78]

The course of Spanish genre painting after Murillo is not a happy one. The one artist who followed Murillo's example of painting carefree youth, Don Pedro Nuñez de Villavicencio, was a dilettante rather than a serious painter, and his output was probably limited. As a knight of the order of St. John he seems to have been acquainted

with Mattia Preti's style at Malta. And it is probable that he was also influenced by the school of Madrid, since he remained in that city from 1683 until his death in 1700.[79] Villavicencio's best known picture, and his only signed work, is the *Children Playing* (fig. 55) now in the Prado, a painting which he presented as a gift to Charles II.[80] The painting is a pastiche of Murillesque motifs. A group of boys, one posed in the typical zigzag fashion, is set off against a rocky outcropping. A basket boy and a companion with a sack on his back wander in the middle ground. Yet the types and lighting are cruder than Murillo's, and the gestures seem forced and affected. The iconography recalls Murillo's dice-playing scenes. We seem to be reminded of the hazards of fortune by the boy holding a piece of bread while he conspicuously points to the dice-playing youths, a re-creation of a similar juxtaposition in Murillo's gambling scenes. But since this was a picture presented to the king, and therefore a kind of demonstration piece, Villavicencio seems to pull out more emblematic stops. Thus, the rose held by the young girl may be a reminder of transitory pleasure,[81] and the bird, apparently a dove, perched atop the column, is associated with carefree innocence since it was claimed to be a bird without trouble, "sin hiel."[82]

A small group of Murillesque paintings have been attributed to Villavicencio. In their chiaroscuro effects, resulting in the simplification of features, and in the flat treatment of draperies, these works recall Villavicencio's signed painting in the Prado. They very well may be by his hand, but they are not very distinguished paintings in any event. Two paintings in Leicester which bear the initials P.V.N. are further variants on the gambling theme.[83] In one, the *Card Players* (fig. 56), the artist underscores the indolence of his youths by depicting a boy with his hand

tucked in his garment, a traditional gesture of idleness.[84] The *Two Youths* in Compiègne (fig. 57) is a reworking of the contrast between the idle, tempting gamester and his reluctant companion found in Murillo's painting in Dulwich.[85] Two pendant paintings attributed to Villavicencio further exemplify his lack of imagination. The *Boy Attacked by a Ram* in Modena (fig. 58) and the *Boy Beset by Dogs* in Budapest (fig. 59) reveal a slick, forced artificiality.[86] The two boys, ultimately and incongruously derived from Raphael's fallen Heliodorus in the *Expulsion of Heliodorus,* are mirror images of one another. In the Budapest painting the offending animal comes from the left, causing the boy to spill a basket of apples. In the Modena painting the besieging ram comes from the right and causes the boy to lose his jug. The ram is flat and unsteadily perched on the ground. Engaging in a quasi-absurd visual dialogue, the boy registers shock and the ram looks solemn. The types are heirs of the pretty basket boys that Murillo painted, but the decorative elements have been greatly intensified. Finally, in its simple blocky modeling and overt repetition of a character from the Prado *Children Playing,* the *Water Carrier* (fig. 60) in the Casa Murillo in Seville serves as not only a fitting example of Villavicencio's style, but also as a fitting epitaph to the Spanish tradition of genre painting.[87] Like Velázquez's more famous prototype, the theme of this painting is probably generosity. But Villavicencio's image is suffused with a soft sentimentality. Velázquez's picture, enhanced by the artist's wonderful feeling for light, texture, and form, presents us with "the true image of nature" synthesized with an intellectual concern for metaphoric statement. In Villavicencio we may find metaphor, but we also find that Velázquez's vision has been conclusively altered.

Notes

1. E. Curtius, *European Literature and the Latin Middle Ages* (New York and Evanston, 1963), 563.

2. Ibid., 564.

3. A. Ponz, *Viaje de España*, vol. 6 (Madrid, 1783), 35.

4. On the date and attribution of this work see J. López-Rey, *Velázquez*, 331–32, no. 605.

5. *La vida y hechos de Estebanillo Gonzalez*, ed. J. Millé y Gimenez (1646; Madrid, 1934), 1:63.

6. 2:lxx, *Obras*, 1512–13. It is likely that embroidery and lace-making scenes in Dutch genre painting also may allude to domestic virtue and propriety. Consider, for example, Hendrik Van der Burch's picture of a woman caught between her domestic duty, embroidery, and the inviting proposition of a cavalier. W. Bernt, *The Netherlandish Painters of the Seventeenth Century* (London, 1970), vol. 1, pl. 211.

7. On the sitter's identity see López-Rey, *Velázquez*, 331.

8. *Arte de la pintura*, 2:137.

9. For a listing of these scenes see López-Rey, *Velázquez*, 152–65.

10. This picture may have been seen by Ponz *(Viaje de España*, vol. 18 [1794], 21). For other paintings of this type see E. Harris, "Obras españolas de pintores desconocidos," *Revista Española de Arte* 12 (1935):258–59 and J. Miguel Serrera, "Una 'Riña de pícaros' de Matias Jimeno," *Archivo Español de Arte* 52 (1979):79–80. The Jimeno painting, signed and dated 1656, is a copy of an early seventeenth-century print by Villamena.

11. López-Rey, *Velázquez*, 162, no. 122.

12. C. Curtis, *Velázquez and Murillo* (London and New York, 1883), 36, no. 81l, 81q and 37, no. 85d. *Sale no. 4026, Oil Paintings, Property of Harold Leger and Estates of Charles Hitchcock Tyler, Mary A. Haney*, Anderson Galleries, 1933, nos. 60, 61. The *Shepherd* was purchased for $200 whereas the *Shepherdess* fetched only $125. For a catalogue of the many pictures by anonymous masters presumably inspired by Velázquez's *bodegones* see Haraszti-Takács, *Spanish Genre Painting*, 231–42.

13. López-Rey, *Velázquez*, 166, no. 133.

14. 2:lxvii, *Obras*, 1502–5. See also N. Salomon, *Recherches sur la thème paysan dans la "Comedia" au temps de Lope de Vega* (Bordeaux, 1965), 684–724, for the delights of pastoral life in Spanish theater.

15. Also working in Seville was Francisco Herrera el Mozo, who like his father presumably painted genre scenes. None, however, are now extant. See Angulo Iñíguez, *Pintura del siglo XVII*, 285. But cf. V. Van Loga, *Die Malerei in Spanien* (Berlin, 1923), 193 and fig. 106. This painting, *Boy with a Crab*, seems Neapolitan and may be influenced by Recco.

16. For this painting see D. Angulo Iñíguez, *Jose Antolínez* (Madird, 1957), 31–32, 42 n. 44.

17. For Velázquez's painting see M. Kahr, *Velázquez*, 128–202, and J. Brown, *Images and Ideas*, 87–110.

18. H. Soehner, *Bayerische Staatsgemälde Sammlungen. Alte Pinakothek München. Spanische Meister* (Munich, 1963), 1:27.

19. Angulo Iñíguez, *Antolínez*, 31.

20. Soria, *Art and Architecture in Spain*, 289.

21. But cf. Soehner, *Spanische Meister*, 27.

22. J. G. Prinz von Hohenzellern and H. Soehner, *Französiche und spanische Malerei* (Munich, 1972), 69.

23. See Angulo Iñíguez, *Antolínez*, 9–10.

24. For these see Curtis, *Velázquez and Murillo*, 276–91.

25. But for an alternate date see D. Angulo Iñíguez, *Murillo, su vida, su arte, su obra* (Madrid, 1981), 2:308–9, no. 400, who suggests ca. 1660. Cf., however, J. Gaya y Nuño, *L'opera completa di Murillo* (Milan, 1978), 92, no. 67, who also dates the work in the late 1650s.

26. For other versions of this painting see Angulo Iñíguez, *Murillo*, 2:309. The now lost male and female beggar sent to a Flemish collection may have had a picaresque sensibility (ibid., 441, 444), but in light of Murillo's interest in themes of charity, I suspect that these were sentimental rather than acerbic paintings.

27. Angulo Iñíguez, *Pintura del siglo XVII*, no. 340.

28. M. E. Perry, *Crime and Society in Early Modern Seville* (Hanover, N.H., and London, 1980), 50–51.

29. Ibid., 192.

30. Ibid., 179, 197–202.

31. Ibid., 237.

32. Ibid., 251–52.

33. For *Periquillo* and the end of the picaresque tradition see F. W. Chandler, *Romances of Roguery* (New York, 1899), 391–94.

34. P. Ariès, *Centuries of Childhood: A Social History of Family Life (New York, 1962), 128–33.*

35. Ibid., 130.

36. C. Brown, Dutch Genre Painting: Themes and Painters in the National Gallery (London, 1976), 9–10. Angulo Iñíguez *(Murillo,* 1:447) has commented on the joyful images of Murillo's children and suggests Dutch and Flemish prototypes. Indeed, the *Laughing Youth* in a private collection in London which Angulo (ibid., 2:300–301, no. 386) attributes to Murillo appears to me to be a Dutch picture. Its low viewpoint and aggressive illusionism highlighted by the youth's pointing gesture suggest a variant of the Hals school. See S. Slive, *Frans Hals,* vol. 3 (London, 1974), figs. 104, 105. Neither I nor Angulo Iñíguez, however, has seen the London painting.

37. On documentation and dating see Angulo Iñíguez, *Murillo,* 2:303, no. 390.

38. B. Wind, "Close Encounters of the Baroque Kind," *Studies in Iconography* 4 (1978):121–22.

39. S. Slive, *Frans Hals,* vol. 1 (London, 1970), 79.

40. W. Bernt, *Netherlandish Painters,* 1:474.

41. J. Denucé, "Brieven en documenten betreffende Jan Brueghel I en II," *Bronnen voor de Geschiednis van de Vlaamsche Kunst* 3 (1934):83–86, 88, 132.

42. Cervantes, *Rinconete y Cortadillo,* in *Obras,* 844.

43. Angulo Iñíguez, *Murillo,* 2:301–2, no. 387.

44. Ibid.

45. J. Deleito y Piñuela, *La mala vida en España,* 146. See ibid., 145–49, for further descriptions and the joys of picaresque life. Cf. Angulo Iñíguez *(Murillo,* 1:446) who connects the painting with the proverb "En manos de muchacho pronto el racimo es escobajo." The interpretations are not mutually exclusive.

46. *Master Paintings from the Hermitage and the State Russian*

Museum (New York, 1975), 58, where a date of ca. 1661 is suggested. But cf. Angulo Iñíguez *(Murillo*, 2:297, 350, nos. 379 and 394) who dates the paintings somewhat before 1660. Angulo regrettably places the *Girl Selling Fruit* in Leningrad rather than Moscow.

47. Perry, *Crime and Society*, 197–98.

48. Angulo Iñíguez, *Murillo*, 2:310–11, no. 402; 302, no. 388.

49. For dating and provenance see ibid., 297–98, no. 380.

50. Ibid., 311, no. 403.

51. J. M. Nash, *The Age of Rembrandt and Vermeer* (London, 1972), no. 145.

52. E. de Jongh, *Zinne en minnebilden van de zeventiende eeuw* (Amsterdam, 1967), 65; Covarrubias, *Tesoro*, 690. But cf. Angulo Iñíguez *(Murillo*, 1:447) who connects the painting with the proverb "El niño con piojos saludable y hermoso; niño sin ellos endeble o enfermo."

53. The theme of the old woman and a distaff is also found in what is a presumably very early painting now in the Prado. Like Angulo Iñíguez, *(Murillo*, 2:557 no. 2.678), I believe that this tightly painted and flat picture is a copy of a lost Murillo.

54. On gypsy costume see François de Vaux de Foletier, *Mille ans d'histoire des Tsiganes* (Paris, 1970), 181.

55. H. Kamen, *Spain in the Later Seventeenth Century* (London and New York, 1980), 282.

56. *Obras*, 778.

57. Ibid., 787. But cf. Angulo Iñíguez, *Murillo*, 1:452, who sees "vanitas" implications in the flowers. Recently J. Brown ("Murillo, pintor de temas eróticas," *Goya* 169–71 [1982]:39–40) suggests that the painting is like a Spanish "Flora."

58. Angulo Iñíguez, *Murillo*, 2:300, no. 383.

59. Ibid., 78.

60. For the tradition that this boy is Gaspar see ibid., 1:449.

61. For Murillo and this order see ibid., 1:80.

62. For the various dates given to this painting see ibid., 2:307–8, no. 399.

63. W. Stirling-Maxwell, *Annals of the Artists of Spain*, vol. 3 (London, 1891), 1092.

64. Correas, *Vocabulario*, 486.

65. Ibid.

66. Perry, *Crime and Society*, 218, 232. Angulo Iñíguez *(Murillo*, 1:453) reads the painting as "una inocente escena de curiosidad femenina."

67. For the date and provenance of this painting see ibid., 2:306–7, no. 396.

68. R. Casagrande, *La cortigiane veneziane nel cinquecento* (Milan, 1968), 65. A similar gesture is found in the so-called *Family Group* now at the Kimbell Museum. See Angulo Iñíguez, *Murillo*, 2:310 no. 401, and 3: fig. 434. To my mind, the painting is too hard to be by Murillo. But cf. J. Brown ("Murillo, pintor de temas eróticos," 39) who views the painting in a sensual context.

69. Perry, *Crime and Society*, 198.

70. Ibid.

71. See F. Haskell, *Patrons and Painters* (New York, 1963), 138.

72. For the dates and provenance of these paintings see Angulo Iñíguez, *Murillo*, 2:299, no. 382; 303, no. 389.

73. *Diccionario de la lengua castellana*, vol. 3 (Madrid, 1732), 2; vol. 5 (1737), 103.

74. *Diccionario de refranes, adagios, proverbios, modismos, locuciones y frases proverbiales de la lengua español*, ed. P. M. Sbarbi (Madrid, 1922), 2:471. The *Dice Players* in the Akademie in Vienna, which Angulo Iñíguez *(Murillo*, 2:305, no. 393) accepts, has a similar iconography. Here, however, acorns, a symbol of sloth and stupidity, adorn the gambler's crown. For acorns see Covarrubias, *Tesoro*, 205, and Sbarbi, *Diccionario*, 1:100.

75. On the possibility that this is a theme of a bad example see Angulo Iñíguez, *Murillo*, 2:399, no. 382.

76. *Games and Pastimes of Childhood* (1657; New York, 1969), 37.

77. Ibid., 49.

78. The numerous pictures that have accrued to Murillo's name have been discussed, and to my mind have been rightly rejected, by Angulo Iñíguez, *Murillo*, 2:536–64. Those pictures that Angulo accepts and that I reject have already been noted, with the exception of the *Boy Drinking* in London (Angulo Iñíguez, *Murillo*, 298, no. 381). Despite its eighteenth-century

provenance and attribution to Murillo this rather boring paint-
ing seems rightly to belong to the "style of Murillo." Cf. J. Gaya y
Nuño, *L'opera completa di Murillo* (Milan, 1978), no. 326.

79. Curtis, *Velázquez and Murillo*, 336–38, still provides an
excellent summary of Villavicencio's life and art. The most
recent comprehensive treatment is by M. Haraszti-Takács, "Pe-
dro Nuñez de Villavicencio, disciple de Murillo," *Bulletin du
Musée Hongrois des Beaux Arts* 48–49 (1977):129–55. However,
this article should be used with some caution, as there is a
tendency to make Villavicencio the repository for attributions
that do not fit other artists. Accordingly, the Murillesque *Boy
Drinking* in London is suggested as a Villavicencio (ibid., 154, no.
21) but published in Haraszti-Takács, *Spanish Genre Painting*,
197, as "style of Murillo," and the *Laughing Boy* in Leningrad,
which has been rightly dismissed from the oeuvre of Velázquez
(López-Rey, *Velázquez*, 154, no. 94), has been tentatively assigned
to Villavicencio by Haraszti-Takács. (Ibid. 154, no. 22) Her other
attributions to the artist seem to me unconvincing. I prefer to
view the *Melon Eaters* in Prague, the *Mussel Eaters* in the Louvre,
and the *Oyster Eaters* in Ponce, (ibid., 152, nos. 10, 11, 12) as
pictures from the Italian school similar to the *Beggars* in Balti-
more once thought to be by Villavicencio. (See F. Zeri, *Walters Art
Gallery, Italian Painting* [1976], 462, no. 337.)

80. For this picture see Haraszti-Takács, *Spanish Genre Paint-
ing*, 153, no. 15.

81. Covarrubias, *Tesoro*, 915.

82. *Diccionario de la lengua castellana*, vol. 5 (Madrid, 1737), 97.

83. For provenance see Haraszti-Takács, *Spanish Genre Paint-
ing*, 153, nos. 13–15.

84. On this posture see S. Koslow, "Frans Hals's Fisherboys:
Exemplars of Idleness," *Art Bulletin* 57 (1975):421.

85. For the provenance see Haraszti-Takács, *Spanish Genre
Painting*, 153, no. 17.

86. Cited in ibid., 152, nos. 8–9.

87. See ibid., 153, no. 16. This painting appears to me to be
cut.

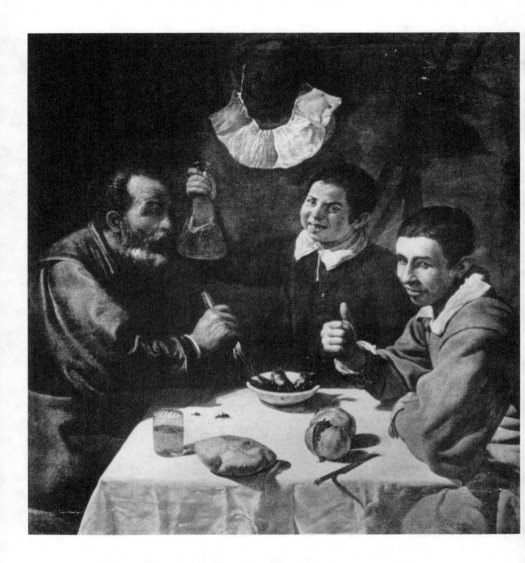

Figure 1. Velázquez, Three Men at a Table,
Leningrad, Hermitage.

140

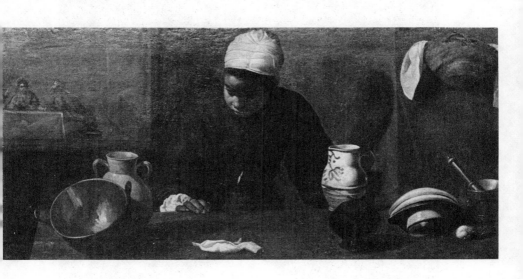

Figure 2. Velázquez, Supper at Emmaus, *Blessington, Ireland, Beit Collection.*

141

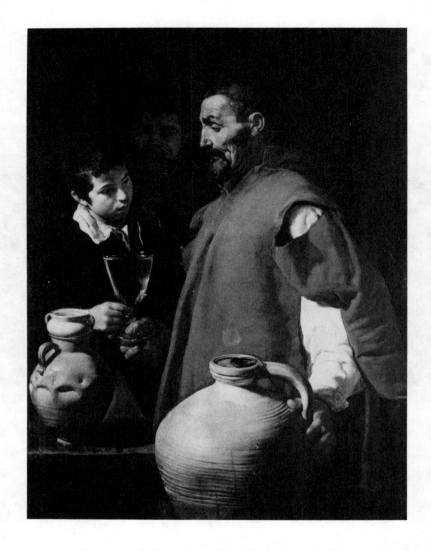

Figure 3. Velázquez, Water Carrier, *London, Wellington Museum.*

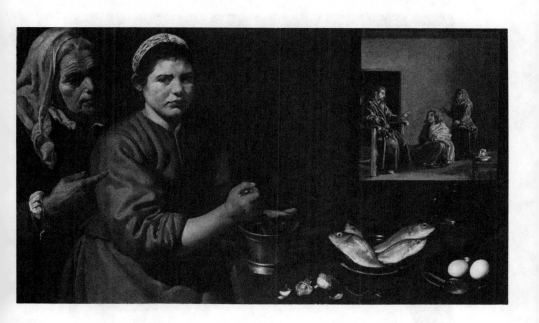

Figure 4. Velázquez, Kitchen Scene with Christ in the
House of Mary and Martha, *London, National Gallery.
Reproduced by Courtesy of the Trustees, the National Gallery.*

143

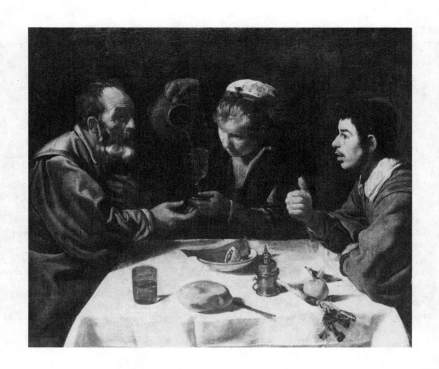

Figure 5. Velázquez, Luncheon, *Budapest, Museum of*
Fine Arts.

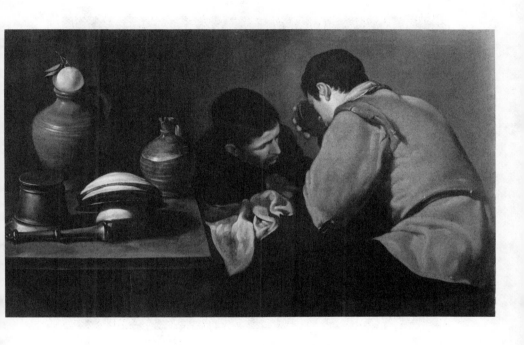

Figure 6. Velázquez, Two Men at a Table, *London,*
Wellington Museum.

145

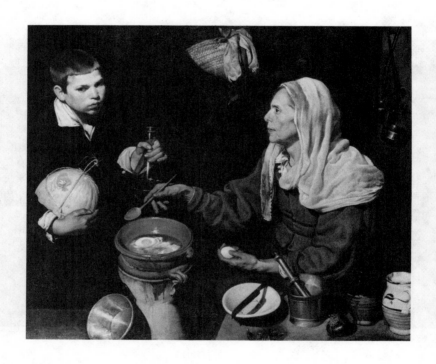

Figure 7. Velázquez, Old Woman Cooking Eggs, *Edinburgh, National Gallery.*

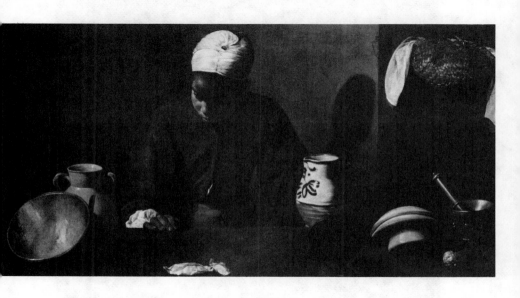

Figure 8. Velázquez, The Servant, *Chicago, Art Institute.*

147

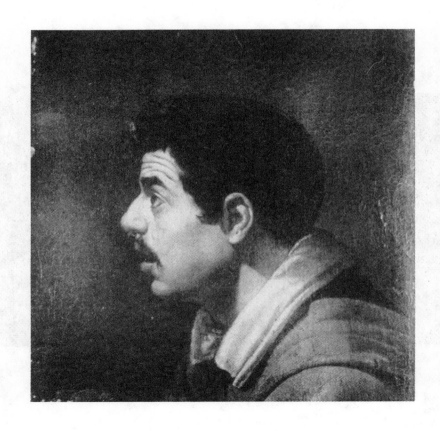

Figure 9. Velázquez, Head of a Young Man,
Leningrad, Hermitage.

148

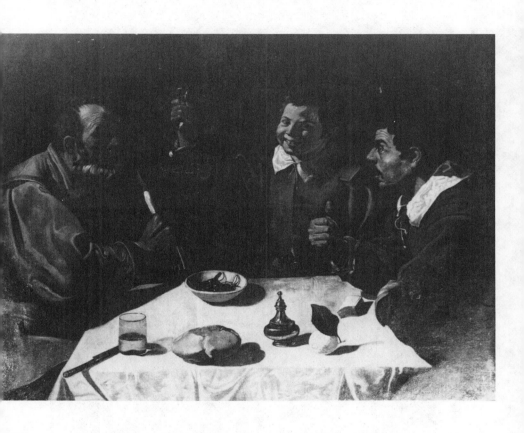

Figure 10. After Velázquez, Three Men at a Table, *Private Collection, photo courtesy Courtauld Institute of Art.*

149

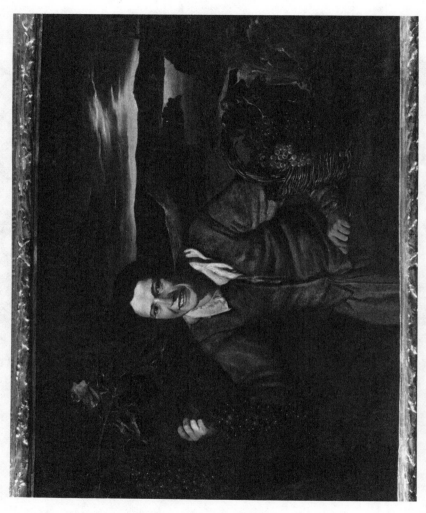

Figure 11. Velázquez? The Vintager, *Jacksonville, Florida, Cummer Art Gallery, reproduced courtesy Cintas Foundation, New York.*

150

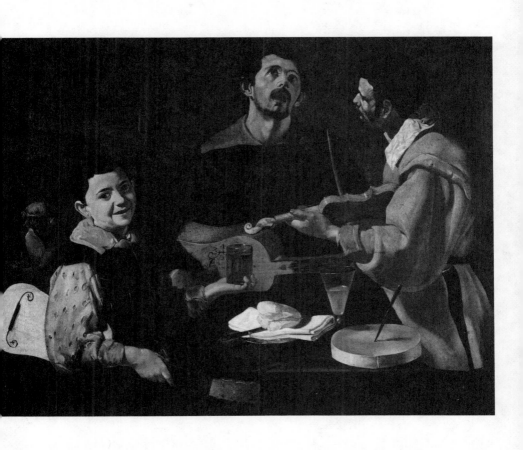

Figure 12. Velázquez? Musical Trio, *Berlin, Gemäldegalerie.*

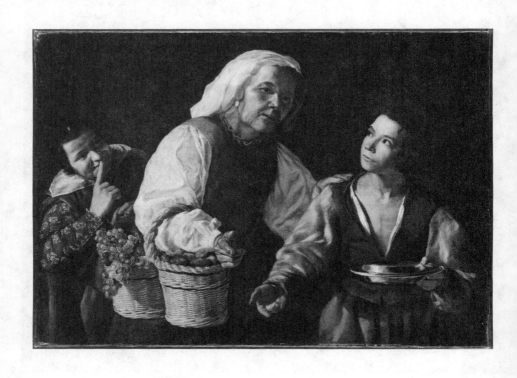

Figure 13. Anonymous Italian Master? Old Woman Selling
Fruit, *Oslo, National Gallery.*

152

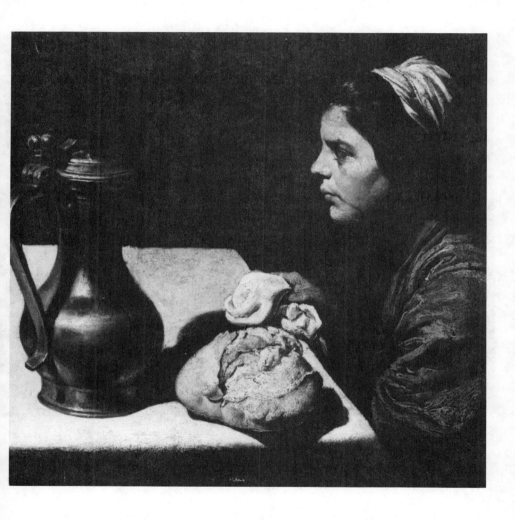

Figure 14. Anonymous Spanish Master, Young Woman at a
Table, *New York, private collection, photo courtesy of Yale
University Art Library.*

153

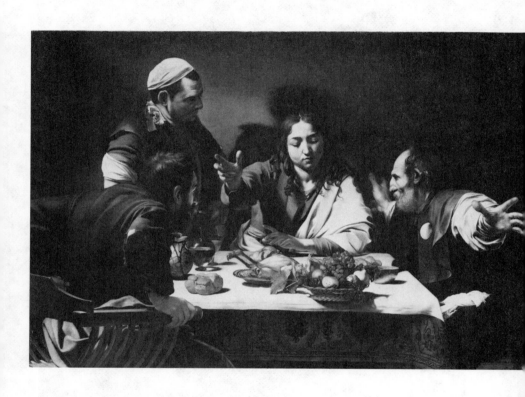

Figure 15. Caravaggio, Supper at Emmaus, *London, National Gallery. Reproduced by Courtesy of the Trustees, the National Gallery.*

154

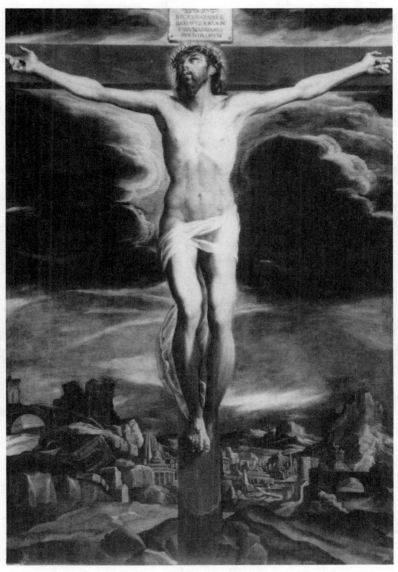

Figure 16. Orazio Borgianni, Crucifixion, *Cádiz, Museo de Bellas Artes, photo MAS.*

155

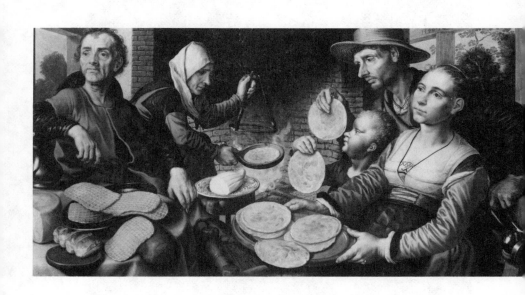

Figure 17. Pieter Aertsen, Pancake Baker, *Rotterdam,
Museum Boymans-Van Beuningen.*

156

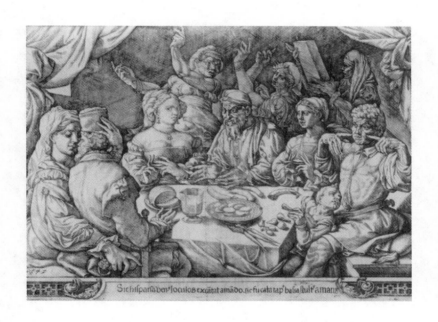

Figure 18. Jacob Matham, Supper at Emmaus,
Amsterdam, Rijksmuseum.

157

Figure 19. Jan Vermeyen, Spanish Supper, *London, British Museum, photo courtesy of the Trustees of the British Museum.*

158

Figure 20. *Vincenzo Campi,* Cheese Eaters, *Lyons, Musée des Beaux Arts, photo J. Camponogara.*

159

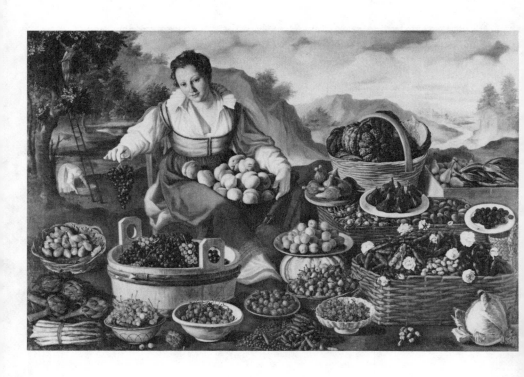

Figure 21. *Vincenzo Campi,* Fruit Vendor, *Milan, Brera,*
photo Brera.

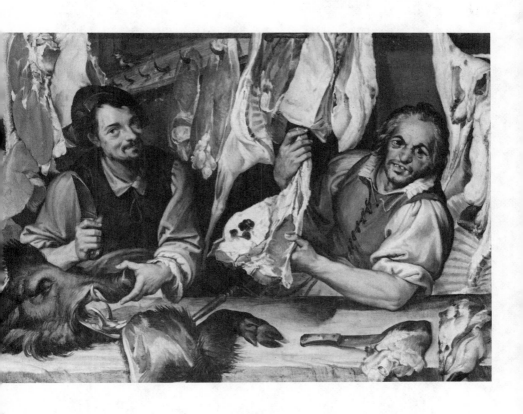

Figure 22. Bartolomeo Passarotti, Butcher Shop, *Rome, National Gallery, photo Villani.*

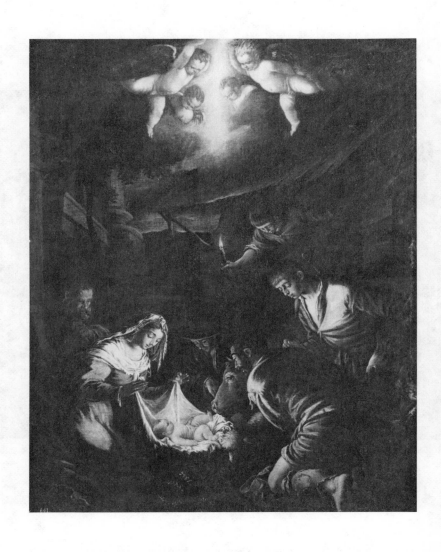

Figure 23. Francesco Bassano, Nativity, *Madrid, Prado.*

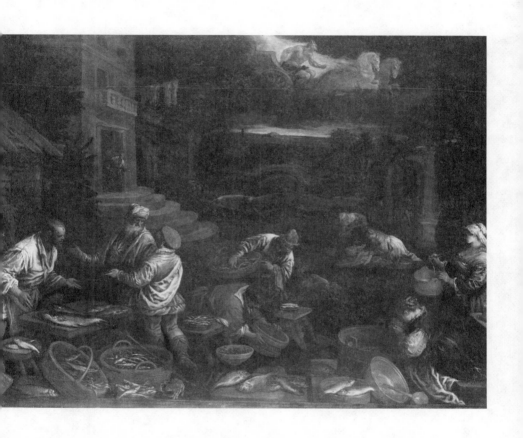

Figure 24. Francesco Bassano, Allegory of Water, *Sarasota, Ringling Museum.*

163

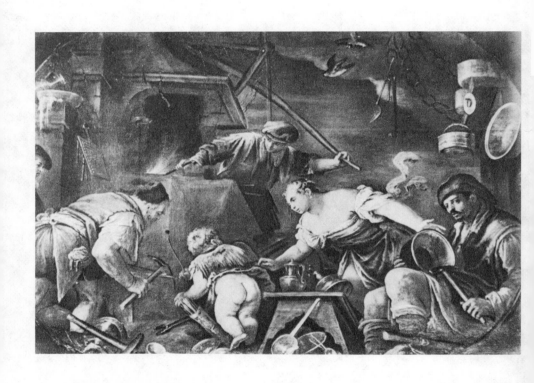

Figure 25. Francesco Bassano, Forge of Vulcan, *Poznan, National Gallery.*

164

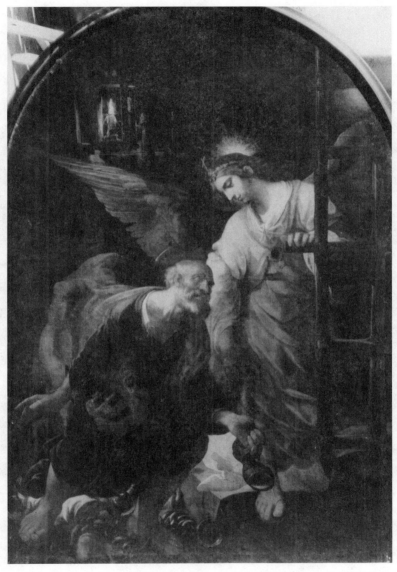

Figure 26. Juan de Roelas, Liberation of St. Peter, *Seville, S. Pedro, photo MAS.*

165

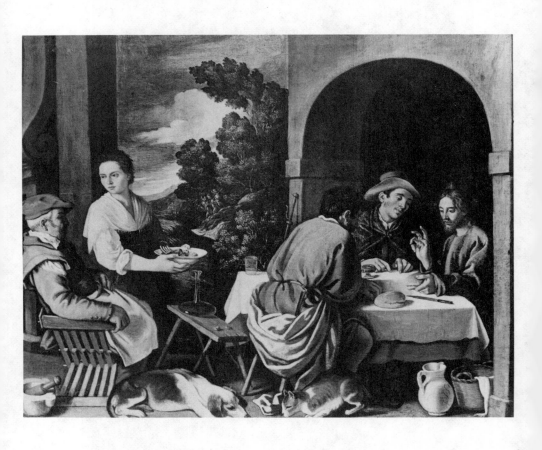

Figure 27. Pedro de Orrente, Supper at Emmaus, *Budapest, Museum of Fine Arts.*

166

Figure 28. Francisco Pacheco, Crucifixion, *Madrid, Gomez-Moreno collection, photo MAS.*

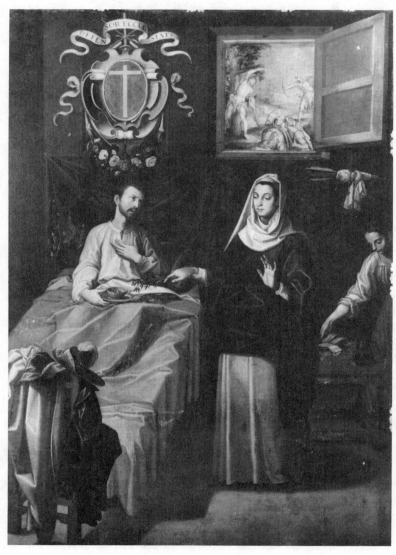

Figure 29. Francisco Pacheco, St. Sebastian Nursed by St. Irene, *formerly Alcalá de Guadaira, St. Sebastian, photo MAS.*

Figure 30. Juan Estéban de Ubeda, Meat Market, *Granada,*
Museo de Bellas Artes.

Figure 31. Jan Vermeyen, Dance of Peasants,
Hamburg, Kunsthalle.

170

Figure 32. Annibale Carracci, **Butcher Shop**, *Oxford, Christ Church, photo Villani.*

171

Figure 33. Vincenzo Campi, Fish Vendors, *Kirchheim,*
photo Hartmann.

172

Figure 34. Niccolo Frangipane, Allegory of Autumn, *Udine, Museo Civico, photo Brisighelli.*

173

Figure 35. *After Peter Paul Rubens,* Old Woman and Boy with Candles, *Georgia Museum of Art, University of Georgia.*

174

Figure 36. Leandro Bassano, Market Scene, *Vienna, Kunsthistorisches Museum.*

175

La marchandiſe que ie vends,
Et que tout le iour ie pourmeine,
Vient de la Seine ou ie la prends,
Ou du puits ou de la ſonteine

Mais du naturel dont ie ſuis,
I'ay ſi peur que l'eau ne me noye,
Que i'en boy le moins que ie puis,
Et le vin eſt toute ma ioye

B.B

lo Blond excud auec Priuilege

Figure 37. Abraham Bosse, Water Carrier, *Paris,*
Bibliothèque Nationale.

PRVNAS ENIM
CONGREGABIS.

Que faites vous plus que les peagers,
Si vous aymez seulement voz amis?
Pource, dit Christ aux hommes mensongers,
Aimez de cœur non feinct voz ennemis:
Secourez les aux perilz où sont mis.
Car leur offrant viure & tout bien honneste,
Embraserez aux haineux ennemis
Charbons de feu allumés sur leur teste.

x Ces

Figure 38. G. de Montenay, "Prunas Enim Congregabis"
Emblemes ou Devises Chrestiennes,
Glasgow University Library.

177

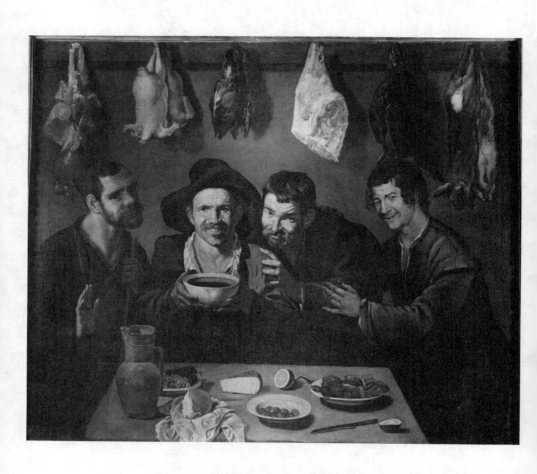

Figure 39. Follower of Velázquez, Four Men at a Table,
Oakley Park, Ludlow, photograph courtesy
Courtauld Institute of Art.

Figure 40. José Antolínez, Picture Seller, *Munich, Alte Pinakothek.*

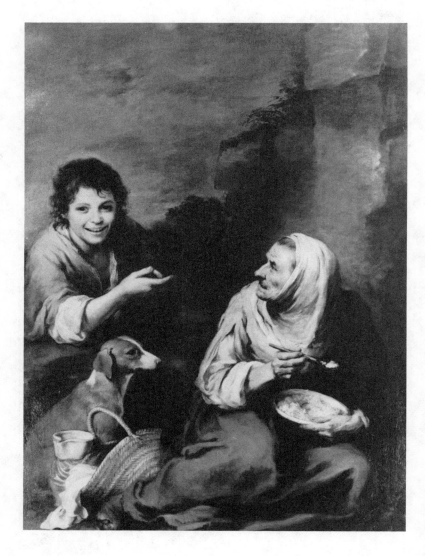

Figure 41. *Bartolomé Murillo,* Old Woman and a Boy,
Dyrham Park, National Trust.

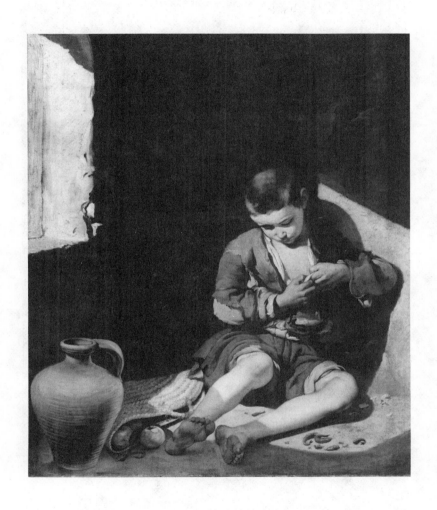

Figure 42. Bartolomé Murillo, Boy Hunting Fleas,
Paris, Louvre.

181

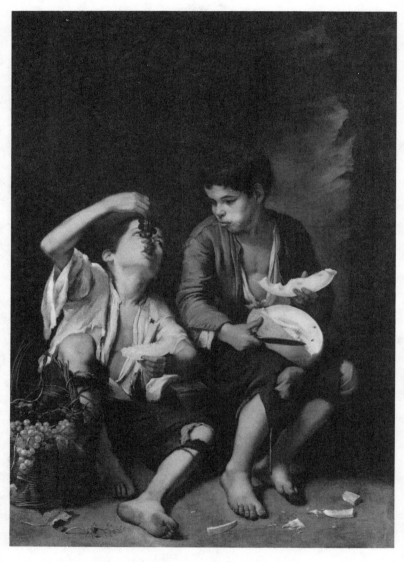

Figure 43. Bartolomé Murillo, Two Boys Eating Fruit, *Munich, Alte Pinakothek.*

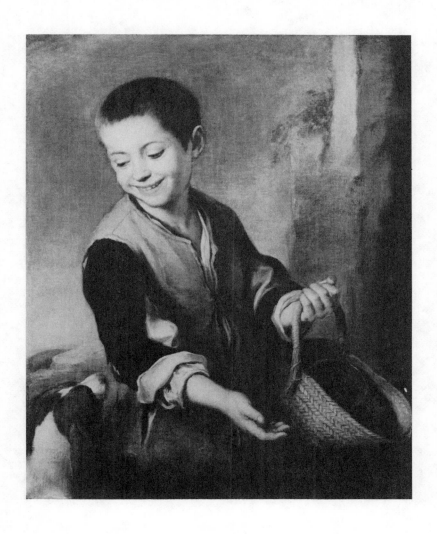

Figure 44. Bartolomé Murillo, Boy with a Dog,
Leningrad, Hermitage.

183

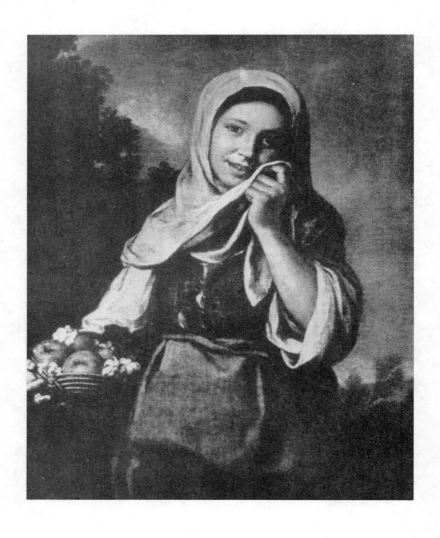

Figure 45. Bartolomé Murillo, Girl Selling Fruit, *Moscow, Pushkin Museum.*

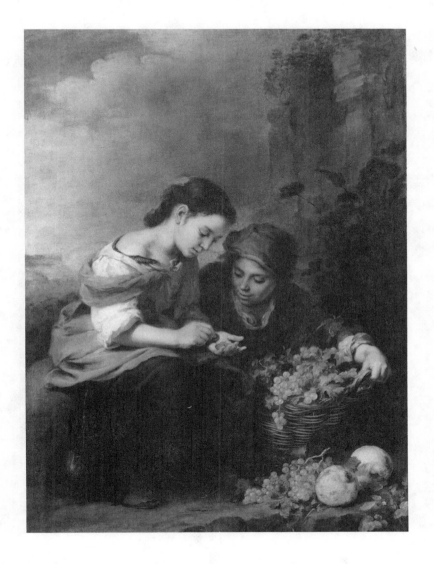

Figure 46. Bartolomé Murillo, Young Fruit Vendors, *Munich, Alte Pinakothek.*

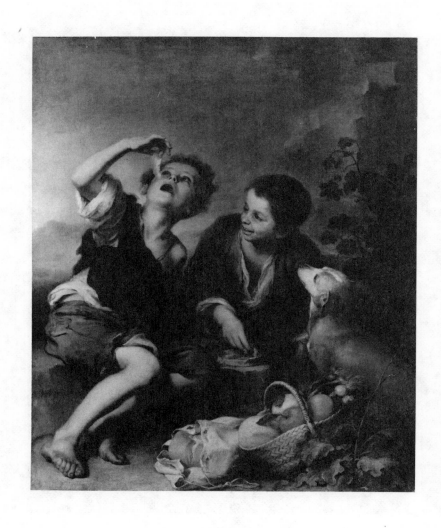

Figure 47. Bartolomé Murillo, Steet Boys, *Munich,
Alte Pinakothek.*

186

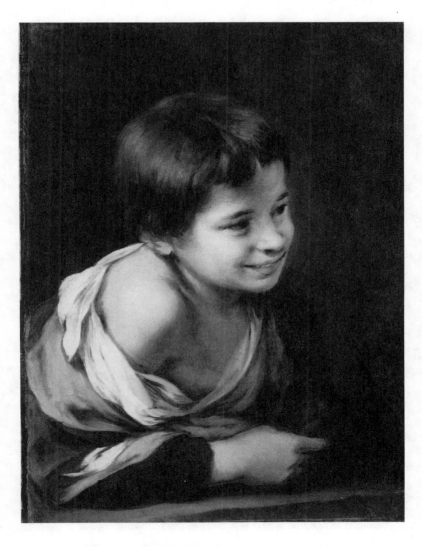

Figure 48. Bartolomé Murillo, Boy Leaning on a Parapet, *London, National Gallery, reproduced by courtesy of the Trustees of the National Gallery.*

187

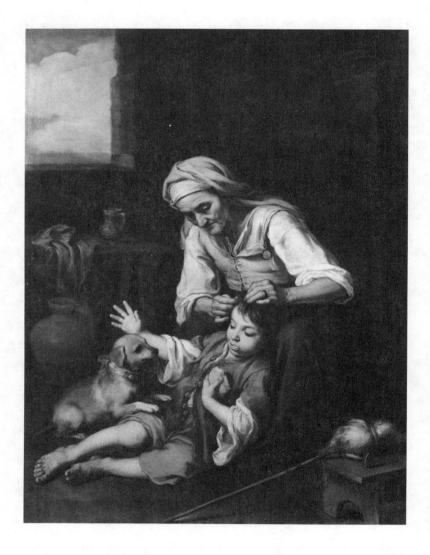

Figure 49. Bartolomé Murillo, Woman Removing Lice
from a Child, *Munich, Alte Pinakothek.*

188

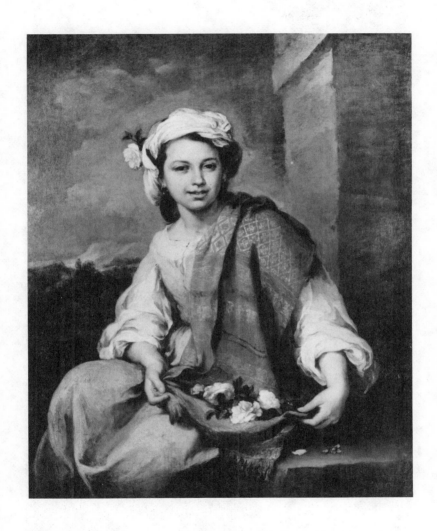

Figure 50. Bartolomé Murillo, Flower Girl, *Dulwich,*
Picture Gallery.

189

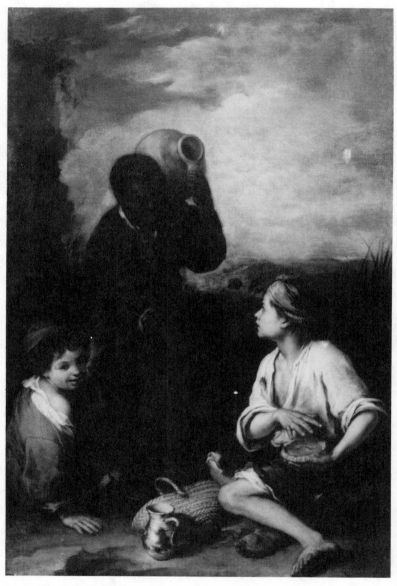

Figure 51. Bartolomé Murillo, Three Boys, *Dulwich, Picture Gallery.*

190

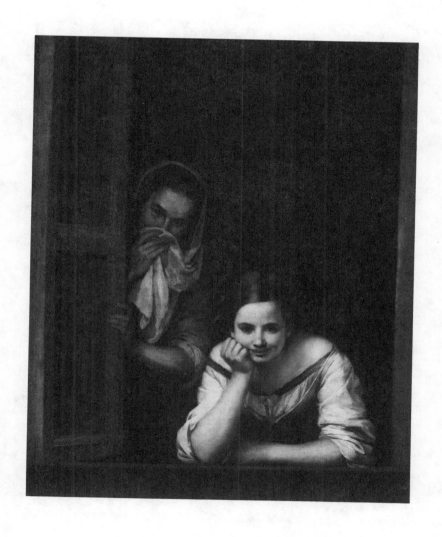

Figure 52. Bartolomé Murillo, Two Gallegas at a Window, *Washington, National Gallery,*

191

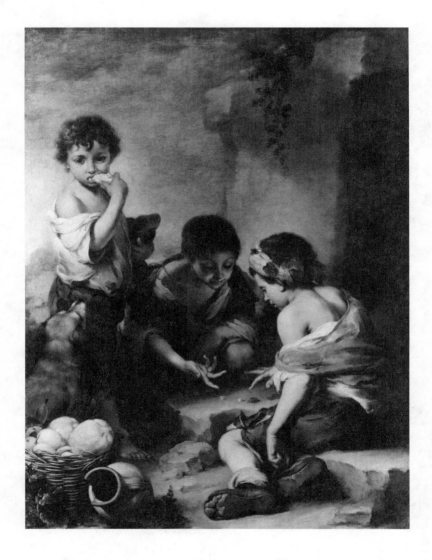

Figure 53. Bartolomé Murillo, Boys Playing Dice, *Munich, Alte Pinakothek.*

192

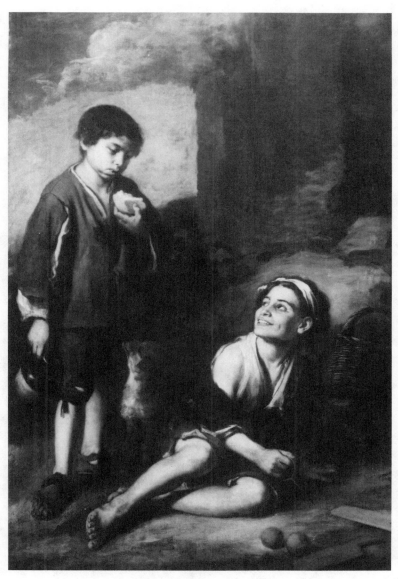

Figure 54. Bartolomé Murillo, Ballgame, *Dulwich, Picture Gallery.*

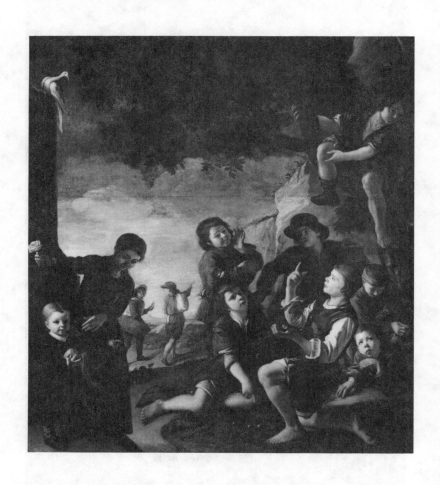

Figure 55. Nuñez de Villavicencio, Children Playing,
Madrid, Prado.

194

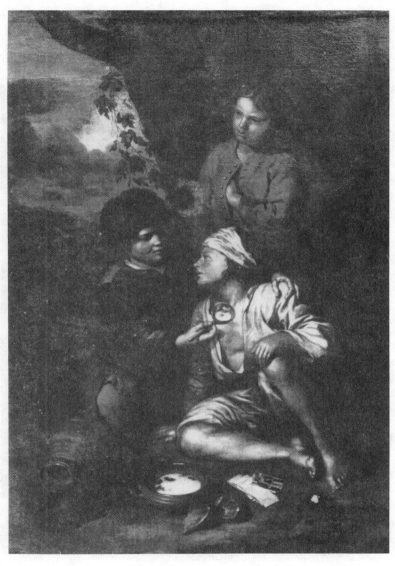

Figure 56. Nuñez de Villavicencio, Card Players, *Leicester, Museums and Art Gallery.*

195

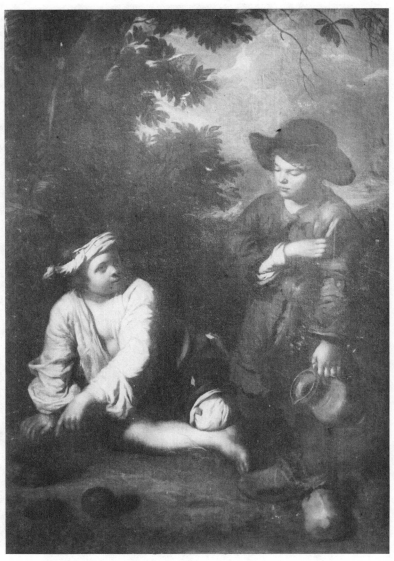

Figure 57. Nuñez de Villavicencio, Two Youths, *Musée Vivenel, Compiègne, photo S.P.A.D.E.M.*

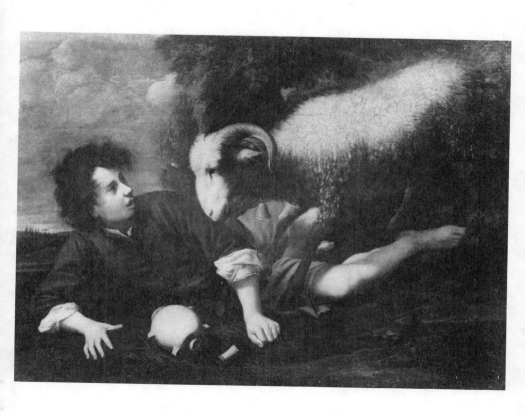

Figure 58. Nuñez de Villavicencio, Boy Attacked by a Ram, *Modena, Galleria Estense.*

197

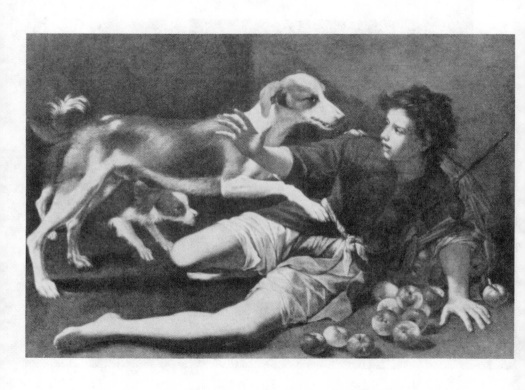

Figure 59. Nuñez de Villavicencio, Boy Beset by Dogs,
Budapest, Museum of Fine Arts.

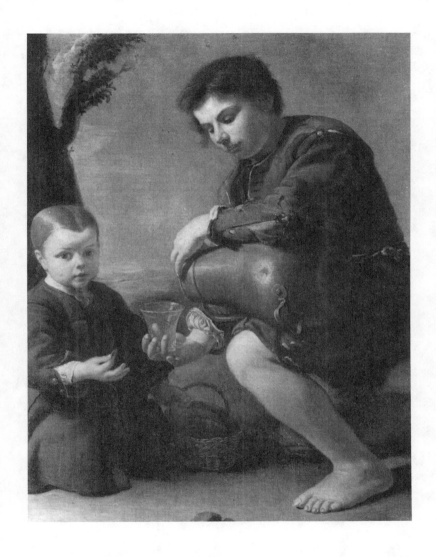

Figure 60. Nuñez de Villavicencio, Water Carrier, *Seville,*
Casa de Murillo, photo MAS.

Bibliography

Agulló Cobo, M. *Noticias sobre pintores madrileños de los siglos XVI y XVII*. Granada, 1978.

Ainaud y Lasarte, J. "Ribalta y Caravaggio." *Anales y Boletin de los Museos de Arte de Barcelona* 5 (1947):345–410.

Alcázar, B. *Poesías de Baltasar del Alcázar*. Seville, 1856.

Alciati, A. *Los emblemas de Alciati*. 1549; Madrid, 1975.

Alemán, M. *Guzmán de Alfarache* (1599). Edited by S. Gili y Gaya. Madrid, 1962.

Alemany y Selfa, B. *Vocabulario de las obras de don Luis de Góngora y Argote*. Madrid, 1930.

Alpers, S. "Realism as a Comic Mode: Low-life Painting Seen through Bredero's Eyes." *Simiolus* 8 (1976):115–42.

Anderson Galleries. *Sale Catalogue no. 4026*. New York, 1933.

Anderson, R. M. "The Golilla, a Spanish Collar of the 17th Century." *Waffen und Kostumkunde* 11 (1969):1–7.

Angulo Iñiguez, D. *Pedro de Campaña*. Madrid, 1951.

———. *Pintura del Renacimento*. Vol. 14 of *Ars Hispaniae*. Madrid, 1954.

———. *Jose Antolínez*. Madrid, 1957.

———. *Pintura del siglo XVII*. Vol. 15 of *Ars Hispaniae*. Madrid, 1971.

———. *Murillo, su vida, su arte, su obra*. 3 vols. Madrid, 1981.

Angulo Iñiguez, D., and A. E. Pérez Sánchez. *Historia de la pintura española escuela toledana de la primera mitad del siglo XVII*. Madrid, 1972.

Arce Beneventano, F. *Adagio y fabulas* (1533). Edited by T. Trallero Bardaji. Barcelona, 1950.

Ariès, P. *Centuries of Childhood: A Social History of Family Life*. New York, 1962.

Arslan, E. *I Bassano*. Milan, 1960.

Asturias, M., and P. Bardi. *Velázquez.* Barcelona, 1977.

Baldinucci, F. *Notizie dei professori del disegno* (1681–96). Florence, 1846.

Barbadillo, M. *Pacheco, su tierra y su tiempo.* Jerez, 1963.

Baroja, J. C. *El carnaval.* Madrid, 1965.

Bataillon, M. *Le roman picaresque.* Paris, 1931.

Bellori, G. P. *Vite de pittori scultori et architetti.* Rome, 1672.

Bergstrom, I. *Maestros españoles de bodegones y floreros del siglo XVII.* Madrid, 1970.

Bernt, W. *The Netherlandish Painters of the Seventeenth Century.* 3 vols. London, 1970.

Bjornson, R. *The Picaresque Hero in European Fiction.* Madison, 1977.

Bleznick, D. *Quevedo.* New York, 1972.

Blüher, K. *Seneca in Spanien.* Munich, 1969.

Blunt, A. *Artistic Theory in Italy, 1450–1600.* Oxford, 1964.

Bomli, P. W. *La femme dans l'Espagne du siècle d'or.* The Hague, 1950.

Boon, K. G. "Jan Vermeyen." In *Thieme-Becker Künstler Lexicon* (Leipzig, n.d.), 34:278–280.

Borea, E. "Caravaggio e la Spagna: Osservazioni su una mostra a Seviglia." *Bolletino d'Arte* 59 (1974):43–52.

Brigstocke, H. *Italian and Spanish Paintings in the National Gallery of Scotland.* Glasgow, 1978.

Brown, C. *Dutch Genre Painting: Themes and Painters in the National Gallery.* London, 1976.

Brown, J. *Francisco de Zurbarán.* New York, n.d.

———. *Images and Ideas in Seventeenth-Century Spanish Painting.* Princeton, 1978.

———. "Murillo, pintor de temas eróticos." *Goya* 169–71 (1982):35–42.

Bruyn, J., and M. Thierry de Bye Dolleman. "Maerten van Heemskercks *Familiengroep* te Kassel: Pieter Jan Foppesz. en zijn gezin." *Oud Holland* 97 (1983):13–24.

Buchanan, W. *Memoirs of Painting, with Chronological History of the Importation of Pictures by the Great Masters into England since the French Revolution.* 2 vols. London, 1824.

Campi, A. *Cremona Fedilissima.* Cremona, 1585.

Carducho, V. *Diálogos de la Pintura* (1633). Edited by D. G. Cruzada Villaamil. Madrid, 1865.

Caro, R. *Días Geniales o Lúdicros.* Edited by J. P. Etienvre. Madrid, 1978.

Carpegna, N. *Catalogo della Galleria Nazionale Palazzo Barberini, Roma.* Rome, 1955.

Casagrande, R. *Le cortigiane veneziane nel cinquecento.* Milan, 1968.

Cavestany, J. *Floreros y bodegones en la pintura española.* Madrid, 1936–40.

Cavina, A. *Carlo Saraceni.* Milan, 1968.

Ceán Bermúdez, J. A. *Diccionario historico de los más illustres professores de las bellas artes* (1800). Madrid, 1965.

———. *Diálogo sobre el arte de la pintura.* Seville, 1819.

———. *Historia del arte de la pintura* (1825). In *Varia Velazqueña,* 2:195–97, Madrid, 1960.

Cela, C. *Diccionario secreto.* Madrid, 1975.

Cervantes Saavedra, M. de. *La Galatea* (1585). Edited by J. B. Avalle-Arce. Madrid, 1961.

———. *Novelas ejemplares.* Edited by F. Rodríguez Marín. Madrid, 1914.

———. *Obras completas.* Edited by A. Valbuena Prat. Madrid, 1965.

Chandler, F. W. *Romances of Roguery.* New York, 1899.

Cinotti, M., and G. A. dell'Acqua. *Caravaggio.* Bergamo, 1983.

Combet, L. *Recherches sur le "refranero" castillan.* Paris, 1970.

Correas, G. *Vocabulario de refranes y frases proverbiales* (1627). Edited by L. Combet. Bordeaux, 1967.

Covarrubias, S. de. *Tesoro de la lengua castellana o española* (1611). Edited by M. de Riquier. Barcelona, 1943.

Criado de Val, M. "Antifrasis y contaminaciones de sentido erótico en *La lozana andaluza.*" In *Homenaje a Dámaso Alonso,* 1:431–57. Madrid, 1960.

Cruz y Bahamonde, N. de la. *Viaje de Espana* (1805–13). In *Varia Velazqueña,* 2:168–69. Madrid, 1960.

Curtis, C. *Velázquez and Murillo.* London and New York, 1883.

Curtius, E. *European Literature and the Latin Middle Ages.* New York and Evanston, 1963.

Cuzin, J. P. *La diseuse de bonne aventure de Caravage.* Paris, 1977.

Dantisco, L. *Destierro de ignorancia.* Barcelona, 1592.

Deleito y Piñuela, J. *La mala vida en España.* Madrid, 1967.

Denucé, J. "Brieven en documenten betreffende Jan Brueghel I en II," *Bronnen voor de Geschiednis van de Vlaamsche Kunst* 3 (1934):1–172.

Dezallier d'Argenville, A. *Abrégé de la vie des plus fameux peintres* (1762). In *Varia Velazqueña,* 2:119–22. Madrid, 1960.

Diccionario castellano. Madrid, 1786.

Diccionario de la lengua castellana. 6 vols. Madrid, 1726–39.

Diccionario de la lengua castellana. Madrid, 1780.

Diccionario de refranes, adagios, proverbios, modismos, locuciones y frases proverbiales de la lengua español. Edited by P. M. Sbarbi. Madrid, 1922.

Didron, M. "Les oeuvres de miséricorde." *Annales Archéologiques* 21 (1861):195–209.

Dimmler, G. R. "The Egg as Emblem: Genesis and Structure of a Jesuit Emblem Book." *Studies in Iconography* 2 (1976):85–106.

Emmens, J. A. " 'Eins aber ist nötig': Zu Inhalt und Bedeutung von Markt und Küchenstücken des 16. Jahrhunderts." In *Album Amicorum J. G. Van Gelder,* The Hague, 1973, 91–103.

Enggass, R., and J. Brown. *Italy and Spain: 1600–1750.* Englewood Cliffs, N.J., 1970.

Ettinghausen, H. *Francesco Quevedo and the Neo-Stoic Movement.* Oxford, 1972.

Evers, H. *Rubens und seine Werk.* Brussels, 1943.

Fitz-Darby, D. *Francisco Ribalta and his School.* Cambridge, 1938.

Foletier, F. de. *Mille ans d'histoire des Tsiganes.* Paris, 1970.

Friedlaender, M. J. *Early Netherlandish Painting.* Vol. 13. New York and Washington, 1975.

Friedlaender, W. *Caravaggio Studies.* Princeton, 1955.

Fuentes literarias para la historia del arte español. Edited by F. J. Sánchez Cantón. 5 vols. Madrid, 1923–41.

Gállego, J. *Velázquez en Sevilla.* Seville, 1974.

Gaya y Nuño, J. "Picaresco y tremendismo en Velázquez." *Goya* 37/38, (1960):92–101.

———. "Peintre picaresque." *L'Oeil* 84 (1961):52–61.

———. *L'opera completa di Murillo.* Milan, 1978.

Genaille, R. "L'oeuvre de Pieter Aertsen." *Gazette des Beaux Arts* 44 (1954):267–88.

Gensel, W. *Velázquez: Des Meisters Gemälde.* Stuttgart and Berlin, 1913.

Gerstenberg, K. *Diego Velázquez.* Munich, 1957.

Góngora, L. de. *Obras completas.* Edited by J. Mille y Giménez and I. Mille y Giménez. Madrid, 1961.

Grosjean, A. "Toward an Interpretation of Pieter Aertsen's Profane Iconography." *Konsthistorisk Tidskrift* 43 (1974):121–43.

Gudiol, J. "Algunas replicas en la obra de Velázquez." In *Varia Velazqueña,* 1:414–19, Madrid, 1960.

———. *Velázquez.* New York, 1974.

Guzmán, P. de. *Los bienes del honesto trabajo.* Madrid, 1614.

Haraszti-Takács, M. *Spanish Masters.* New York, 1966.

———. "Quelques problèmes des bodegones de Velázquez." *Bulletin du Musée Hongrois des Beaux Arts* 41 (1973):21–48.

———. "Pedro Nuñez de Villavicencio, disciple de Murillo," *Bulletin du Musée Hongrois des Beaux Arts* 48/49 (1977):129–55.

———. *Spanish Genre Painting in the Seventeenth Century.* Budapest, 1983.

Harris, E. "Obras españolas de ´pintores desconocidos." *Revista Española de Arte* 12 (1935):258–59.

Haverkamp-Begemann, E. *Willem Buytewech.* Amsterdam, 1958.

Held, J., and D. Posner. *17th and 18th Century Art.* New York, n.d.

Herrero-Garcia, M. *Ideas de los españoles del siglo XVII.* Madrid, 1928.

Holt, E. *A Documentary History of Art.* Vol. 2. Garden City, N.Y., 1958.

Hoogewerff, G. J. *De Bentveughels.* The Hague, 1952.

Jaffé, M. *Rubens and Italy.* Oxford, 1977.

Janson, H. W. *Apes and Ape Lore in the Middle Ages and the Renaissance.* London, 1952.

Jongh, E. de. *Zinne en minnebilden van de zeventiende eeuw.* Amsterdam, 1967.

———. *Tot Lering en vermaak.* Amsterdam, 1976.

Jongh, E. de, et al. *Die Sprache der Bilder.* Braunschweig, 1978.

Jordan, W. and S. Schroth, *Spanish Still-Life*, Fort Worth, 1985.

Justi, C. *Diego Velázquez und sein Jahrhundert*. 2 vols. Bonn, 1922.

Juvenal. *Satires*. Loeb Classical Library, 1957.

Kahr, M. *Velázquez: The Art of Painting*. New York, 1976.

Kamen, H. *The War of Succession in Spain, 1700–1715*. Bloomington, Ind., 1969.

———. *Spain in the Later Seventeenth Century*. London and New York, 1980.

Kemenov, V. *Velázquez in Soviet Museums*. Leningrad, 1977.

Kinkead, D. "Tres bodegones de Diego Velázquez en una colección sevillana del siglo XVII." *Archivo Español de Arte* 52 (1980):185–86.

Koslow, S. "Frans Hals's Fisherboys: Exemplars of Idleness." *Art Bulletin* 57 (1975):418–32.

Kubler, G. and M. Soria. *Art and Architecture in Spain and Portugal and their American Dominions, 1500–1800*, Baltimore, 1969.

La vida y hechos de Estebanillo González (1646). Edited by J. Mille y Giménez. Madrid, 1934.

La vida de Lazarillo de Tormes (1554). Edited by J. Cejador y Frauca. Madrid, 1926.

Lafuente, E. *Velázquez*. Oxford, 1943.

León, L. de. *The Perfect Wife*. Translated by A. P. Hubbard. Denton, Tex., 1943.

Lioba-Lechner, M. "Ei." *Reallexikon zur deutschen Kunstgeschichte*, vol. 4 (Stuttgart, 1958), 893–903.

Londoño, S. de. *Discorso sobre la forma de reduzir la disciplina militar*. Madrid, 1593.

López-Rey, J. *Velázquez: A Catalogue Raisonné of his Oeuvre*. London, 1963.

———. *Velázquez' Work and World*. London, 1968.

López de Ubeda, F. *La picara Justina* (1605). Edited by J. Puyol. Madrid, 1912.

Maclaren, N., and A. Braham. *National Gallery Catalogues, The Spanish School*. London, 1970.

Mal Lara, J. de. *Filosofía vulgar* (1568). Edited by A. Villanova. Barcelona, 1958.

Malon de Chaide, P. de. *La conversión de la Magdalena* (1588). Madrid, 1947.

Mancini, G. *Considerazioni sulla pittura.* Edited by A. Marucchi and L. Salerno. Rome, 1956.

Martínez, J. *Discursos practicables del nobilísimo arte del pintura.* Madrid, 1866.

Master Paintings from the Hermitage and the State Russian Museum. New York, 1975.

Mayer, A. "Velázquez und die niederlandischen Küchenstücke." *Kunstchronik und Kunstmarkt* 30 (1918/1919):236–37.

———. "Das Original der 'Küchenmagd' von Velázquez." *Der Cicerone* 19 (1927):562.

———. *Velázquez: A Catalogue Raisonné of the Pictures and Drawings.* London, 1936.

Meijer, B. W. "Niccolo Frangipane." *Saggi e Memorie de Storia dell'Arte* 8 (1972):151–91.

Mendez Casal, A. "El Pintor Alejandro Loarte." *Revista Española de Arte* 4 (1934):187–202.

Mérimée, H. *Spectacles et comédiens à Valencia (1580–1630).* Toulouse and Paris, 1913.

Miedema, H. "Realism and Comic Mode: The Peasant." *Simiolus* 9 (1977):205–19.

Mirimonde, A. P. "La musique dans les allégories de l'amour." *Gazette des Beaux Arts* 49 (1967):319–46.

———. "Le symbolisme musical chez Jerome Bosch." *Gazette des Beaux Arts* 77 (1971):19–50.

Moffit, J. "Review of M. Kahr's *Velázquez.*" *Art Journal* 38 (1979):213–16.

———. "Image and Meaning in Velázquez's Water Carrier of Seville." *Traza y Baza* 7 (1979):5–23.

———. "Observations on Symbolic Content in Two Early Bodegones by Diego Velázquez," *Boletín del Museo e Instituto Camón Aznar,* 1 (1980):82–95.

Moir. A. "Alonzo Rodríguez." *Art Bulletin* 44 (1962):205–18.

———. *The Italian Followers of Caravaggio.* Cambridge, 1967.

———. *Caravaggio and his Copyists.* New York, 1976.

Montenay, G. de. *Emblèmes ou devises chrestiennes (1571).* Yorkshire, 1973.

Moret, M. *Aspects de la société marchande de Seville au début du XVIIe siècle.* Paris, 1967.

Moxey, K. "The 'Humanist' Market Scenes of Joachim Beuckelaer: Moralizing Exempla or 'Slices of Life.' " *Jaarboek van het Koninklijk Museum voor Schone Kunsten—Antwerpen* (1976):109–86.

——. *Pieter Aertsen, Joachim Beuckelaer and the Rise of Secular Painting in the Context of the Reformation.* New York and London, 1977.

Muller, P. "Francisco Pacheco as a Painter." *Marsyas* 10 (1961):34–44.

Nash, J. M. *The Age of Rembrandt and Vermeer.* London, 1972.

Navio, J. López. "Velázquez tasa los cuadros de su protector D. Juan de Fonseca." *Archivo Español de Arte* 34 (1961):53–83.

Orellana, M. A. de. *Biografía pictórica valentina, o Vida de los pintores, arquitectos, escultores y grabadores valencianos.* Edited by X. de Salas. Valencia, 1967.

Ortiz, A. *The Golden Age of Spain, 1516–1659.* New York, 1971.

Oviedo, G. Fernández de. *Las quinquagenas de la nobleza de España.* Madrid, 1880.

Pacheco, F. *Arte de la pintura (1649).* Edited by F. J. Sánchez Cantón. Madrid, 1956

Paleotti, G. *Discorso intorno alle imagine sacre e profane* (1582). In *Trattati d'arte del cinquecento,* edited by P. Barocchi. Vol. 2. Bari, 1961.

Pantorba, B. *La vida y la obra de Velázquez.* Madrid, 1955.

——. *Tutta la pittura del Velázquez.* Milan, 1965.

Péréz Sánchez, A. E. *Borgianni, Cavarozzi y Nardi en España.* Madrid, 1964.

——. "Sobre bodegones italianos, napolitanos especialmente." *Archivo Español de Arte* 40 (1967):309–23.

——. *Pintura italiana del siglo XVII.* Madrid, 1970.

——. *Caravaggio y el naturalismo español.* Seville, 1973.

Perry, M. E. *Crime and Society in Early Modern Seville.* Hanover and London, 1980.

Pike, R. *Enterprise and Adventure: The Genoese in Seville and the Opening of the New World.* Ithaca, 1966.

Pliny. *The Elder Pliny's Chapters on the History of Art.* Edited by K. Jex-Blake and E. Sellers. Chicago, 1968.

Poesía Erótica. Edited by J. Diez Borque. Madrid, 1977.

Ponz, A. *Viaje de España.* 18 vols. Madrid, 1772–94.

Popham, A. E. "Catalogue of Etchings by Jan Cornelisz. Vermeyen." *Oud Holland* 44 (1927):174–82.

Posner, D. *Annibale Carracci: A Study in the Reform of Italian Painting around 1590.* London, 1971.

————. "Caravaggio's Homo-erotic Early Works." *Art Quarterly* 34 (1971):301–24.

Prinz von Hohenzellern, J. G. and H. Soehner. *Französiche und spanische Malerei.* Munich, 1972.

Proske, B. *Juan Martínez Montañez.* New York, 1967.

Quevedo y Villegas, F. de. *Obras completas.* Edited by F. Buendia. Madrid, 1964.

Ramírez, A. *Epistolario de Justo Lipsio y los españoles.* St. Louis, 1966.

Renger, K. *Graphik der Niederlande 1508–1617: Kupferstich und Radierungen von Lucas van Leyden bis Hendrick Goltzius.* Munich, 1979.

Rodríguez Moniño, A. *Diccionario bibliografico pliegos sueltos poeticos.* Madrid, 1970.

————. *Manual bibliografico de cancioneros y romanceros.* 2 vols. Madrid, 1973.

Rojas, F. de. *The Celestina.* Translated by L. B. Simpson. Berkeley and Los Angeles, 1955.

Ruiz, Juan. *Libro de buen amor.* Edited by M. Criado de Val and E. W. Naylor. Madrid, 1965.

Salas, M. J. *Historia de la assistencia social en España en la edad moderna.* Madrid, 1958.

Salomon, N. *Recherches sur la thème paysan dans la "Comedia" au temps de Lope de Vega.* Bordeaux, 1965.

Sánchez Cantón, F. J. "Sobre la vida y las obras de Juan Pantoja de la Cruz." *Archivo Español de Arte* 20 (1947):95–120.

Schleier, E. *Picture Gallery Berlin: Catalogue of Paintings.* Berlin, 1978.

Scribner, C. *"In Alia Effigiae:* Caravaggio's London *Supper at Emmaus." Art Bulletin* 59 (1977):375–82.

Seneca. *Moral Essays.* Loeb Classical Library, 1925.

Sentenach, N. *The Painters of the School of Seville.* London, n.d.

Serrera, J. M. "Una 'Riña de pícaros' de Matias Jimeno." *Archivo Español de Arte* 52 (1979):79–80.

Shergold, N. D. "Ganassa and the 'Commedia dell'Arte' in Sixteenth Century Spain." *Modern Language Review* 51 (1956):359–68.

Slive, S. *Frans Hals.* 3 vols. London, 1970–74.

Soehner, H. "Velázquez und Italien." *Zeitschrift für Kunstgeschichte* 18 (1955):1–39.

———. "Die Herkunft der Bodegones de Velázquez." In *Varia Velazqueña,* 1:233–49. Madrid, 1960.

———. *Bayerische Staatsgemälde Sammlungen. Alte Pinakothek München; Spanische Meister.* Munich, 1963.

Soria, M. S. "An Unknown Early Painting by Velázquez." *Burlington Magazine* 91 (1949):123–27.

———. "Velázquez and Tristán." In *Varia Velazqueña,* 1:233–49. Madrid, 1960.

Spear, R. *Caravaggio and his Followers.* New York, 1975.

Stechow, W., and C. Comer. "The History of the Term Genre." *Allen Memorial Art Museum Bulletin* 33 (1975–76):89–94.

Stefano, A. di. "Un boceto de Velázquez en Roma." *Archivo Español de Arte* 27 (1954):257–59.

Steinberg, L. "Review of J. López-Rey, *Velázquez.*" *Art Bulletin* 47 (1965):274–94.

———. "The Water Carrier of Velázquez." *Art News* 70 (1971):54.

Stella, C. *Games and Pastimes of Childhood* (1657). New York, 1969.

Sterling, C. *La nature morte de l'antiquité à nos jours.* Paris, 1959.

Stirling-Maxwell, W. *Annals of the Artists of Spain.* Vol. 3. London, 1891.

Suida-Manning, B., and W. Suida. *Luca Cambiaso.* Milan, 1958.

Sutton, P. *Dutch Genre Painting.* Philadelphia, 1984.

Swinburne, H. *Travels through Spain* (1779). In *Varia Velazqueña,* 2:134. Madrid, 1960.

Tervarent, G. de. *Attributs et symboles dans l'art profane, 1450–1600.* Geneva, 1958.

Thacher, J. "The Paintings of Francisco de Herrera the Elder." *Art Bulletin* 19 (1937):325–80.

Theiss, W. *Exemplarische Allegorik*. Munich, 1968.

Tolnay, C. de. *The Drawings of Peter Brueghel the Elder*. New York, n.d.

Trapier, E. du Gué. *Velázquez*. New York, 1948.

Tzeutschler-Lurie, A. and D: Mahon. "Caravaggio's Crucifixion of St. Andrew from Valladolid." *Bulletin of the Cleveland Museum of Art* 64 (1977):3–24.

Van Loga, V. *Die Malerei in Spanien*. Berlin, 1923.

Villa N. *Le XVIIᵉ siècle vu par Abraham Bosse*. Paris, 1967.

Villalon, C. de. *Viaje de Turquia* (1577). Edited by M. Serrano y Sanz. Madrid, 1905.

Volk, M. C. *Vincencio Carducho and Seventeenth Century Castilian Painting*. New York and London, 1977.

Wind, B. "Studies in Genre Painting: 1580–1630." Ph.D. dissertation, New York University, 1973.

———. "Pitture Ridicole: Some Late Cinquecento Comic Genre Paintings," *Storia dell'Arte* 20 (1974):25–35.

———. "Annibale Carracci's *Scherzo:* The Christ Church *Butcher Shop*." *Art Bulletin* 68 (1976):93–96.

———. "Vincenzo Campi and Hans Fugger: A Peep at Late Cinquecento Bawdy Humor." *Arte Lombarda* 47/48 (1977):108–14.

———. "Close Encounters of the Baroque Kind." *Studies in Iconography* 4 (1978):115–24.

Wit, J. de. *Dutch Pictures in Oxford*. Oxford, 1975.

Zamboni, S. "Vincenzo Campi." *Arte Antica e Moderna* 30 (1965):124–47.

Zeri, F. *Walters Art Gallery, Italian Painting*. Baltimore, 1976.

Index of Names

213